EROTICA II

In this second illustrated anthology of erotica, Part one, 'The watchers and the watched', examines the mainspring of erotic writing and art: the literary selections feature voyeurism both calculated and unplanned. Part two, 'Shades of light and dark', explores the ambivalence of the sexual urge. On the one hand it is associated with the dark side of human nature, but on the other sex can be hilarious and revealing.

Once again, the resulting work concentrates on the life-enhancing and amusing aspects of erotica, appealing as much to women as it does to men. This is not a book for the shy or easily shocked but there *is* something here for everybody – as long as you agree that sex is far too important to be taken seriously.

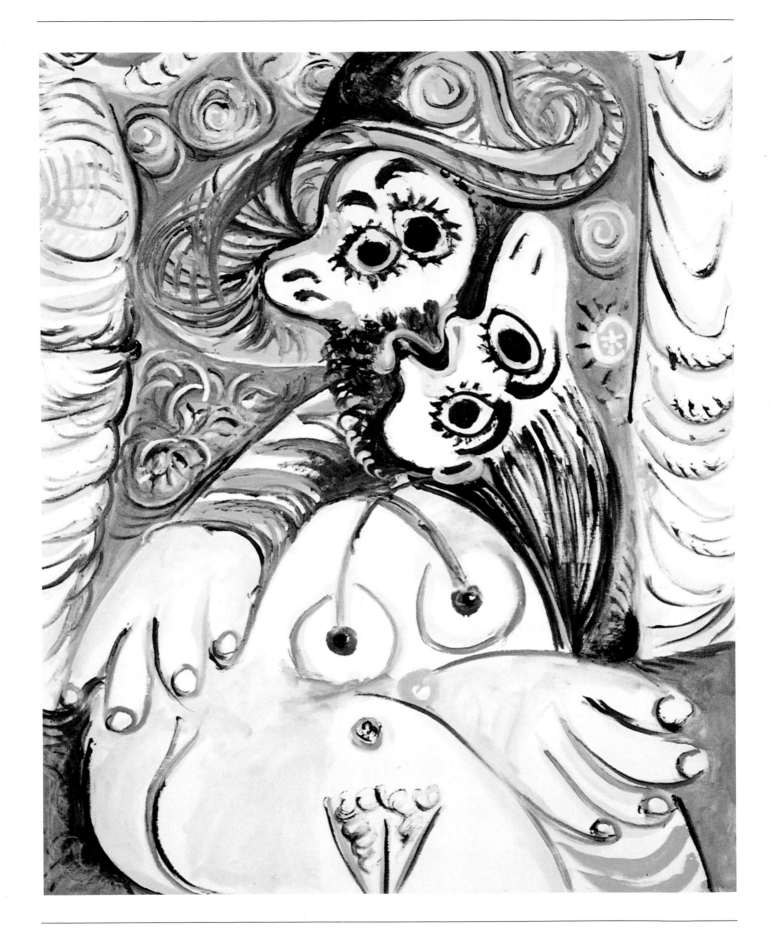

EROTICA II

An Illustrated Anthology of Sexual Art and Literature

Charlotte Hill
and
William Wallace

Carroll & Graf Publishers, Inc.
New York

First published in the United States in 1993 by
Carroll & Graf Publishers, Inc.
260 Fifth Avenue
New York, NY 10001

Fourth printing 1997

Library of Congress Cataloging-in-Publication Data
Erotica II: an illustrated anthology of sexual art & literature
Charlotte Hill & William Wallace.
 p. cm.
"An Eddison Sadd edition" —T.p. verso.
ISBN 0–88184–787–9 : $17.95
1. Erotica. 2. Arts. I. Hill, Charlotte. II. Wallace, William.
III. Title: Erotica 2. IV. Title: Erotica two.
NX650.E7E77 1993
700—dc20 93-24669
 CIP

AN EDDISON · SADD EDITION
Edited, designed and produced by
Eddison Sadd Editions Limited
St Chad's Court, 146B King's Cross Road
London WC1X 9DH

Phototypeset in Caslon ITC No 224 Book by
Dorchester Typesetting Group Ltd, England
Origination by Progress Colour, England
Printed and bound through World Print Ltd, Hong Kong

───────◊───────

FRONTISPIECE
A late painting by Pablo Picasso
(1881–1973) exploring the kiss.
OPPOSITE
Old goats ensnared by beauty in a
nineteenth-century book
illustration.

───────◊───────

Contents

INTRODUCTION

The purpose of erotica

BELOW Towards the end of his life Picasso was asked the difference between art and eroticism: he replied thoughtfully, 'but there is no difference.' Here, in the timeless pursuit of love, the artist chases his model and his muse across the landscape of his imagination.

This is the second anthology of its kind: a further exploration of erotic art, illustration and literature. As before, the method has been to dust off and bring into the light material which has seldom been seen, leaving behind what is – in our view – better left gathering dust. A few extracts and images may be familiar, but we hope they reveal different aspects of themselves in new company. We make no excuse for inviting the great and the good to the party together with authors so disreputable that they are shy only about their names. It is really not so surprising to find strange bedfellows in an anthology of erotica.

Erotica should be read aloud, in bed, by one lover to another: that is the ideal. The critic Marghanita Laski said at the time of the prosecution of Mayflower Books over the publication of *Fanny*

15.8.68. III

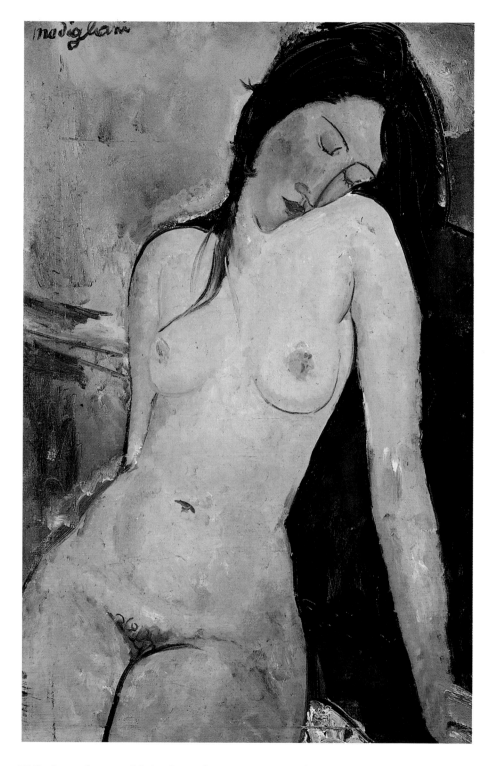

LEFT One of the greatest of all the nudes painted by Amedeo Modigliani (1884–1920). She is both a generalized image of woman and a particular person: an icon and a sensual, intimate portrait.
BELOW Sexuality became the main subject of Picasso's art during the final blaze of his creative powers. In trying to understand the extraordinary strength of line and universality of the final etchings we should heed the artist's own warning: 'Everyone wants to understand art. Why not try to understand the song of a bird?'

Hill that she could find nothing wrong with the novel provided one had a companion at the time of reading it. There is nothing wrong with the solitary reading of erotic literature either, but we should not lose sight of its main intention: to excite the imagination and to start that reciprocal inflammation of body and mind which is sexual desire. A. P. Herbert expressed all this more succinctly,

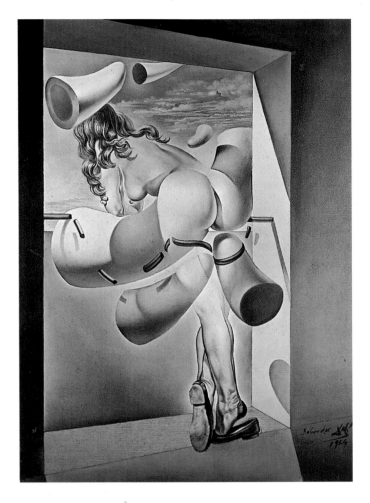

ABOVE While paying lip service to the Surrealist convention of guilt-laden sex in its title, *Young Virgin Auto-sodomized by her own Chastity*, painted in 1954, is rather cleverer than that. Salvador Dali shows us something about male sexuality in particular by tricking us into responding to a bottom that is not a bottom. This revelation of the male tendency to be excited by parts rather than by the whole is a brilliant piece of Surrealism: simultaneously both joke and nightmare.

saying that the purpose of erotica was to make us 'as randy as possible as quickly as possible'. But the best erotic writing (in common with all the best fiction) draws on springs deep in the writer's unconscious and is not simply the creation of conscious intelligence. This may explain why characters in erotic fiction who have no business to be anything more than two-dimensional cardboard cut-outs, for all the attention the writer has given their characterization, sometimes come alarmingly to life.

Erotica is seldom great literature (much is barely literature at all), but there is a down-to-earth reason why the writing is often unexpectedly good. Wealthy patrons and entrepreneurial printers and booksellers have always been prepared to pay handsomely for erotica. John Cleland wrote *Fanny Hill* to clear his debts; Anaïs Nin produced her erotic stories in order to support herself, and her circle of friends, in Paris. And many others – sometimes great writers – have contributed to the genre for straightforward financial reasons. Anyone with the inclination could spend years of research attempting to attribute the many anonymous Victorian erotic novels to the leading literary figures of that age.

Erotic art and photography work on our imagination more directly than literature. Biologically we are programmed to respond to certain visual erotic stimuli. Taste and preference come into this, of course, but give us the right signal – in stone, paint or photographic emulsion – and as sexual beings we cannot help but respond. Erotic images make such a strong and direct appeal that they can, fetishistically, become sexual icons: themselves the object of our awakened eroticism. The youth who violated Praxiteles' statue of Aphrodite personified this one aspect of human sexuality as surely as the goddess personifies them all.

If erotica excites, it also educates. In India, China and Japan this was always the dual intention of much erotic literature and art. There is still a surprising amount of ignorance about sexual matters. It is another reason why the publication of good erotica is important in a civilized society. Instruction manuals are all very well, but how much more we learn from a good erotic novel.

Producing erotic anthologies is also educative. Having decided to include some photographs in this book, we were given an opportunity to see one of the largest archives of sexual photographs in the world, spanning the entire history of photography. Presumably because they have not passed through the filter of an artist's mind and are taken directly from the life, sexually explicit photographs

attract more attention from censors and regulators than works of art. For that reason all but a small handful of images were simply unpublishable. We sorted through the archive – categorizing the photographs roughly – in order to gain some insights into this secret and illegal market shaped by supply and demand. There were few surprises in the 'specialist' categories, which ranged from revolting through sad to bizarre. The surprises came among the highly explicit photographs of mainstream sexuality taken from 1850 to the present day: a significant minority of these love's labours lost were astonishingly beautiful. Had the subjects simply transcended the mercenary purpose of the photographer? Had what was observed drawn some response from the photographer far bigger than his petty intentions? The answer to both questions is 'yes'; we are better than we think. What the camera recorded in those ordinary rooms in Vienna and Los Angeles, Montmartre and Soho was both special and commonplace. It is an inheritance no one can take from us: a fact central to our humanity. Sex is beautiful.

BELOW In his Neoclassical drawings Picasso depicted the aggressive aspect of male sexuality as a mythical being such as the centaur – half-man, half-beast. But in this tender, later work the minotaur is rather less of a bully boy.

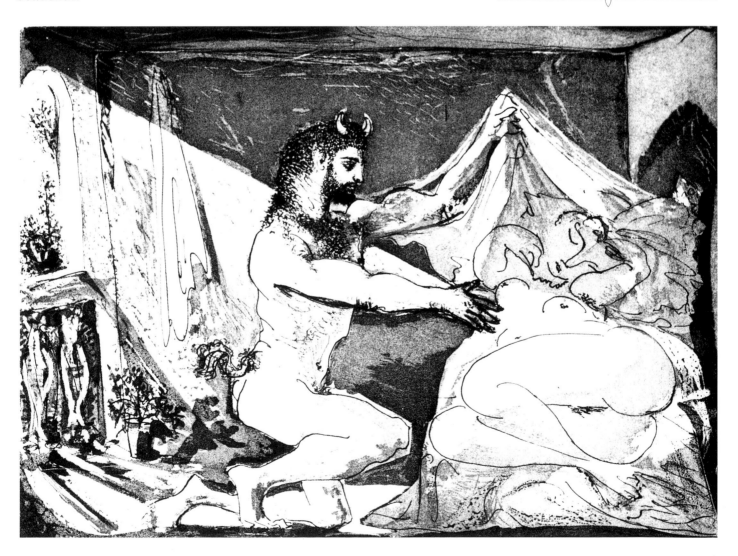

PART ONE

The watchers and the watched

F ar back in time, at a period so remote that we have only palaeontologists and geneticists for our guides, the human race consisted of a few small groups of hominids living in the African Rift Valley. This beautiful country was the real Garden of Eden. As these beings were, quite literally, the mothers and fathers of us all, it seems faintly indecent to speculate about their sexual behaviour. However, from zoological studies of our nearest animal relatives we can be certain of some general characteristics. For example, when one pair – let us call them Adam and Eve – began to enjoy one another it is likely to have started an explosive sexual chain reaction among the other adults of the group. This is the way human beings were before the dawn of time, and it is the way we still are: communal and imitative.

This imitative faculty is the foundation of our ability to learn which has given us our ascendancy over the rest of creation. It also makes us highly suggestible. Upon this convenient rock the advertising executives have built a mighty industry. Show us our favourite food and we want to eat it, we begin to salivate, sometimes we can almost scent it. Our voyeuristic attitude towards sex functions in much the same way. Voyeurism is not only the mainspring of erotica, it is the subject of much of it.

◊

S ome psychologists seek to explain voyeurism as an attempt to witness the 'primal scene' of our own conception. Most of us are content to hope that, like Edmund in *King Lear*, there was 'good sport' at our making. Laura in Mirabeau's *The Lifted Curtain* – a case study for Freudians, as was its brilliant author – is prompted by a mixture of jealousy and curiosity actually to spy upon her father.

> One evening after supper, we retired to a salon where my father had coffee and liqueurs served. In less than half an hour, Lucette was sound asleep. At that, my father took me up in his arms and carried me to my room where he put me to bed. Surprised at this new arrangement, my curiosity was instantly aroused. I got up a few moments later and tip-toed to the glass door, whose velvet curtain I slightly pushed aside so that I could look into the salon.

My father compounded with my mother under the dragon's tail, and my nativity was under Ursa Major; so that it follows I am rough and lecherous.

FROM *KING LEAR*
WILLIAM SHAKESPEARE (1564–1616)

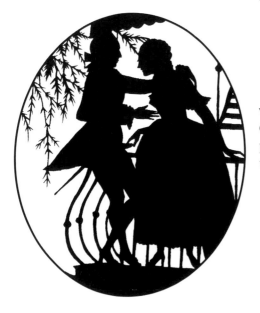

I was astonished to see Lucette's bosom completely uncovered. What charming breasts she possessed! They were two hemispheres as white as snow and firm as marble in the centre of which rose two little strawberries. The only movement they showed was from her regular breathing. My father was fondling them, kissing them and sucking them. In spite of his actions, she continued slumbering. Soon he began to remove all of her clothing, placing it on the edge of the bed. When he took off her shift, I saw two plump rounded thighs of alabaster which he spread apart. Then I made out a little vermilion slit adorned with a chestnut-brown tuft of hair. This he half opened, inserting his fingers which he vigorously manipulated in and out. Nothing roused her out of her lethargy.

Excited by the sight and instructed by the example, I imitated on myself the movements I saw and experienced sensations hitherto unknown to me. Laying her on the bed, my father came to the glass door to close it. I saved myself by hastening to the couch on which he had placed me. As soon as I was stretched out on the sheets, I began my rubbing, pondering what I had just viewed and profiting from what I had learned. I was on fire. The sensation I was undergoing increased in intensity, reaching such a height that it seemed my entire body and soul were concentrated in that one spot. Finally, I sank back in a state of exhausted ecstasy that enchanted me.

Returning to my senses, I was astonished to find myself almost soaked between my thighs. At first, I was very worried, but this anxiety was dispelled by the remembrance of the bliss I had just enjoyed.

. . . I took advantage of my father's absence to satisfy my burning curiosity. While Lucette was engaged in some task in another part of the house, I punctured a little hole in the silken curtain of the glass door.

I had not long to wait to profit from my stratagem.

On my father's return, he immediately donned a flimsy dressing-gown and led to his room Lucette, who was in equally casual attire. They were careful to close the door and draw the curtain, but my preparations frustrated their precautions, at least in part. As soon as they were in the room, I was at the door with my face glued to the glass by the lifted curtain. The first person to meet my eyes was Lucette with her magnificent bosom completely bare. It was so seductive that I could not blame my father for immediately covering it with quick, eager kisses. Unable to hold himself back he tore off her clothing, and in a twinkling of the eye, skirt, corset and chemise were on the floor. How temptingly lovely she was in her natural state! I could not tear my eyes from her. She possessed all the charms and freshness of youth. Feminine beauty has a singular power and attraction for those of the same sex. My arms yearned to embrace those divine contours.

My father was soon in a state similar to his partner's. My eyes were fixed on him, because I had never seen him that way before. Now he placed her on the divan, which I could not see from my observation post.

Devoured by curiosity, I threw caution to the winds. I lifted the

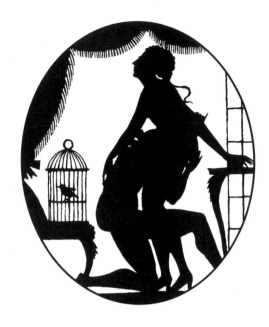

ABOVE, BELOW and OPPOSITE
Silhouettes from the collection 'Er und Sie' (He and She) published in Vienna in 1922. The artist exploits the intimate, personal quality of the medium – which we associate with portraits – to enhance the erotic effect.

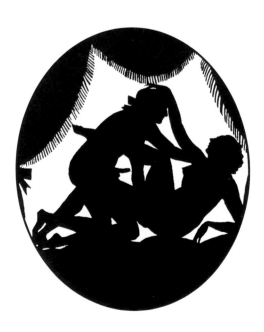

curtain until I could see everything. Not a detail escaped my eyes, and they spared themselves not the slightest voluptuousness.

I was able to perceive clearly Lucette stretched out on the couch and her fully expanded slit between the two chubby eminences. My father displayed a veritable jewel, a big member, stiff, surrounded by hair at the root below which dangled two balls. The tip was scarlet red. I saw it enter Lucette's slit, lose itself there, and then reappear. This in-and-out movement continued for some time. From the fiery kisses they exchanged, I surmised that they were in raptures. Finally, I noticed the organ completely emerge. From the carmine tip which was all wet spurted a white fluid on Lucette's flat belly.

How the sight aroused me! I was so excited and carried away by desires I had not yet known that I attempted, at least partially, to participate in their delirium.

So entranced was I by the tableau that I remained too long and my imprudence betrayed me. My father, who had been too preoccupied with Lucette, now disengaging himself from Lucette's arms, saw the partially lifted curtain.

Comte Gabriel Honoré Riqueti de Mirabeau (1749–91), the greatest orator of the French Revolution, was imprisoned four times for 'wildness' on the orders of his father, the Marquis. These periods of confinement gave Mirabeau – the libertine, the resented son, the eternal outsider and 'voyeur' on society – time to write a good deal of high-quality erotica, much of it politically motivated. His enemies used the fact to blacken his reputation, but the people loved him all the same and he became a successful politician. Who better than the alienated Mirabeau to bridge two worlds? His reward is to rest with France's heroes in the Panthéon.

Another brilliant outsider, Oscar Wilde, partly wrote and helped collate the novel *Teleny*. Concerned mainly with one man's consuming love for another, the plot inevitably features jealousy. Like the narrator in *The Lifted Curtain*, Des Grieux is driven to spy upon the object of his desires, Teleny, voyeuristically. In this first extract from the book the tormented watcher can only imagine, and wish.

'I suffered. My thoughts, night and day, were with him. My brain was always aglow; my blood was overheated; my body ever shivering with excitement. I daily read all the newspapers to see what they said about him; and whenever his name met my eyes the paper shook in my trembling hands. If my mother or anybody else mentioned his name I blushed and then grew pale.

'I remembered what a shock of pleasure, not unmingled with jealousy, I felt, when for the first time I saw his likeness in a window amongst those of other celebrities. I went and bought it at once, not simply to treasure and doat upon it, but also that other people might not look at it.'

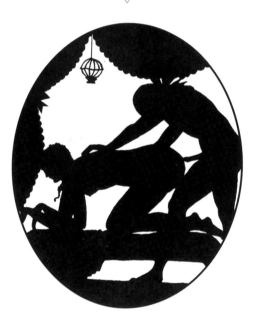

BELOW Erotic silhouettes are extremely rare. This is surprising since the technique is strongly suggestive of shadows cast against a blind: intimate scenes observed voyeuristically by an unsuspected third party – us.
OPPOSITE A sinuous lithograph by Margit Gaal, 1921.

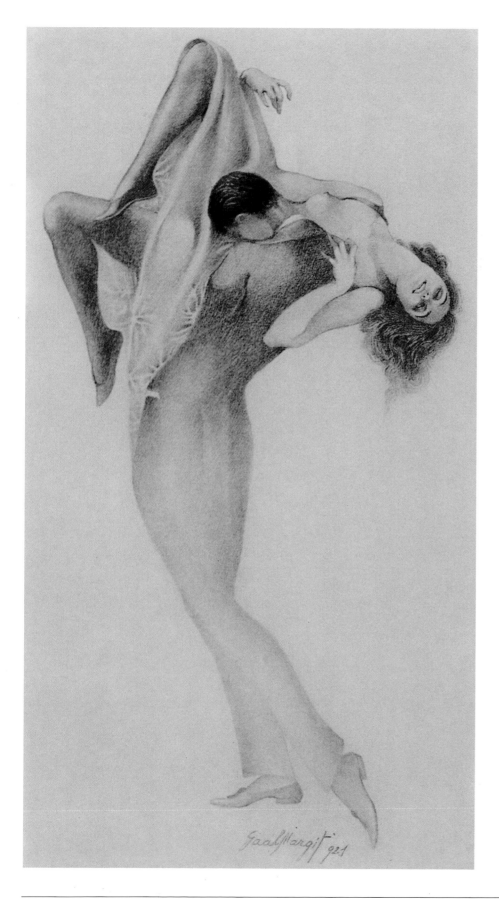

Un rêve de cuisses de femmes
Ayant pour ciel et pour plafond
Les culs et les cons de ces dames,
Très beaux, qui viennent et qui vont

Dans un ballon de jupes gaies
Sur des airs gentils et cochons;
Et les culs vous ont de ces raies,
Et les cons vous ont des manchons!

I'm in a dream of women's thighs:
No ceilings there, no walls around;
The bums of ladies fill the skies
And quims fly past without a sound.

Ballooning skirts of coloured stuffs
Float in on nice and bawdy airs,
The cunts all showing off their muffs,
The buttocks how they part in pairs.

FROM *AT THE DANCE*
PAUL VERLAINE (1844–96)

'What! you were so very jealous?'

'Foolishly so. Unseen and at a distance I used to follow him about, after every concert he played.

'Usually he was alone. Once, however, I saw him enter a cab waiting at the back door of the theatre. It had seemed to me as if someone else was within the vehicle – a woman, if I had not been mistaken. I hailed another cab, and followed them. Their carriage stopped at Teleny's house. I at once bade my Jehu do the same.

RIGHT An erotic postcard from the *Belle Epoque*.

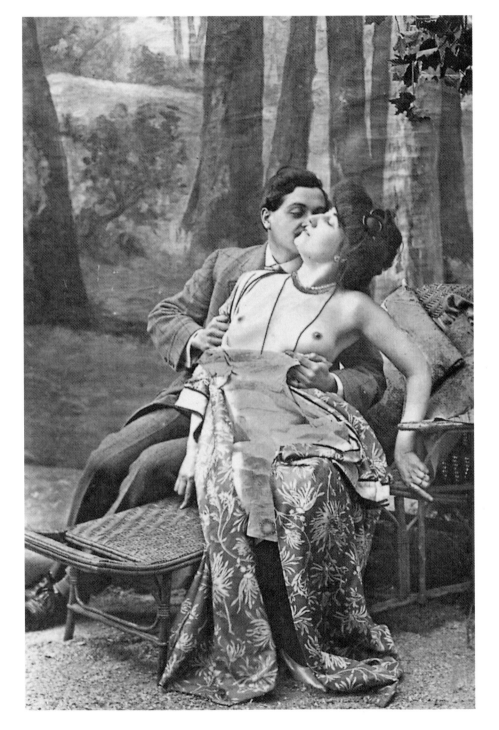

La Chair, même, la chair de la femme proclame
Le cul, le vit, le torse et l'œil du fier Puceau,
– Et c'est pourquoi, d'après le conseil à Rousseau,
Il faut parfois, poète, un peu 'quitter la dame'.

'The Flesh itself (a woman's!) always has implied
The arse, the cock, the chest, the eye of the Proud Youth . . .'
– And, poet, that is why, in line with Rousseau's truth,
One sometimes ought to 'leave the ladies on one side'.

From *NOW, POET, DON'T BE SACRILEGIOUS*
PAUL VERLAINE (1844–96)

'I saw Teleny alight. As he did so, he offered his hand to a lady, thickly veiled, who tripped out of the carriage and darted into the open doorway. The cab then went off.

'I bade my driver wait there the whole night. At dawn the carriage of the evening before came and stopped. My driver looked up. A few minutes afterwards the door was again opened. The lady hurried out, and was handed into her carriage by her lover. I followed her, and stopped where she alighted.'

'A few days afterwards I knew whom she was.'

'And who was she?'

'A lady of unblemished reputation, a Countess with whom Teleny had played some duets.

'In the cab, that night, my mind was so intently fixed upon Teleny that my inward self seemed to disintegrate itself from my body and to follow like his own shadow the man I loved. I unconsciously threw myself into a kind of trance and I had a most vivid hallucination, which, strange as it might appear, coincided with all that my friend did and felt.

'For instance, as soon as the door was shut behind them, the lady caught Teleny in her arms, and gave him a long kiss. Their entrance would have lasted several seconds more had Teleny not lost his breath.

'You smile; yes, I suppose you yourself are aware how easily people lose their breath in kissing, when the lips do not feel that blissful intoxicating lust in all its intensity. She would have given him another kiss, but Teleny whispered to her: "Let us go up to my room; there we shall be far safer than here."

'Soon they were in his apartment.

'She looked timidly around, and seeing herself in that young man's room alone with him, she blushed and seemed thoroughly ashamed of herself.

'"Oh, René," said she, "what must you think of me?"

'"That you love me dearly," quoth he; "do you not?"

'"Yes, indeed; not wisely, but too well."

'Thereupon taking off her wrappers, she rushed up and clasped her lover in her arms, showering her warm kisses on his head, his eyes, his cheeks and then upon his mouth. That mouth I so longed to kiss!

'With lips pressed together, she remained for some time inhaling his breath, and – almost frightened at her boldness – she touched his lips with the tip of her tongue. Then, taking courage, soon afterwards she slipped it in his mouth, and then after a while, she thrust it in and out, as if she were enticing him to try the act of nature by it; she was so convulsed with lust by this kiss that she had to clasp herself to him not to fall, for the blood was rushing to her head, and her knees were almost giving way beneath her. At last, taking his right hand, after squeezing it hesitatingly for a moment, she placed it within her breasts, giving him her nipple to pinch, and as he did so, the pleasure she felt was so great that she was swooning away for joy.

'"Oh, Teleny!" said she: "I can't! I can't any more."

'And she rubbed herself as strongly as she could against him, protruding her middle parts against his.'

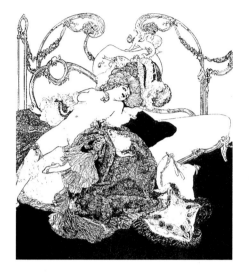

ABOVE A drawing by the German illustrator Franz von Bayros. A brilliant draughtsman, he kept a dark candle burning for the Decadents more than a quarter of a century after the death of Aubrey Beardsley in 1898.

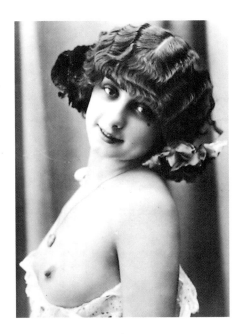

ABOVE and OPPOSITE However charming or erotic Victorian photographs are, whatever magic contemporary chemicals and lenses have made of flesh tones, they always have a poignant quality. These were people who once lived, who crimped their hair, who tried not to laugh at the photographer's props. Now they are symbols of the *fin-de-siècle*: a reminder of the 'great vital constants' – sex and death.

'And Teleny?'

'Well, jealous as I was, I could not help feeling how different his manner was now from the rapturous way with which he had clung to me that evening, when he had taken the bunch of heliotrope from his button-hole and had put it in mine.

'He accepted rather than returned her caresses. Anyhow, she seemed pleased, for she thought him shy.

'She was now hanging on him. One of her arms was clasped around his waist, the other one around his neck. Her dainty, tapering, bejewelled fingers were playing with his curly hair, and paddling his neck.

'He was squeezing her breasts, and, as I said before, slightly fingering her nipples.

'She gazed deep into his eyes, and then sighed.

'"You do not love me," at last she said. "I can see it in your eyes. You are not thinking of me, but of somebody else."

'And it was true. At that moment, he was thinking of me – fondly, longingly; and then, as he did so, he got more excited, and he caught her in his arms, and hugged and kissed her with far more eagerness than he had hitherto done – nay, he began to suck her tongue as if it had been mine, and then began to thrust his own into her mouth.

'After a few moments of rapture she, this time, stopped to take breath.

'"Yes, I am wrong. You love me. I see it now. You do not despise me because I am here, do you? Ah! if you could only read in my heart, and see how madly I love you, darling!"

'And she looked at him with longing, passionate eyes.

'"Still, you think me light, don't you? I am an adulteress!"

'And thereupon she shuddered, and hid her face in her hands.

'He looked at her for a moment pitifully, then he took down her hands gently, and kissed her.

'"You do not know how I have tried to resist you, but I could not. I am on fire. My blood is no longer blood, but some burning love-philtre. I cannot help myself," said she, lifting up her head defiantly as if she were facing the whole world, "here I am, do with me what you like, only tell me that you love me, that you love no other woman but me, swear it."

'"I swear," said he languidly, "that I love no other woman."

'She did not understand the meaning of his words.

'"But tell it to me again, say it often, it is so sweet to hear it repeated from the lips of those we doat on," said she, with passionate eagerness.

'"I assure you that I have never cared for any woman so much as I do for you."

'"Cared?" said she, disappointed.

'"Loved, I mean."

'"And you can swear it?"

'"On the cross if you like," added he, smiling.

'"And you do not think badly of me because I am here? Well, you are the only one for whom I have ever been unfaithful to my husband; though God knows if he be faithful to me. Still my love does not atone for my sin, does it?"

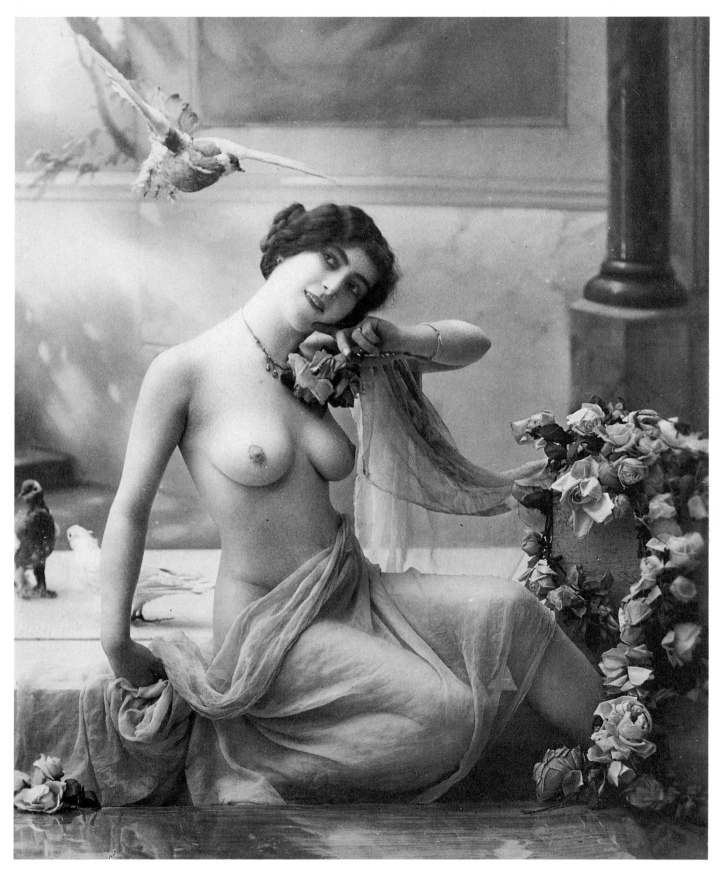

'Teleny did not give her any answer for an instant, he looked at her with dreamy eyes, then shuddered as if awaking from a trance.

'"Sin," he said, "is the only thing worth living for."

'She looked at him rather astonished, but then she kissed him again and again and answered: "Well, yes, you are perhaps right; it is so, the fruit of the forbidden tree was pleasant to the sight, to the taste, and to the smell."

'They sat down on a divan. When they were clasped again in each other's arms he slipped his hand somewhat timidly and almost unwillingly under her skirts.

'She caught hold of his hand, and arrested it.

'"No, René, I beg of you! Could we not love each other with a Platonic love? Is that not enough?"

'"Is it enough for you?" said he, almost superciliously.

'She pressed her lips again upon his, and almost relinquished her grasp. The hand went stealthily up along the leg, stopped a moment on the knees, caressing them; but the legs closely pressed together prevented it from slipping between them, and thus reaching the higher storey. It crept up, nevertheless, caressing the thighs through the fine linen underclothing, and thus, by stolen marches, it reached its aim. The hand then slipped between the opening of the drawers, and began to feel the soft skin. She tried to stop him.

'"No, no!" said she; "please don't; you are tickling me."

'He then took courage, and plunged his fingers boldly in the fine curly locks of the fleece that covered all her middle parts.

'She continued to hold her thighs tightly closed together, especially when the naughty fingers began to graze the edge of the moist lips. At that touch, however, her strength gave way; the nerves relaxed and allowed the tip of a finger to worm its way within the slit – nay, the tiny berry protruded out to welcome it.

'After a few moments she breathed more strongly. She encircled his breast with her arms, kissed him, and then hid her head on his shoulders.

'"Oh, what a rapture I feel!" she cried. "What a magnetic fluid you possess to make me feel as I do!"

'He did not give her any answer; but, unbuttoning his trousers, he took hold of her dainty little hand. He endeavoured to introduce it within the gap. She tried to resist, but weakly, and as if asking but to yield. She soon gave way, and boldly caught hold of his phallus, now stiff and hard, moving lustily by its own inward strength.

'After a few moments of pleasant manipulation, their lips pressed together, he lightly, and almost against her knowledge, pressed her down on the couch, lifted up her legs, pulled up her skirts without for a moment taking his tongue out of her mouth or stopping his tickling of her tingling clitoris already wet with its own tears. Then – sustaining his weight on his elbows – he got his legs between her thighs. That her excitement increased could be easily seen by the shivering of the lips which he had no need to open as he pressed down upon her, for they parted of themselves to give entrance to the little blind God of Love.

ABOVE A French postcard printed at the turn of the century.
OPPOSITE An erotic illustration published in Paris at the same time. The French capital occupies a unique position in the Anglo-Saxon erotic imagination. The first publisher of *Teleny*, Leonard Smithers, even changed the setting of Wilde's novel from London to Paris 'so as not to shock the amour propre of his English subscribers'.

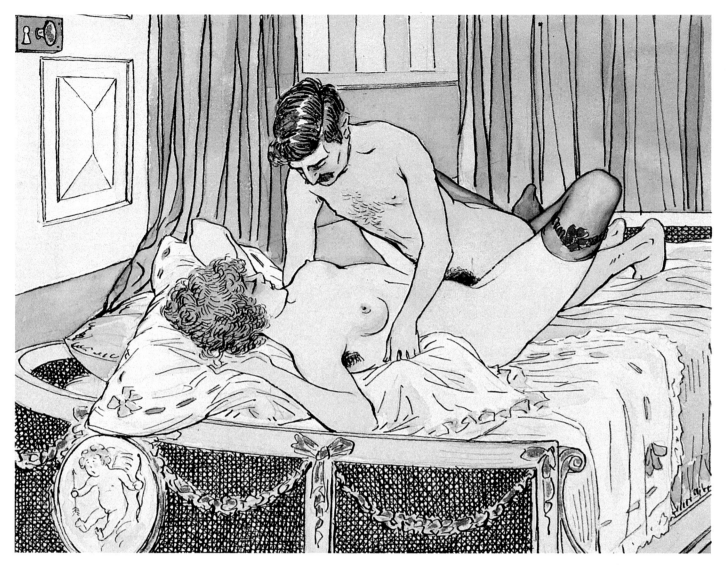

'Within one thrust he introduced himself within the precincts of Love's temple; with another, the rod was halfway in; with the third he reached the very bottom of the den of pleasure; for, though she was no longer in the first days of earliest youth, still she had hardly reached her prime, and her flesh was not only firm, but she was so tight that he was fairly clasped and sucked by those pulpy lips; so, after moving up and down a few times, thrusting himself always further, he crushed her down with his full weight; for both his hands were either handling her breasts, or else, having slipped them under her, he was opening her buttocks; and then, lifting her firmly upon him, he thrust a finger in her backside hole, thus wedging her on both sides, making her feel a more intense pleasure by thus sodomizing her.

'After a few seconds of this little game he began to breathe strongly – to pant. The milky fluid that had for days accumulated itself now rushed out in thick jets, coursing up into her very womb. She, thus flooded, shewed her hysteric enjoyment by her screams, her tears, her sighs. Finally, all strength gave way; arms

There is no such thing as a moral or an immoral book. Books are well written, or badly written. That is all.

OSCAR WILDE (1854–1900)

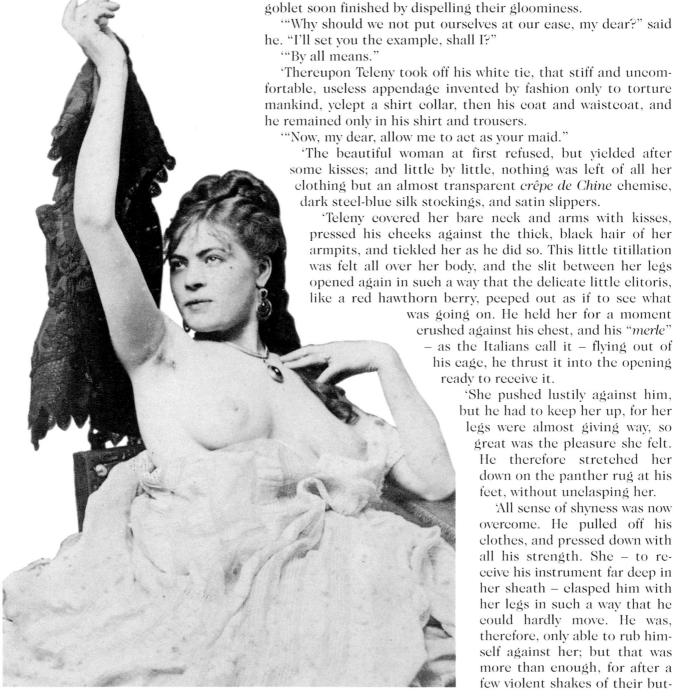

and legs stiffened themselves; she fell lifeless on the couch; whilst he remained stretched over her at the risk of giving the Count her husband, an heir of gipsy blood.

'He soon recovered his strength and rose. She was then recalled to her senses, but only to melt into a flood of tears.

'A bumper of champagne brought them both, however, to a less gloomy sense of life. A few partridge sandwiches, some lobster patties, a caviare salad, with a few more glasses of champagne, together with many *marrons glacés*, and a punch made of maraschino, pineapple juice and whisky, drunk out of the same goblet soon finished by dispelling their gloominess.

'"Why should we not put ourselves at our ease, my dear?" said he. "I'll set you the example, shall I?"

'"By all means."

'Thereupon Teleny took off his white tie, that stiff and uncomfortable, useless appendage invented by fashion only to torture mankind, yclept a shirt collar, then his coat and waistcoat, and he remained only in his shirt and trousers.

'"Now, my dear, allow me to act as your maid."

'The beautiful woman at first refused, but yielded after some kisses; and little by little, nothing was left of all her clothing but an almost transparent *crêpe de Chine* chemise, dark steel-blue silk stockings, and satin slippers.

'Teleny covered her bare neck and arms with kisses, pressed his cheeks against the thick, black hair of her armpits, and tickled her as he did so. This little titillation was felt all over her body, and the slit between her legs opened again in such a way that the delicate little clitoris, like a red hawthorn berry, peeped out as if to see what was going on. He held her for a moment crushed against his chest, and his "*merle*" – as the Italians call it – flying out of his cage, he thrust it into the opening ready to receive it.

'She pushed lustily against him, but he had to keep her up, for her legs were almost giving way, so great was the pleasure she felt. He therefore stretched her down on the panther rug at his feet, without unclasping her.

'All sense of shyness was now overcome. He pulled off his clothes, and pressed down with all his strength. She – to receive his instrument far deep in her sheath – clasped him with her legs in such a way that he could hardly move. He was, therefore, only able to rub himself against her; but that was more than enough, for after a few violent shakes of their but-

tocks, legs pressed, and breasts crushed, the burning liquid which he injected within her body gave her a spasmodic pleasure, and she fell senseless on the panther skin whilst he rolled, motionless, by her side.

'Till then I felt that my image had always been present before his eyes, although he was enjoying this handsome woman – so beautiful, for she had hardly yet reached the bloom of ripe womanhood; but now the pleasure she had given him had made him quite forget me. I therefore hated him. For a moment I felt that I should like to be a wild beast – to drive my nails into his flesh, to torture him like a cat does a mouse, and to tear him into pieces.

'What right had he to love anybody but myself? Did I love a single being in this world as I loved him? Could I feel pleasure with anyone else?

'No, my love was not a maudlin sentimentality, it was the maddening passion that overpowers the body and shatters the brain!

'If he could love women, why did he then make love to me, obliging me to love him, making me a contemptible being in my own eyes?

'In the paroxysm of my excitement I writhed, I bit my lips till they bled. I dug my nails into my flesh; I cried out with jealousy and shame. It wanted but little to have made me jump out of the cab, and go and ring at the door of his house.

'This state of things lasted for a few moments, and then I began to wonder what he was doing, and the fit of hallucination came over me again. I saw him awakening from the slumber into which he had fallen when overpowered by enjoyment.

'As he awoke he looked at her. Now I could see her plainly, for I believe that she was only visible to me through his medium.'

'But you fell asleep, and dreamt all this whilst you were in the cab, did you not?'

'Oh, no! All happened as I am telling you. I related my whole vision to him some time afterwards, and he acknowledged that everything had occurred exactly as I had seen it.'

'But how could this be?'

'There was, as I told you before, a strong transmission of thoughts between us. This is by no means a remarkable coincidence. You smile and look incredulous; well follow the doings of the Psychical Society, and this vision will certainly not astonish you any more.'

'Well, never mind, go on.'

'As Teleny awoke, he looked at his mistress lying on the panther-skin at his side.

'She was as sound asleep as anyone would be after a banquet, intoxicated by strong drink; or as a baby, that having sucked its fill, stretches itself glutted by the side of its mother's breast. It was the heavy sleep of lusty life, not the placid stillness of cold death. The blood – like the sap of a young tree in spring – mounted to her parted, pouting lips, through which a warm scented breath escaped at cadenced intervals, emitting that slight murmur which the child hears as he listens in a shell – the sound of slumbering life.

'The breasts – as if swollen with milk – stood up, and the

ABOVE The suggestive keyhole motif was popular with publishers of erotic postcards in *fin-de-siècle* Paris.

nipples erect seemed to be asking for those caresses she was so fond of; over all her body there was a shivering of insatiable desire.

'Her thighs were bare, and the thick curly hair that covered her middle parts, as black as jet, was sprinkled over with pearly drops of milky dew. . . .

'Though all lust was gone, Teleny felt a heartfelt pity for that handsome young woman who, maddened by love for him, had put into jeopardy her whole existence to throw herself into his arms.

'Who is the man that is not flattered by the love he inspires in a high-born, wealthy, and handsome young woman, who forgets her marriage to enjoy a few moments' bliss in his arms? But, then, why do women generally love men who often care so little for them?

'Teleny did his best to comfort her, to tell her over and over again that he cared for no woman, to assure her that he would be eternally faithful to her for her sacrifice; but pity is not love, nor is affection the eagerness of desire.

'Nature was more than satisfied; her beauty had lost all its attraction; they kissed again and again; he languidly passed his hands over all her body, from the nape of the neck to the deep dent between those round hills, which seemed covered with fallen snow, giving her a most delightful sensation as he did so; he caressed her breasts, suckled and bit the tiny protruding nipples, whilst his fingers were often thrust far within the warm flesh hidden under that mass of jet-black hair. She glowed, she breathed, she shivered with pleasure; but Teleny, though performing his work with masterly skill, remained cold at her side.

'"No, I see that you don't love me; for it is not possible that you – a young man –"

'She did not finish. Teleny felt the sting of her reproaches, but remained passive; for the phallus is not stiffened by taunts.

'She took the lifeless object in her delicate fingers. She rubbed and manipulated it. She even rolled it between her two soft hands. It remained like a piece of dough. She sighed as piteously as Ovid's mistress must have done on a like occasion. She did like this woman did some hundreds of years before. She bent down; she took the tip of that inert piece of flesh between her lips – the pulpy lips which looked like a tiny apricot – so round, sappy, and luscious. Soon it was all in her mouth. She sucked it with as much evident pleasure as if she were a famished baby taking her nurse's breast. As it went in and out, she tickled the prepuce with her expert tongue, touched the tiny lips on her palate.

'The phallus, though somewhat harder, remained always limp and nerveless.

'You know our ignorant forefathers believed in the practice called "*nouer les aiguillettes*" [lit. 'tying the knots'] – that is rendering the male incapable of performing the pleasant work for which Nature has destined him. We, the enlightened

BELOW A carefully composed nineteenth-century photograph. OPPOSITE Auguste Rodin's superb marble sculpture *The Eternal Idol*, finished in 1889. The artist's tactile passion for the human body defied all convention; a contemporary tells us that he habitually fondled and caressed his models, gazing at them 'with greedy and sensuous pleasure'. Perhaps that is why the jealous Diaghilev forbade his protégé Nijinsky to complete his sittings for Rodin, and why only a plaster nude of the beautiful dancer was ever made.

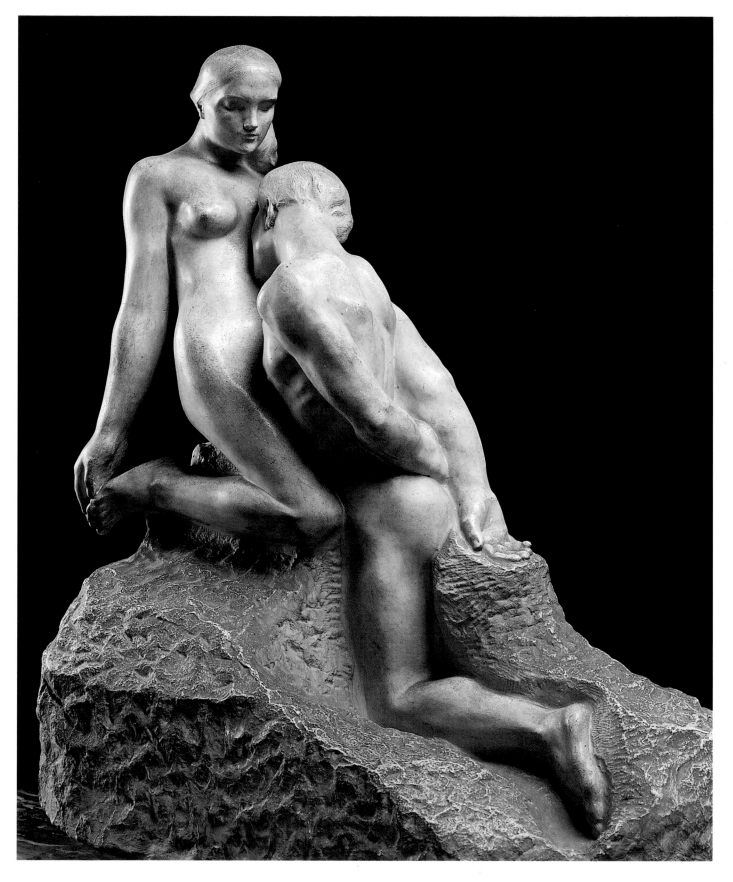

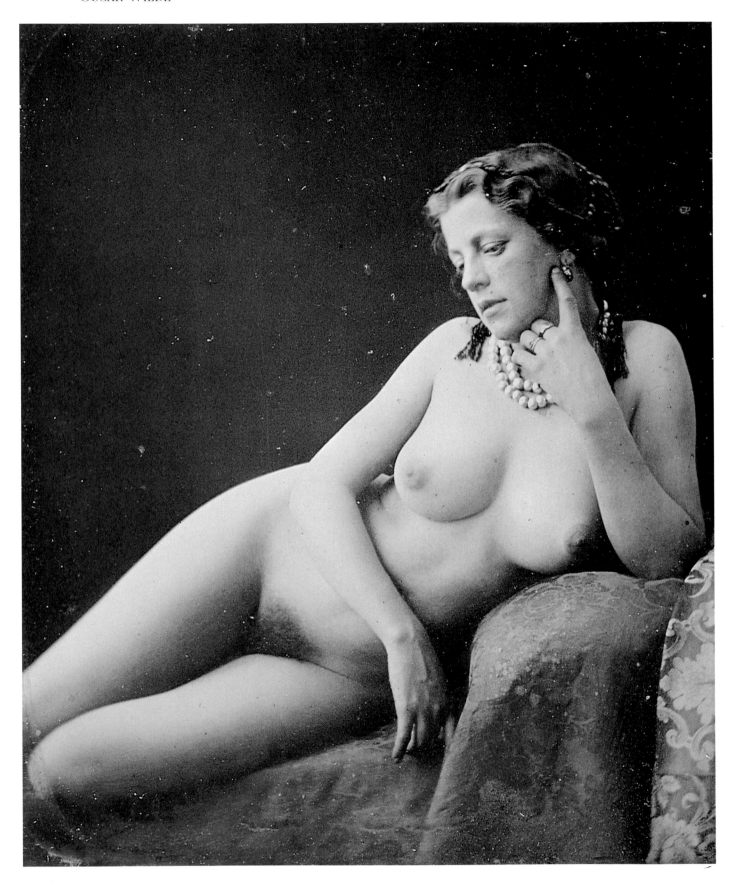

generation, have discarded such gross superstitions, and still our ignorant forefathers were sometimes right.'

'What! you do not mean to say that you believe in such tom-foolery?'

'It might be tomfoolery, as you say; but still it is a fact. Hypnotize a person, and then you will see if you can get the mastery over him or not.'

'Still, you had not hypnotized Teleny?'

'No, but our natures seemed to be bound to one another by a secret affinity.'

'At that moment I felt a secret shame for Teleny. Not being able to understand the working of his brain, she seemed to regard him in the light of a young cock, who, having crowed lustily once or twice at early dawn, has strained his neck to such a pitch that he can only emit hoarse, feeble, gurgling sounds out of it after that.

'Moreover, I almost felt sorry for that woman; and I thought, if

I were only in her place, how disappointed I should be. And I sighed, repeating almost audibly – "Were I but in her stead."

'The image which had formed itself within my mind so vividly was all at once reverberated within René's brain; and he thought, if instead of this lady's mouth those lips were my lips; and his phallus at once stiffened and awoke into life; the glans swelled with blood; not only an erection took place, but it almost ejaculated. The Countess – for she was a Countess – was herself surprised at this sudden change, and stopped, for she had now obtained what she wanted; and she knew that –, "*Dépasser le but, c'est manquer la chose*" ['to overshoot the aim is to miss the mark'].

'Teleny, however, began to fear that if he had his mistress's face before his eyes, my image might entirely vanish; and that – beautiful as she was – he would never be able to accomplish his work to the end. So he began by covering her with kisses; then deftly turned her on her front. She yielded without understand-

Elle est dodue ta quéquette,
Et veloutée, du pubis
Au prépuce fermant le pis,
Aux trois quarts, d'une rose crête.

Elle se renfle un brin au bout
Et dessine sous la peau douce
Le gland gros comme un demi-pouce
Montrant ses lèvres juste au bout.

Après que je l'aurai baisée
En tout amour reconnaissant,
Laisse ma main, la caressant,
La saisir d'une prise osée,

Pour, soudain, la décalotter,
En sorte que, violet tendre,
Le Gland joyeux, sans plus attendre,
Splendidement vienne éclater.

It's plump, your little prick, and sleek
As velvet, from the pubic mound
To where the foreskin closes round
The tip, and crowns the rosy peak.

It swells a little at the end
Under the soft skin, sketching out
The gland, an inch long, with a pout
Of red lips showing at the end.

After I've bowed at length and kissed
The rod with loving gratitude,
Let my caressing hand grow rude
And seize it in a daring fist

And then suddenly doff its cap
So that your tender violet bud
Bursts out, not wanting for more
* blood,*
Joyfully beaming from your lap.

FROM *EVEN WITHOUT PRESENTING ARMS...*
PAUL VERLAINE (1844–96)

ing what was required of her. He bent her pliant body on her knees, so that she presented a most beautiful sight to his view.

'This splendid sight ravished him to such an extent that by looking at it his hitherto limp tool acquired its full size and stiffness, and in its lusty vigour leapt in such a way that it knocked against his navel.

'He was even tempted for a moment to introduce it within the small dot of a hole, which, if not exactly the den of life, is surely that of pleasure; but he forbore. He even resisted the temptation of kissing it, or of darting his tongue into it; but bending over her, and placing himself between her legs, he tried to introduce the glans within the aperture of her two lips, now thick and swollen by dint of much rubbing.

'Wide apart as her legs were, he first had to open the lips with his fingers on account of the mass of bushy hair, that grew all around them; for now the tiny curls had entangled themselves together like tendrils, as if to bar the entrance; therefore, when he had brushed the hair aside, he pressed his tool in it, but the turgid dry flesh arrested him. The clitoris thus pressed danced with delight, so that he took it in his hand, and rubbed and shook it softly and gently on the top part of her lips.

'She began to shake, to rub herself with delight; she groaned, she sobbed hysterically; and when he felt himself bathed with delicious tears he thrust his instrument far within her body, clasping her tightly around the neck. So, after a few bold strokes, he managed to get in the whole of the rod down to the very root of the column, crushing his hair against hers, so far in the utmost recesses of the womb that it gave her a pleasurable pain as it touched the neck of the vagina.

'For about ten minutes – which to her felt an eternity – she continued panting, throbbing, gasping, groaning, shrieking, roaring, laughing, and crying in the vehemence of her delight.

'"Oh! Oh! I am feeling it again! In – in – quick – quicker! There! there! – enough! – stop!"

'But he did not listen to her, and he went on plunging and replunging with increased vigour. Having vainly begged for a truce, she began to move again with renewed life.

'Having her *a retro*, his thoughts were thus concentrated upon me; and the tightness of the orifice in which the penis was sheathed, added to the titillation produced by the lips of the womb, gave him such an overpowering sensation that he redoubled his strength, and shoved his muscular instrument with such mighty strokes that the frail woman shook under the repeated thumps. Her knees were almost giving way under the brutal force he displayed. When again, all at once, the floodgates of the seminal ducts were open, and he squirted a jet of molten liquid down into the innermost recesses of her womb.

'A moment of delirium followed; the contraction of all her muscles gripped him and sucked him up eagerly, greedily; and

ABOVE Sweet and self-conscious by modern standards, most nineteenth-century 'glamour' postcards were nevertheless photographic nudes, primarily concerned with feminine beauty rather than crude sexual exploitation.
OPPOSITE A coloured engraving by an unknown artist made to illustrate an edition of Verlaine's *Oeuvres Libres* (see the poem fragment on page 25).

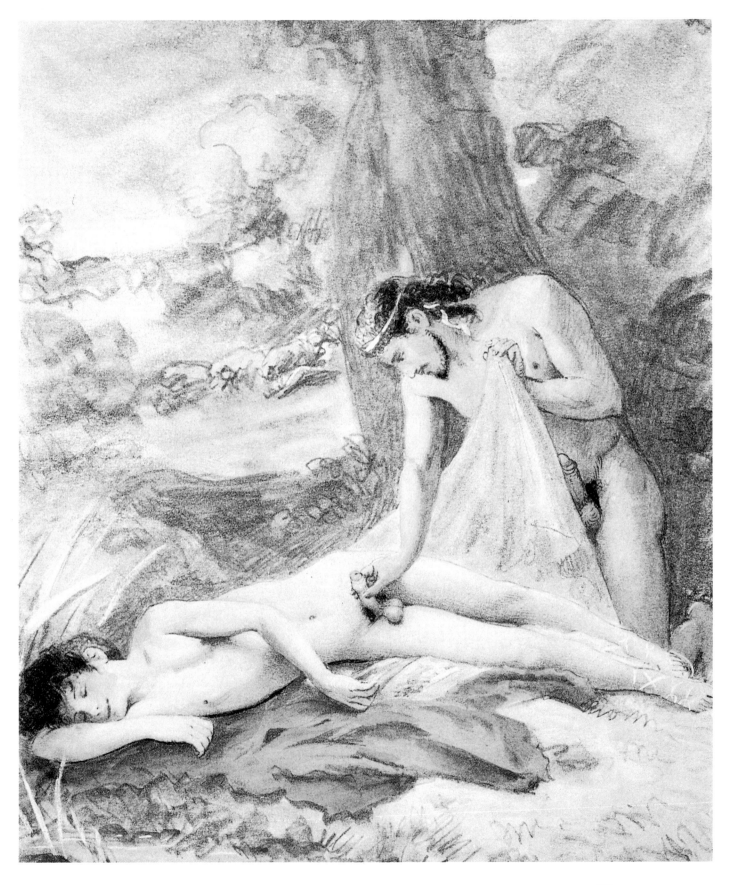

after a short spasmodic convulsion, they both fell senseless side by side, still tightly wedged in one another.'

'And so ends the Epistle!'

'Not quite so, for nine months afterwards the Countess gave birth to a fine boy –'

'Who, of course, looked like his father? Doesn't every child look like its father?'

'Still, this one happened to look neither like the Count nor like Teleny.'

'Who the deuce did it look like then?'

'Like myself.'

'Bosh!'

'Bosh as much as you like. Anyhow, the rickety old Count is very proud of this son of his, having discovered a certain likeness between his only heir and the portrait of one of his ancestors. He is always pointing out this atavism to all his visitors; but whenever he struts about, and begins to expound learnedly over the matter, I am told that the Countess shrugs her shoulders and puckers down her lips contemptuously, as if she were not quite convinced of the fact.'

Teleny was published privately and anonymously in 1893, the year in which *A Woman of No Importance* was completed. Oscar Wilde was 38, he had been married for nine years and had two children. As a dramatist he was at the height of his powers and popularity. Two years earlier he had met Lord Alfred Douglas and begun the turbulent affair that was to lead to his tragic downfall in 1895. In the second extract the voyeurism of Des Grieux has a desperate quality. Once again jealousy is the spur, but it cuts more cruelly now. Des Grieux and Teleny are lovers and betrayal is in the air. The apocalyptic fireworks, as plot, Freudian sub-plot and the couple overlooked by Des Grieux reach a simultaneous climax, are best left for the reader to enjoy.

'Trembling from head to foot, sick at heart, I bent down and looked through the key-hole.

'Was I dreaming – was this a dreadful nightmare?

'I stuck my nails deep into my flesh to convince myself of my self-consciousness.

'And yet I could not feel sure that I was alive and awake.

'Life at times loses its sense of reality; it appears to us like a weird, optical illusion – a phantasmagoric bubble that will disappear at the slightest breath.

'I held my breath, and looked.

'This was, then, no illusion – no vision of my over-heated fancy.

'There, on that chair – warm yet with our embraces – two beings were seated.

'But who were they?

'Perhaps Teleny had ceded his apartment to some friend for that night. Perhaps he had forgotten to mention the fact to me, or else he had not thought it necessary to do so.

'Yes, surely, it must be so. Teleny could not deceive me.

Meine Ruh' ist hin
Mein Herz ist schwer;
Ich finde sie nimmer
Und nimmermehr

Mein Busen drängt
Sich nach ihm hin.
Ach dürft' ich fassen
Und halten ihn,

Und küssen ihn
So wie ich wollt',
An seinen Küssen
Vergehen sollt'!

My peace is gone
My heart is sore
I'll find it never
Never more.

My breast desires
And longs for him
Could I but hold
And cling to him

And kiss him as
I long to kiss
And with his kisses
Die of bliss.

GRETCHEN AT THE SPINNING WHEEL
FROM FAUST PART I
JOHANN WOLFGANG VON GOETHE
(1749–1832)

'I looked again. The light within the room being much brighter than that of the hall, I was able to perceive everything clearly.

'A man whose form I could not see was seated on that chair contrived by Teleny's ingenious mind to enhance sensual bliss. A woman with dark, dishevelled hair, robed in a white satin gown, was sitting astride upon him. Her back was thus turned to the door.

'I strained my eyes to catch every detail, and I saw that she was not really seated but standing on tiptoe, so that, though rather stout, she skipped lightly upon the man's knees.

'Though I could not see, I understood that every time she fell she received within her hole the good-sized pivot on which she seemed so tightly wedged. Moreover, that the pleasure she received thereby was so thrilling that it caused her to rebound like an elastic ball, but only to fall again, and thus engulf within her pulpy, spongy, well-moistened lips, the whole of that quivering rod of pleasure down to its hairy root. Whoever she was – grand lady or whore – she was no tyro, but a woman of great experience, to be able to ride that Cytherean race with such consummate skill.

'As I gazed on, I saw that her enjoyment kept getting stronger and ever stronger: it was reaching its paroxysm. From an amble she had gone on quietly to a trot, then to a canter; then, as she rode along, she clasped, with ever-increasing passion, the head of the man on whose knees she was astride. It was clear that the contact of her lover's lips, and the swelling and wriggling of his tool within her, thrilled her to an erotic rage, so she went off in a gallop, thus –

<div style="text-align:center">

Leaping higher, higher, higher,
With a desperate desire

</div>

to reach the delightful aim of her journey.

'In the meanwhile, the male, whoever he was, after having passed his hands on the massy lobes of her hind-parts, began to pat and press and knead her breasts, adding thus to her pleasure a thousand little caresses which almost maddened her.

'I remember now a most curious fact, shewing the way in which our brains work, and how our mind is attracted by slight extraneous objects, even when engrossed by the saddest thoughts. I remember feeling a certain artistic pleasure at the ever-changing effect of light and shadow thrown in different parts of the lady's rich satin gown, as it kept shimmering under the rays of the lamp hanging overhead. I recollect admiring its pearly, silky, metallic tints, now glistening, then glimmering, or fading into a dull lustre.

'Just then, however, the train of her gown had got entangled somewhere round the leg of the chair, so, as this incident impeded her rhythmical and ever quicker movements, enclasping her love's neck, she managed deftly to cast off her gown, and thus remained stark naked in the man's embrace.

'What a splendid body she had! Juno's in all its majesty could not have been more perfect. I had, however, hardly time to admire her luxuriant beauty, her grace, her strength, the

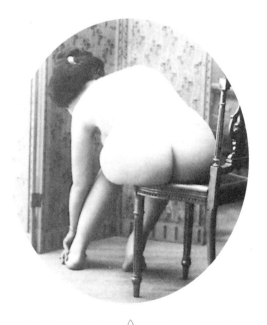

ABOVE A postcard distributed by one of the main Parisian manufacturers c. 1900.

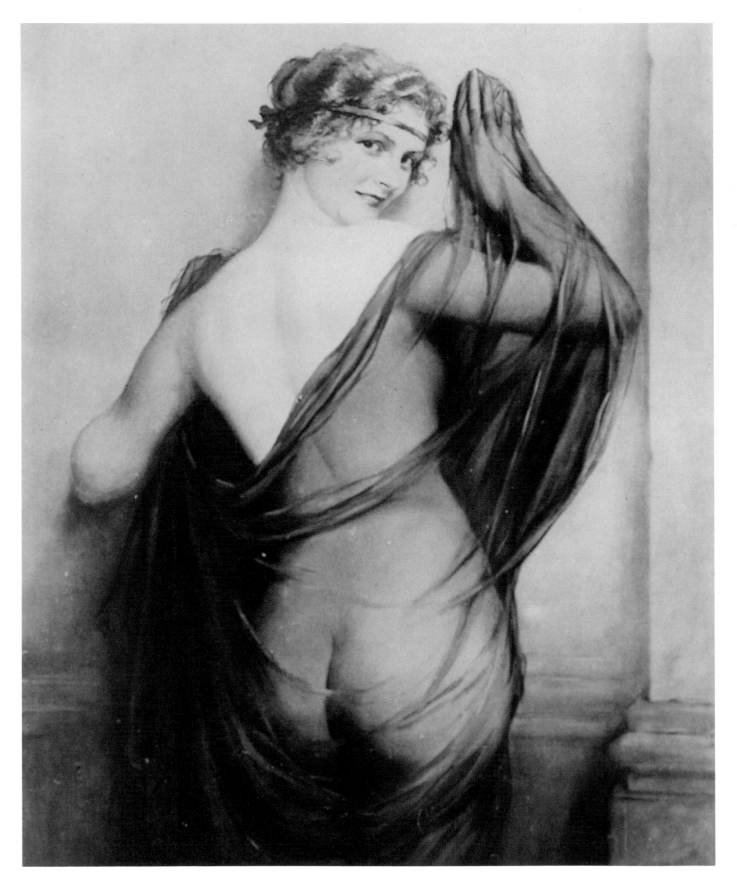

splendid symmetry of her outlines, her agility, or her skill, for the race was now reaching its end.

'They were both trembling under the spell of that rapturous titillation which just precedes the overflowing of the spermatic ducts. Evidently the tip of the man's tool was being sucked by the mouth of the vagina, a contraction of all the nerves had ensued; the sheath in which the whole column was enclosed had tightened, and both their bodies were writhing convulsively.

'Surely after such overpowering spasms, prolapsus and inflammation of the womb must ensue, but then what rapture she must give.

'Then I heard mingled sighs and panting, low cooings, gurgling sounds of lust, dying in stifled kisses given by lips that still cleaved languidly to each other; then, as they quivered with the last pangs of pleasure, I quivered in agony, for I was almost sure that that man must be my lover.

'"But who can that hateful woman be?" I asked myself.

'Still the sight of those two naked bodies clasped in such a thrilling embrace, those two massy lobes of flesh, as white as newlyfallen snow; the smothered sound of their ecstatic bliss, overcame for a moment my excruciating jealousy, and I got to be excited to such an ungovernable pitch that I could hardly forbear from rushing into that room. My fluttering bird – my nightingale, as they call it in Italy – like Sterne's starling – was trying to escape from its cage; and not only that, but it also lifted up its head in such a way that it seemed to wish to reach the key-hole.

'My fingers were already on the handle of the door. Why should I not burst in and have my share in the feast, though in a humbler way, and like a beggar go in by the back entrance?

'Why not, indeed!

'Just then, the lady whose arms were still tightly clasped round the man's neck, said –

'"Bon Dieu! how good it is! I have not felt such intensity of rapture for a long time."

'For an instant I was stunned. My fingers relinquished the handle of the door, my arm fell, even my bird dropped down lifeless.

'What a voice!

'"But I know that voice," I said to myself. "Its sound is most familiar to me. Only the blood which is reaching up to my head and tingling in my ears prevents me from understanding whose voice it is."

'Whilst in my amazement I had lifted up my head, she had got up and turned round. Standing as she was now, and nearer the door, my eyes could not reach her face, still I could see her naked body – from the shoulders downwards. It was a marvellous figure, the finest one I had ever seen. A woman's torso in the height of its beauty.

'Her skin was of a dazzling whiteness, and could vie in smoothness as well as in pearly lustre with the satin of the gown she had cast off. Her breasts – perhaps a little too big to be aesthetically beautiful – seemed to belong to one of those voluptuous Venetian courtesans painted by Titian; they stood out plump and hard as if swollen with milk; the protruding nipples, like two dainty pink

OPPOSITE and BELOW At the end of the nineteenth century photography was still imitating art, as in *The Blue Veil*. Meanwhile some artists had been influenced by photography to produce idealized wonders like this painting entitled *Voluptuousness*, which was reproduced in sepia monochrome as a postcard.

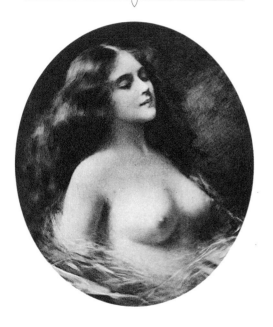

buds, were surrounded by a brownish halo which looked like the silky fringe of the passion flower.

'The powerful line of the hips shewed to advantage the beauty of the legs. Her stomach – so perfectly round and smooth – was half covered with a magnificent fur, as black and as glossy as a beaver's, and yet I could see that she had been a mother, for it was *moiré* like watered silk. From the yawning, humid lips pearly drops were slowly trickling down.

'Though not exactly in early youth, she was no less desirable for all that. Her beauty had all the gorgeousness of the full-blown rose, and the pleasure she evidently could give was that of the incarnadined flower in its fragrant bloom; that bliss which makes the bee which sucks its honey swoon in its bosom with delight. That aphrodisiacal body, as I could see, was made for, and surely had afforded pleasure to, more than one man, inasmuch as she had evidently been formed by nature to be one of Venus' Votaresses.

'After thus exhibiting her wonderful beauty to my dazed eyes, she stepped aside and I could see the partner of her alliance. Though his face was covered with his hands, it was Teleny. There was no mistake about it.

'First his god-like figure, then his phallus, which I knew so well, then – I almost fainted as my eyes fell upon it – on his finger glittered the ring I had given him.

'She spoke again.

'He drew his hands from off his face.

'It was he! It was Teleny – my friend – my lover – my life!

'How can I describe what I felt? It seemed to me as if I was breathing fire; as if a rain of glowing ashes was being poured down upon me.

'The door was locked. I caught its handle, and shook it as a mighty whirlwind shakes the sails of some large frigate, and then tears them to shreds. I burst it open.

'I staggered on the sill. The floor seemed to be giving way under my feet; everything was spinning around me; I was in the very midst of a mighty whirlpool. I caught myself by the doorposts not to fall, for there, to my inexpressible horror, I found myself face to face with – my own mother!

'There was a threefold cry of shame, of terror, of despair – a piercing, shrill cry that rang through the still night air, awakening all the inmates of that quiet house from their peaceful slumbers.'

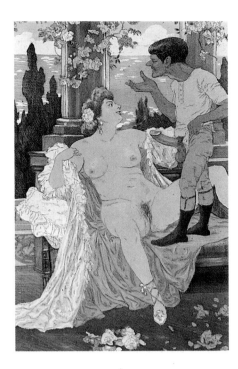

ABOVE The ithyphallic figure who has the (as yet) undivided attention of his companion in this lithograph owes more than a little to the real-life figure epitomizing the Paris of the *Belle Epoque*: Henri de Toulouse-Lautrec. Lautrec's intimate companions – the ladies of the *maisons closes* – all testified that what Nature took from Henri in height, she more than compensated for in other directions.

The cool prose of Anaïs Nin, written some forty years later, makes an interesting contrast with the fevered writing of Wilde and his collaborators. As usual, she controls characters who are little more than marionettes with the icy detachment of a puppetmaster, relying on her powers of description for the erotic charge. It is one of those short stories where all is not made clear until the end, at which point we have the distinct sense that the writer has manipulated us.

She murmured, 'Take your clothes off.'

He undressed. Naked, he knew his power. He was more at ease naked than clothed because he had been an athlete, a swimmer, a walker, a mountain climber. And he knew then that he could please her.

She looked at him.

Was she pleased? When he bent over her, was she more responsive? He could not tell. By now he desired her so much that he could not wait to touch her with the tip of his sex, but she stopped him. She wanted to kiss and fondle it. She set about this with so much eagerness that he found himself with her full backside near his face and able to kiss and fondle her to his content.

By now he was taken with the desire to explore and touch every nook of her body. He parted the opening of her sex with his two fingers, he feasted his eyes on the glowing skin, the delicate flow of honey, the hair curling around his fingers. His mouth grew more and more avid, as if it had become a sex organ in itself, capable of so enjoying her that if he continued to fondle her flesh with his tongue he would reach some absolutely unknown pleasure. As he bit into her flesh with such a delicious sensation, he felt again in her a quiver of pleasure. Now he forced her away from his sex, for fear she might experience all her pleasure merely kissing him and that he would be cheated of feeling himself inside of her womb. It was as if they both had become

BELOW A woodcut by the artist Italo Zetti, designed to be used as a bookplate.

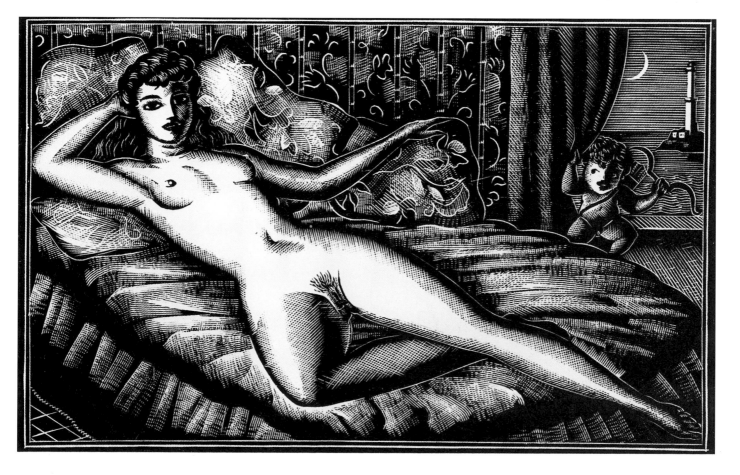

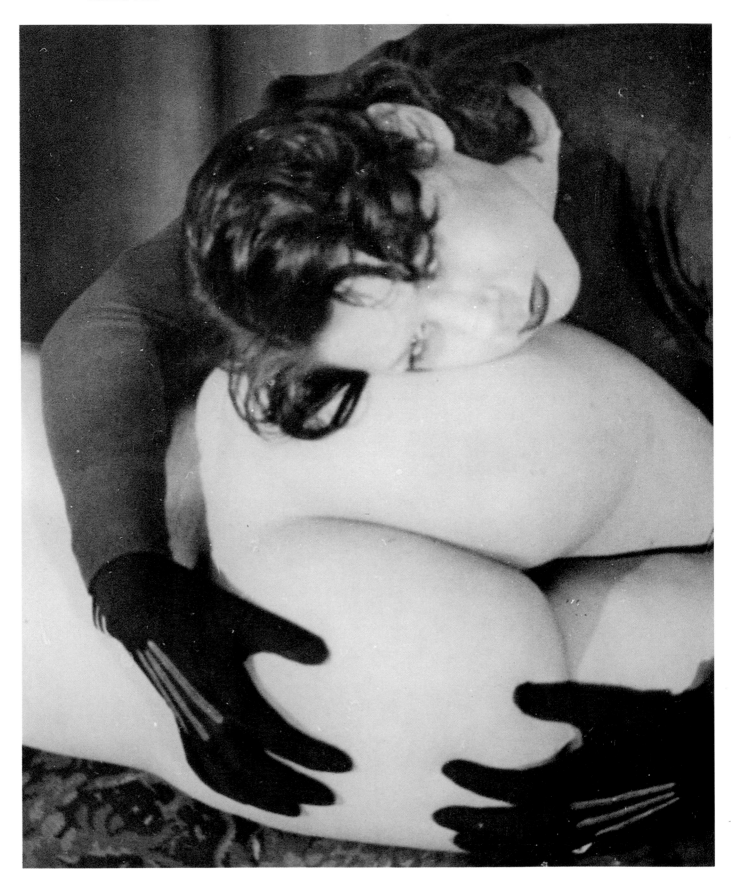

ravenously hungry for the taste of flesh. And now their two mouths melted into each other, seeking the leaping tongues.

Her blood was fired now. By his slowness he seemed to have done this, at last. Her eyes shone brilliantly, her mouth could not leave his body. And finally he took her, as she offered herself, opening her vulva with her lovely fingers, as if she could no longer wait. Even then they suspended their pleasure, and she felt him quietly, enclosed.

Then she pointed to the mirror and said, laughing, 'Look, it appears as if we were not making love, as if I were merely sitting on your knees, and you, you rascal, you have had it inside me all the time, and you're even quivering. Ah, I can't bear it any longer, this pretending I have nothing inside. It's burning me up. Move now, move!'

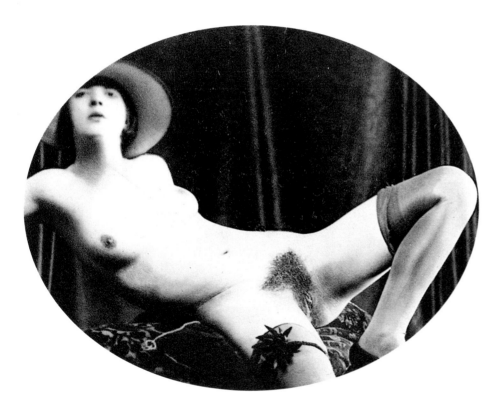

OPPOSITE She both holds and frames the seat of her affections. The gesture is proprietorial, protective – the image unexpectedly beautiful.
LEFT Humour and pathos are frequently uninvited guests at the studios of pornographic photographers.

She threw herself over him so that she could gyrate around his erect penis, deriving from this erotic dance a pleasure which made her cry out. And at the same time a lightning flash of ecstasy tore through George's body.

Despite the intensity of their lovemaking, when he left, she did not ask him his name, she did not ask him to return. She gave him a light kiss on his almost painful lips and sent him away. For months the memory of this night haunted him and he could not repeat the experience with any woman.

One day he encountered a friend who had just been paid lavishly for some articles and invited him to have a drink. He told George the spectacular story of a scene he had witnessed. He was

Why, Jenny, as I watch you there –
For all your wealth of loosened hair,
Your silk ungirdled and unlaced
And warm sweets open to the waist,
All golden in the lamplight's gleam –
You know not what a book you seem,
Half-read by lightning in a dream!

FROM *JENNY*
DANTE GABRIEL ROSSETTI (1828–82)

OPPOSITE A contemporary erotic
icon by an unknown artist.

spending money freely in a bar when a very distinguished man approached him and suggested a pleasant pastime, observing a magnificent love scene, and as George's friend happened to be a confirmed voyeur, the suggestion met with instant acceptance. He had been taken to a mysterious house, into a sumptuous apartment, and concealed in a dark room, where he had seen a nymphomaniac making love with an especially gifted and potent man.

George's heart stood still. 'Describe her,' he said.

His friend described the woman George had made love to, even to the satin dress. He also described the canopied bed, the mirrors, everything. George's friend had paid one hundred dollars for the spectacle, but it had been worthwhile and had lasted for hours.

In a second extract Anaïs Nin uses voyeurism very differently – not simply as a way of giving a theatrical twist to the end of a tale, but as an exploration of the erotic meaning of watching and being watched. An artist's model describes an incident from his youth.

'It happened when I was about fifteen and still sexually innocent. My family had taken an apartment in Paris which had many balconies, and doors giving on these balconies. In the summer I used to walk about my room naked. Once I was doing this when the doors were open, and then I noticed that a woman was watching me across the way.

'She was sitting on her balcony watching me, completely unashamed, and something drove me to pretend that I was not noticing her at all. I feared that if she knew I was aware of her she might leave.

'And being watched by her gave me the most extraordinary pleasure. I would walk about or be on my bed. She never moved. We repeated this scene every day for a week, but on the third day I had an erection.

'Could she detect this from across the street, could she see? I began to touch myself, feeling all the time how attentive she was to my every gesture. I was bathed in delicious excitement. From where I lay I could see her very luxuriant form. Looking straight at her now, I played with my sex, and finally got myself so excited that I came.

'The woman never ceased looking at me. Would she make a sign? Did it excite her to watch me? It must have. The next day I awaited her appearance with anxiety. She emerged at the same hour, sat on her balcony and looked towards me. From this distance I could not tell if she was smiling or not. I lay on my bed again.

'We did not try to meet in the street, though we were neighbors. All I remember was the pleasure I derived from this, which no other pleasure ever equaled. At the mere recollection of these episodes, I get excited. Marianne gives me somewhat the same pleasure. I like the hungry way she looks at me, admiring, worshiping me.'

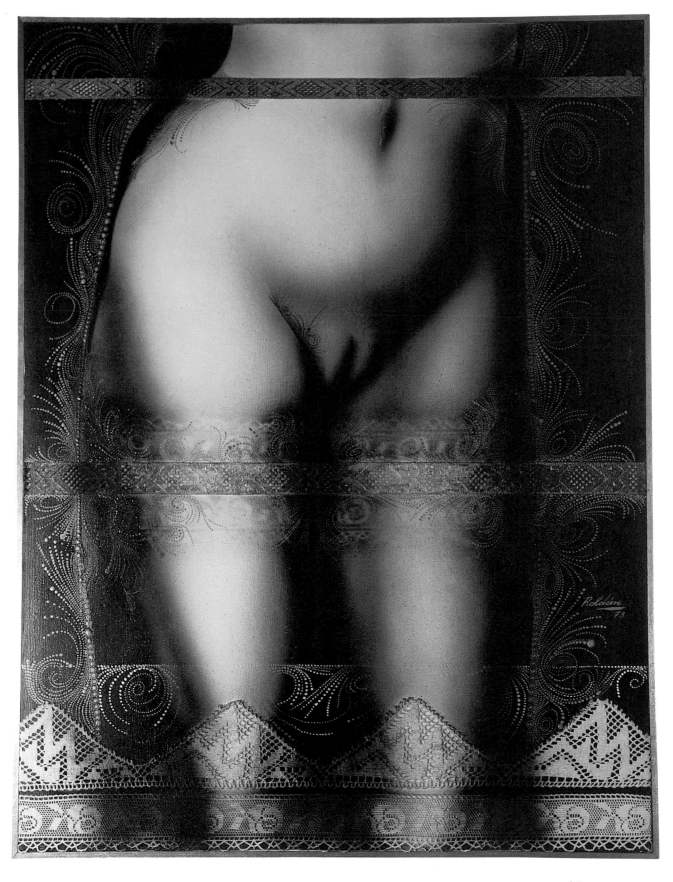

I wish I were the wind, and you,
walking along the seashore,
would uncover your breasts and let
 me
touch them as I blow.

ANONYMOUS GREEK EPIGRAM
(BEFORE FIFTH CENTURY AD)

BELOW An illustration from
Casanova's *History of My Life*.
OPPOSITE A nineteenth-century
erotic figurine in carnival
costume.

When Marianne read this, she felt she would never overcome his passivity. She wept a little, feeling betrayed as a woman. Yet she loved him. He was sensitive, gentle, tender. He never hurt her feelings. He was not exactly protective, but he was fraternal, responsive to her moods. He treated her like the artist of the family, was respectful of her painting, carried her canvases, wanted to be useful to her.

She was a monitor in a painting class. He loved to accompany her there in the morning with the pretext of carrying her paints. But soon she saw that he had another purpose. He was passionately interested in the models. Not in them personally, but in their experience of posing. He wanted to be a model.

At this Marianne rebelled. If he had not derived a sexual pleasure from being looked at, she might not have minded. But knowing this, it was as if he were giving himself to the whole class. She could not bear the thought. She fought him.

But he was possessed by the idea and finally was accepted as a model. That day Marianne refused to go to the class. She stayed at home and wept like a jealous woman who knows her lover is with another woman.

She raged. She tore up her drawings of him as if to tear his image from her eyes, the image of his golden, smooth, perfect body. Even if the students were indifferent to the models, he was reacting to their eyes, and Marianne could not bear it.

This incident began to separate them. It seemed as if the more pleasure she gave him, the more he succumbed to his vice, and sought it unceasingly.

The aphrodisiac effects of voyeurism are exploited in this humorous piece from *Memoirs of a Venetian Courtesan*. The heroine – depressed after the death of her husband – enjoys some therapeutic theatre arranged by her friend, the opera singer Faustolla.

For several weeks Faustolla has insisted that I must take a lover. She understands my reluctance but reminds me that she does not talk of 'love' in fact, but of recreation. To make her point she asks whether I prefer the other options open to me, for she sees only two: Veniero or the madness which afflicts those nuns who cannot divert their desires but merely deny them.

Arriving at her rooms today (a special concession from my protector who will no doubt exact a price for it) I was conducted immediately to the bedroom. Here she gave me a great glass of wine and had me sit on a chair in her dressing room. To my amazement she then closed the doors on me leaving only a chink between. In front of this she placed a screen. 'The Theatre of Saint Angela. You cannot be seen but that is of little consequence since the performers expect no applause. The opera's libretto is an imaginative re-working of an old theme for which I make no apologies since my whole purpose is to recall it to your mind.'

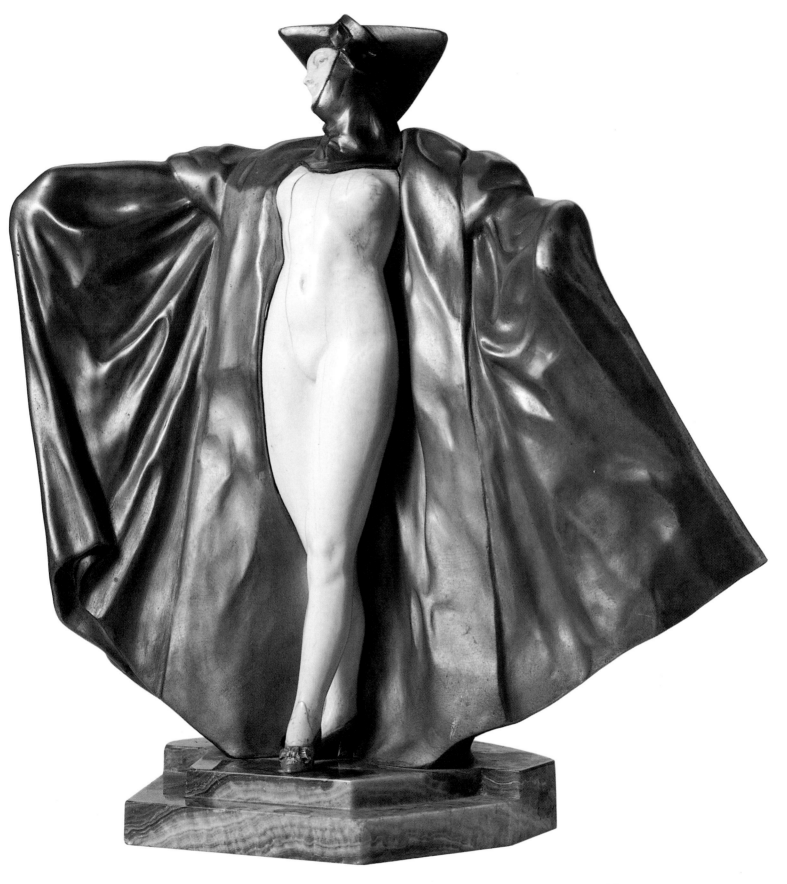

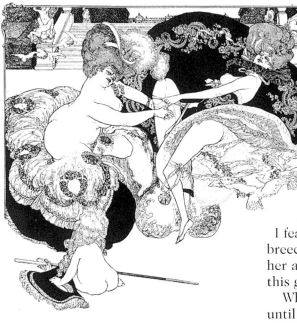

ABOVE Franz von Bayros studied at the academies of Munich and Vienna. His art is an unmistakable cocktail of rococo daintiness, Beardsley-esque technique and witty, decadent eroticism.

With this Faustolla swept out, leaving my head spinning. By the time the full import of what she had said had dawned upon me I could already hear voices approaching.

A young man was praising her latest performance. As they entered the room I recognized Faustolla's lover, Fabrizio. Foolishly I made as if to greet him, having forgotten for the moment my status as hidden audience.

Faustolla had not forgotten her role. First she introduced the central character to fix him in the mind of the audience (a convention quite unnecessary in this case!). I do not mean Fabrizio but his gigantic cock. Falling to her knees before my hiding place, so close I feared to breathe, she took this prodigy from the young man's breeches. With a sideways glance to me – which somehow made her actions more disturbing – she began to lick, stroke and suck this giant sweetmeat.

While she made her noisy feast, Fabrizio tore at his clothes until he was quite nude. Erected before me, and rising majestically from his belly, was the campanile. The architect had made some changes. This edifice was pale for most of its length and red at the end rather than the reverse, and the great bells were hung at the base, but the scale was similar!

Rising from her understandable homage, Faustolla now removed her garments. While she accomplished this her eyes never left his cock. The shining end was like a roof tile that has had rain upon it. The long column was veined white marble. The balls had the brown-red of weathered bricks. When eyes were not enough, and she was impelled to caress Fabrizio with her fingers, his cock moved like a man who has been startled.

As each of Faustolla's charms were revealed her lover explored it, first with eyes and then with hands. I could enjoy the perfect white of her heavy breasts and their scarlet teats; but I could not lift the weight of them or stiffen the nipples between my finger tips as he did. I envied too the exploring fingers in the moist cleft between her thighs and the hands which stroked the twin alabaster globes of her bottom.

And how I envied Faustolla when she turned and leaned forward over the bed: cunt open to receive her lover.

Reds and whites Faustolla, no browns or ochre. Her sex was crimson. Fabrizio lowered the head of his cock and nuzzled the glistening portal. I heard her gasp 'Yes, Yes.'

He pushed slowly into her. Then stopped again. Her call more urgent this time, as if all she wanted in the world was his cock in her: 'Yes! Yes!'

Again he pushed, pushed until I saw his dark balls rest against her pale skin. Now she was silent as he began to move in and out of her. The gusts of their breath the only sound.

He moved against her like the clapper of a great bell. I could see the rhythm of the ponderous movement, but I could only guess at the vibrations and their tone.

Perhaps guessing this – though I think for the time Faustolla

had forgotten her audience in the passion of the part – she became suddenly vocal. But in the excitement of the quickening rhythm these sounds were not from her usual repertoire but shrieks and gasps.

These animal sounds spurred Fabrizio to such a fury of fucking that I knew the crisis must be close. It came to her first when she shouted a great 'Yes' of confirmation. This was the cue for her partner who gave a long, dying groan and collapsed on her back.

I thought my loins had turned to water, so wet was I. Yet Faustolla was wetter. When her gallant slipped to the floor behind her, the crimson landscape was awash with spume. A string of pearls cascaded down on to he who had so recently bestowed them.

All quiet. Two swooning on the bed as if dead. Another sipping from a glass of wine with trembling hands.

The second act. Placing her lover so that his head was away from me and between her legs, Faustolla smiled at me. From this kneeling position she leaned forward and took hold of his penis. Since he was busy with his tongue in her sex, his face buried between the cheeks of her arse, she was free to make a direct appeal to her audience.

First she commends his penis to me, moving it in such a way as to show off all its features. Then, with mime of course, she asked

The moth's kiss, first!
Kiss me as if you made believe
You were not sure, this eve,
How my face, your flower, had pursed
Its petals up; so, here and there
You brush it, till I grow aware
Who wants me, and wide ope I burst.

FROM *IN A GONDOLA*
ROBERT BROWNING (1812–89)

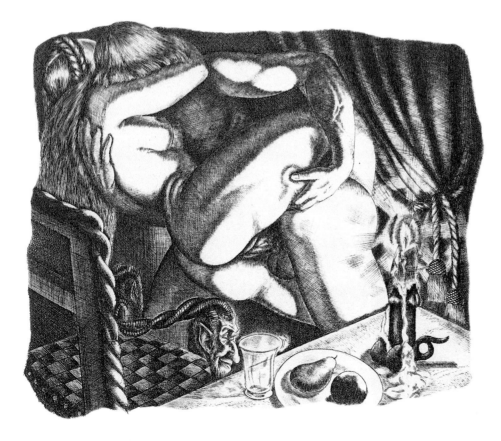

LEFT An engraving by an unknown artist made to illustrate the *Sonetti Lusuriosi* (Lewd Sonnets) of Pietro Aretino (see the poem on page 107).

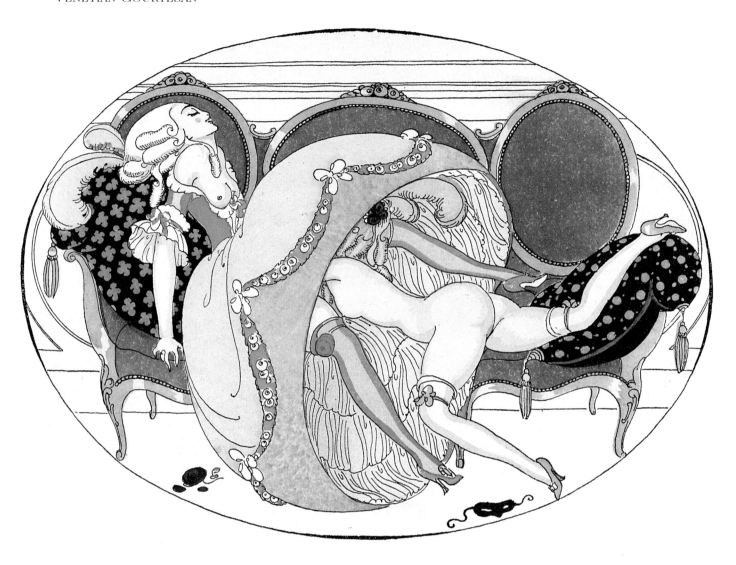

ABOVE and OPPOSITE Coloured
stencil engravings first published
in 1917.

if I would like it? Feigning disappointment at my supposed rejection of this generous offer she affects to comfort the cock. It must have been greatly offended by my coldness (coldness!) because it begins to thrash about: throwing itself from side to side in despair.

This moves Faustolla and she gives the cock sanctuary in her mouth. Strictly speaking only one third can be said to be truly closeted from the cruelties of the world but it is a sympathetic and imaginative audience. The pathos of this moment deeply affects Faustolla. As she rocks her mouth up and down to warm and comfort her guest, I can see real tears in her eyes.

Soon the cock is ready to take on the world again. Perhaps he is too full of his own importance because she begins to wave the great shining thing about. There is something in this stiff dance which brings an involuntary gasp from the audience. This causes a smile on stage just as the curtain is lowered.

I am wet again as I recall the lustful celebration which I then witnessed: a beautiful woman pleasuring herself on a cock of truly

theatrical proportions. More than that: her every action, though intended for his pleasure and hers, was addressed also to me. I believe my presence intensified her pleasure just as I am sure that the knowledge that this was being done for me, made what I witnessed all the more affecting.

Her auburn hair danced about her white shoulders as she rose and fell. Sometimes she leaned forward on him so that the weight of her hair and breasts took them away from her body. Their movement was different then and slower. When she leaned back her breasts flattened and the points of the nipples moved quickly.

Fabrizio was a long time in reaching his crisis. Sometimes she turned away from me and her sex was hidden, a mystery somewhere deep within her haunches. All I could see was the long shaft of his cock appearing and disappearing between her buttocks.

When she turned to face me again, knees drawn up, I could see everything: his penis disappearing into the froth of hair as she pushed down onto it; her lips holding it as she pulled up.

At those times when she faced me and leaned back I could see her clitoris. Sometimes she reached down to the crimson bud and touched it, moving her finger quickly. Then she always sought my eyes.

That was how it was when Fabrizio began to groan with his orgasm. This time she must follow. Faustolla sought my eyes in vain. Then closed hers. A moment later she made a sound in the back of her throat and began to gasp like one drowning as each wave of pleasure broke.

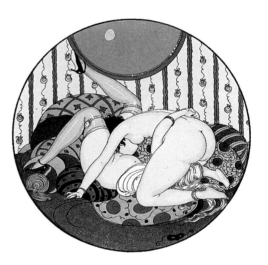

Afterwards, when Fabrizio had gone, she opened the doors of my torture chamber and smiled. I did not have to ask her. She led me to the bed and pushed me back.

I felt her fingers in the damp hair, then opening my lips. The crisis came moments after I felt her tongue for the first time.

———— ◊ ————

The voyeurism implicit in all erotic fiction is enhanced when voyeurism is also the subject of that fiction. The lubricity is further increased when one of the participants is aware that they are being watched, as in this episode involving an alternative 'Charlie's Aunt'.

'For God's sake fuck me – fuck me!'

Of course my cock was bursting to do so; with one shove he was sheathed to the cods; my loved mistress spent with that alone, so highly was she excited, not only by the preparations, but as she herself acknowledged to me, by the idea of the instantaneous infidelity to her husband, at the moment after he had just fucked her – such is the wild imagination of women when they give way to every libidinous thought. It would have been exactly the same if some equally fortunate lover had been awaiting my retiring from the field. The idea of success in deception is a passion with them, and they would almost sacrifice any thing to obtain it. Before I could arrive at the grand crisis, she was again

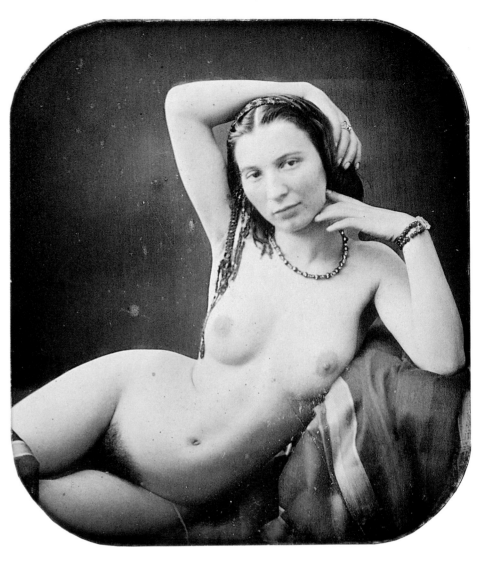

ready, and we died away in an agony of blissful lubricity – she held me, as usual, so tight that I never thought of withdrawing from the folds of her delicious cunt, but lay still enjoying the never ceasing compressions of its velvety folds, which sometimes really had almost the force of a vice. I was rapidly ready for a second bout, which, like the first, ended in extatic joys, beyond the power of description. My charming mistress thought I ought now to desist, but pleading my forty hours' fast (for, of course, she knew nothing of my fucking Mary), I begged her to allow me to run one more course.

'Then, my darling Charlie, you must let me turn on my side, for I am so heated with your weight and my husband's that I must have some relief, but there is no occasion for you to withdraw, leave me to manage it.'

With an art quite her own, she accomplished her object, her splendid buttocks' pressing before my eyes against my belly fired me immediately. My cock swelled and stood firm as ever. Then passing an arm round her body, I used my fingers on her excited and stiffly projecting clitoris. We had a much longer and more

voluptuous fuck than before; nothing could exceed the delicious movements of my divine mistress; she twisted her body so, that I could suck one of her bubbies, while I fucked and frigged her; she spent with such a scream of delight that I am sure she must have been heard in the house, had it not been for the inner baize door to the room. She continued throbbing so deliciously on my prick that I began to flatter myself I should obtain a fourth favour, but she suddenly bolted out of my arms and out of bed. Turning round, and taking my whole prick into her mouth, and giving it a voluptuous suck, she said –

'No, my loved boy, we must be prudent if we mean to have a repetition of these most exquisite interviews. You have given me most extatic pleasure, and by moderation, and running no risk in too long indulgence of our passions, we may safely manage to enjoy similar interviews every day. Get into the dressing-room, remain there until I leave my room and pass your door. After I have seen that no one is near, I will cough twice, wait a minute longer, then quietly leave and descend by the back stairs.'

All was happily effected, and for the week longer they remained with us, I found means to repeat the charming lesson every day, without raising suspicion in any one's mind.

The preceding episode – 'A Peep-Hole Aftermath' – is taken from *The Romance of Lust*, one of the most popular erotic novels of the Victorian period. Having persuaded his aunt to allow him to watch her with his uncle, the hero then enjoys the effects of this aphrodisiac aperitif. *The Romance of Lust* was published in four volumes between 1873 and 1876. It appears to have been written by several people, but was edited by William Simpson Potter. The novel is in the picaresque tradition. It has no real plot but is well written and nicely paced, which is just as well for the reader, who is led through a bewildering forest of sexual encounters. *The Romance of Lust* is a truly alternative novel: the shadow of contemporary convention. Its hero Charlie seduces not only aunts, but sisters, uncles, indeed everyone and anyone. His sexual tastes are catholic, although he does have a marked preference for the alternative sexual venue: indeed, the novel could just as easily have been called the 'romance of sodomy'.

————————◊————————

The pastiche novel *Passion's Apprentice* makes use of the voyeur motif in an unusual way, combining sex with farce. We join the hero and unwilling voyeur – William Ashton – in the rooms of a Paris milliner.

It seemed the difficult business of millinery did not in itself provide Marie-Louise with all the comforts she wanted. She had therefore taken the practical, time-honoured and mutually beneficial step of acquiring a rich lover or protector. No, she could not say if she loved him or not. In respect of that particular verb she was as perplexed as Ashton.

Et qui remonte et redescend
Et rebondit sur mes roustons
En sauts où mon vit à tâtons
Pris d'un vertige incandescent

Parmi des foutres et des mouilles
Meurt, puis revit, puis meurt encore,
Revit, remeurt, revit encore
Par tout ce foutre et que de mouilles!

Cependant que mes doigts, non sans
Te faire un tas de postillons,
Légers comme des papillons
Mais profondément caressants,

Et que mes paumes, de tes fesses
Froides modérément tout juste
Remontent lento vers le buste
Tiède sous leurs chaudes caresses.

And lifting up and dropping back
To land on bollocks with a bump,
And bouncing where my white-hot
* stump*
Dizzily feeling round the crack

Among the juices and the come
Dies and revives and dies again,
Retools, and dies, and tools again,
Through so much juice and all that
* come.*

My fingers meanwhile, which full-pelt
Were tapping light quick commentaries
On your unguarded orifice,
Butterflies, but profoundly felt,

Leave the glen slowly for their calm
Long climb from buttocks' moderate
* chill*
Around toward each tremulous hill,
Warm in the hot and hollowed palm.

FROM *THE WAY THE LADIES RIDE*
PAUL VERLAINE (1844–96)

Marie-Louise and Ashton had begun their guiltless enjoyment of each other about ten days after his arrival. Having slipped naturally into the familiar and friendly intimacy already described, Ashton had found that he was always welcome at her rooms in the evening if the marvels of Paris theatre or opera had not lured him. She had made it clear in her frank way that he was to 'take her as he found her' but providing the spectacle of her sewing feathers onto a hat or attending to some aspect of her toilette did not offend him then her door was always open. When her protector returned from the trip to Marseilles which had engaged him for several weeks this arrangement would need to adhere to a somewhat less flexible timetable, but they had already enjoyed several happy evenings together.

On the occasion in question Ashton had arrived just as his good-natured friend had begun to wash her hair. Of course he did not mind. It would be a new experience for him – and so indeed it was.

Marie-Louise had glowing auburn hair and the milky skin which often accompanies that colouring. She was wearing a loosely-fitting silk gown and had already put out water and the other things she would need on the washstand.

'Are you to be a spectator or will you help me?'

'I will help of course.' Ashton was amazed at the length of her hair, unpinned she could have sat upon it.

She bent over the bowl. 'Pour the water now.'

He did so, and also followed her other directions. As Marie-Louise bent forward her gown hung away from her, revealing milky white breasts and nipples so intense in colour they almost looked sore.

Ashton, who was already suffering from the misery of sexual abstinence, was transfixed. He had of course been very aware of Marie-Louise, who was as attractive as she was cheerful, but for some reason had not considered making love to her a possibility. Consideration of that very possibility now animated both his mind and his body. The raging erection struggling to assert itself within the confines of his trousers was not pacified when he noticed that below the glorious breasts an equally glorious belly and froth of red hair was visible.

Ashton may have gasped, perhaps his eyes betrayed him when her own hot green orbs confronted him. The more prosaic bulge in his trousers could have given the clue. Whatever the reason, when Marie-Louise had finished drying with the towel and stood supporting herself on her hands against the mantelpiece, head dropped forward so that her damp hair was in front of the fire, she suddenly said: 'I want it as badly as you. Why don't we do it?'

For a moment all was silence. Ashton was not sure he had understood: then he did. Staying in the same position she loosened her gown with one hand and let it slip to the floor.

BELOW A late nineteenth-century engraving.

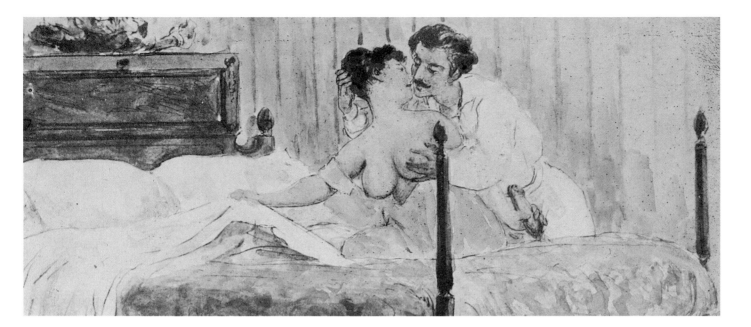

Instantly he was behind her, lifting the soft weight of her
breasts with one hand, and exploring between her legs with the
other. She remained as she was before the fire. He tore off his
clothes and dropped to his knees behind her. She bent her legs a
little and pushed out her buttocks so that he could lick her. Her
body perfume was intense, the taste of her scarlet sex like ripe
fruit that has burst open.

He stood now and slowly pushed his throbbing penis where his
tongue had been. She gave a long moan; supported by him and
with him still inside her, she sank to her knees. Rutting her now
with a fury, he drove in and out until there was a lather which
sucked and slapped between belly and buttocks. At the finish she
shouted 'Yes, yes, yes!' as if to confirm her pleasure. Her sex
gripped him then, milking the last seed from his manhood.

Ashton and Marie-Louise took such pleasure in each other that it
made them reckless. To risk being together on the very day her
protector returned was ill-considered enough, to ignore the
chiming of the clock was madness. Fate was not slow to rebuke
them for this self-indulgence.

The returning merchant could not have guessed at the extraor-
dinary and immediate effect of his thunderous knock upon the
door. Within, and mercifully hidden from his eyes, the sound
drove Ashton to the only possible exit and Marie-Louise into a
fury of tidying. Four strides took Ashton from the couch and out
onto the tiny balcony. Ashamed that he had shown no presence of
mind beyond the selfish impulse of snatching off the table cover
when the freezing night air first struck his naked body, he
watched the meticulous preparations of Marie-Louise with ad-
miration. Before her protector had time to knock again she called
out that she was washing and would be finished in a moment.
This was indeed true. Stooping over the wash bowl to freshen her-
self after many hours of lovemaking with Ashton took only a

*Hast du die Lippen mir wund geküsst,
So küsse sie wieder heil.*

*You who bruised my lips with kissing
Kiss them well again.*

HEINRICH HEINE (1797–1856)

moment. As there was no slop pail it took only another moment to open the narrow doors of the balcony, fling out the tell-tale water, kiss her lover, re-close the doors and draw the curtains.

Through the narrow chink which remained, Ashton saw her put his clothes and boots under the large chair. Calling out all the time to her protector in mock chiding tones, she upbraided him for being so impetuous. 'Surely he was very early?' At this time she was smoothing the bed which had been so deliciously rumpled. 'Did he not know that there were little things a lady must do before receiving her lover?' Now she was removing the boots from beneath the chair which prevented it from resting flat and sliding them under the curtain. 'Was he very passionate today?' Until now she had been naked. After a visit to her perfume bottle she took a fresh silk gown from the armoire and slipped it on. 'If passion had made him forget his manners then she forgave him.'

All this had taken less time than it takes to tell it. Finally, the extraordinary girl went to her lover's hiding place to check on his condition. At the sight of Ashton, naked except for the table cover which concealed only his upper torso and which he wore in the manner of an old lady's shawl, she could not control her laughter.

This was too much for her protector. His knocking became

BELOW Bedroom frolics: an engraving from the turn of the century.

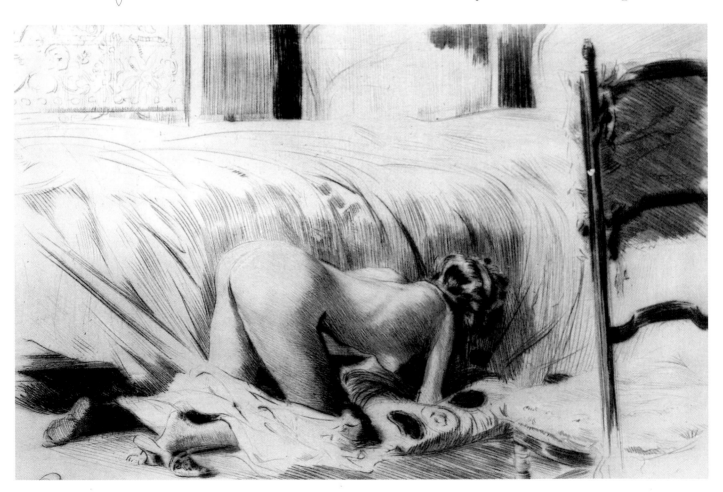

furious and he called out to her angrily. For the first time a look
of fear swept over her beautiful face. After all he paid for all her
luxuries, her clothes, for this apartment. He was not a bad man,
indeed he was kind and sometimes generous. But his good nature
would not countenance this ghastly disclosure! The stakes could
not have been higher. Ashton knew what was going through her
mind, but she bravely suppressed the dark thoughts and even
managed a smile and a wink for him. She re-closed the curtains
carefully. Not only to conceal her lover and his boots, but also to
protect him from whatever scene was to be enacted in the room.

In this last intention she was unsuccessful. A narrow chink
remained, imperceptible from within but enough to reveal the
entire brightly lit room to Ashton. He saw Marie-Louise cross to
the door, pausing momentarily by the pier glass to check her hair
and face. She opened the door and a tall man entered clutching
an assortment of parcels. Evidently annoyed, he ignored her kiss
and strode towards the window.

Filled with horror, Ashton turned and pressed against the iron
railings. Far below, invisible in the murky blackness, was an alley-
way. To jump was certain death. A sickly glow above the rooftops
was a mocking reminder of the busy streets close by. But no one
in the great city of Paris could help him now.

He turned to confront his fate, assuming – by what lunatic
rules he knew not – what seemed an appropriate expression. The
doors did not open. He moved nearer to the glass and saw the
man's back. On the table to the right were a hat and the parcels.
He almost cried out with relief.

Her protector's anger had evidently blown itself out, but
Marie-Louise fell to her knees before him. He said nothing. She
said nothing. Ashton was perplexed. Still nothing was said. What
was the meaning of this silent tableau when all had been so noisy
a few moments before? The man made a strange sound and with
difficulty stooped and helped Marie-Louise to her feet. In doing
so he turned. Then Ashton understood. A penis, fiery red and
glistening, stuck out from his trousers.

The unwilling voyeur turned his back on the disturbing scene.
In fairness he had to accept that the only person with any cause
for complaint in this situation was the protector of Marie-Louise.
And he remained in blissful ignorance. For once, only the guilty
suffered. Marie-Louise knew mental torment because of the fear
of discovery. Ashton's punishment, he now realized, was that
reserved by Dante for the very worst sinners – cold.

The night was so cold that splashes from the wash bowl had
already turned to ice at his feet. This made movement dangerous,
but move he must if he was not to perish on his frozen perch.
Clutching the table cover around him he hopped from one bare
foot to the other, trying to avoid the iron railing which had
become sticky with frost. He could not prevent his teeth from
chattering and feared it might have been audible in the room.
But their attention was on other things.

Marie-Louise's protector had removed his clothes and sat
crushing Ashton's under the armchair. She was leaning over the
arm sucking and tonguing his penis, while tugging and fondling

*Gudewife, when your gudeman's frae
 hame,
 Might I but be sae bauld,
As come to your bed-chamber,
 When winter nights are cauld;
As come to your bed-chamber,
 When nights are cauld and wat,
And lie in your gudeman's stead,
 Wad ye do that?*

*Young man, an ye should be so kind,
 When our gudeman's frae hame,
As come to my bed-chamber,
 Where I am lain my lane;
And lie in our gudeman's stead,
 I will tell you what,
He fucks me five times ilka night,
 Wad ye do that?*

WAD YE DO THAT?
FROM THE MERRY MUSES OF CALEDONIA
ROBERT BURNS (1759–96)

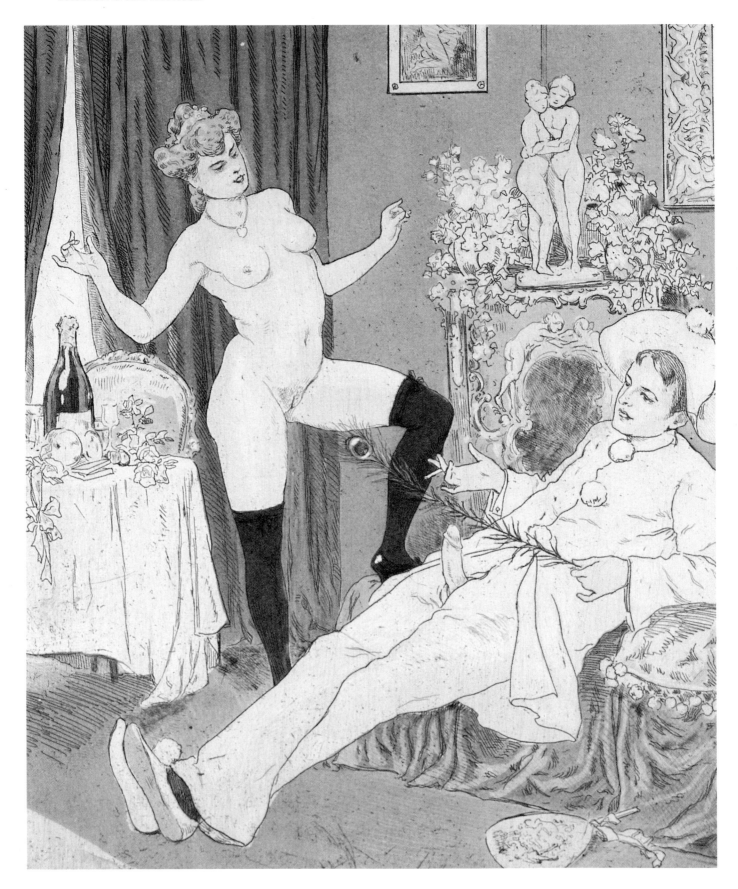

his testicles with her long white fingers. Standing up, and slipping out of her gown, she knelt on the arms of the chair and lowered herself slowly on to him. In any other circumstances the sight of his long stalk appearing and disappearing between the white orbs of her bottom would have excited a saint to lust. But a clutch icier than piety had hold of Ashton's vitals which had shrunk to a sad vestige resembling a frozen gooseberry. The gooseberry fool! He laughed despite himself.

It was no gooseberry, but some rude and brightly coloured tropical fruit which appeared as the merchant slipped down onto the floor until his face rested between the thighs of Marie-Louise. Now his tongue took up the work. Her movements became more erratic, breathing the tide of familiar little gasps. When the hair of the man's beard permitted Ashton could see his tongue lapping at the long, glistening inner lips of her sex.

Now the merchant stood up behind her. She dropped forward against the back of the chair and reaching back with both hands pulled her bottom cheeks apart. Ashton gasped, or the merchant did, he could not tell. Nothing was more beautiful than the gaping sex of Marie-Louise at that moment.

She groaned as he buried himself in her. Foam hung about the long brown shaft as he worked in and out with a fury. Ashton saw her white fingers reach back and grasp his testicles. It was too much for her protector. With a shout he gave a final thrust and fell forward onto her.

Ashton's passions were in turmoil. He wanted to laugh and cry, all at once. He looked to his own frozen assets and laughed bitterly.

Suddenly the door opened. Involuntarily he pressed back against the iron rail which seared his skin. 'He has gone to the closet. Quickly.' He was stupid, numb with the cold. He took the bottle of brandy and the blanket without speaking. There was a sound behind her. She kicked his boots out onto the balcony and was gone again, the curtain closed.

The sound of a boot striking the ground far below echoed forlornly between the walls. With difficulty he pulled on the other with frost-bitten fingers and wrapped the blanket around him. He consumed the brandy with painful gulps until he had nearly finished the bottle. At a whim he poured some over his manhood and tried to rub some life into it, but it was hopeless.

Inside, Marie-Louise was riding her protector on the bed. Ashton thought how beautifully her breasts moved. How he should like to feel the weight of them and unpin her hair.

Even with the stimulus of the brandy, everything was becoming very slow. Ashton moved into a kind of dream state where events were jumbled. He saw most of what they did to each other, but with increasing detachment. When Marie-Louise masturbated her protector their observer was merely curious at the amount of semen which still spurted from the man. She massaged it into her breasts and nipples. She had never done that for him, he reflected.

He then lost all sense of time. Finally the doors opened. Propped on the one leg which had a boot, somehow holding the

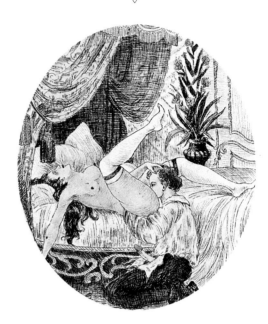

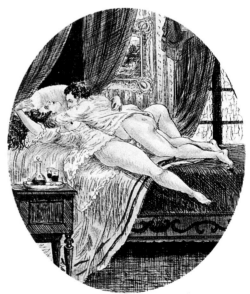

coverings around his upper body, he looked like a rather miserable stork.

Marie-Louise slowly brought her lover back to life in front of the fire. It is not easy to speak with your mouth full – even when it is only a morsel blighted by the frost – but her words were just intelligible. 'Cheri, you taste of brandy.' Ashton did not explain.

———— ◊ ————

In stark contrast to the farcical – and fictional – voyeurism of *Passion's Apprentice* are the all-too-real scenes recorded in *My Secret Life* by its anonymous author 'Walter'. *My Secret Life* is the most extraordinary sexual document to come from the Victorian – or perhaps any other – age: a man's complete erotic biography covering his life from childhood to late middle age, omitting nothing. The 'Walter' of this unique book has an obsessive interest in sex and in recording his experiences of it. This he does in minute detail across nine volumes, describing his relations with '2500 women of all countries of the world (except Lapland)'. A full life in one very particular sense, but not a happy one. In all those pages, love is hardly ever mentioned and then most memorably (and perhaps significantly) in describing his parting from his cousin Fred. 'He went abroad, and was killed in battle, I loved him'. 'Walter' was a user of women, a male predator – a type we will meet again in the second half of this anthology. When he was about thirty-five he met the prostitute Sarah Frazer (he tells us he never changes the names of 'gay' women). With her help he 'did, said, saw, and heard well nigh everything a man and a woman could do with their genitals'. It is important to remember that the following descriptions are not fiction but plain fact.

I went to the house first. Sarah entered followed by a very tall woman with her veil down, who stood and looked through it at me. Sarah having locked the door said, 'Take off your bonnet, Eliza.' – The woman only looked curiously round the room. – 'Take off your bonnet.' – Then she took the bonnet off, and stood looking at me. – 'Sit down,' said Sarah – and down she sat.

She was full thirty-five years old, but what a lovely creature. – I think I see her now, altho I never saw her but that once. – She had beautiful blue eyes, the lightest auburn hair crimped over her forehead, a beautiful pink bloom on her cheeks, and flesh quite white. – She was dressed in black silk, which contrasted well with her pink and white face. – She was big all over. – Big breasts jutted out in front – the tight sleeve shewed a big round arm – her ample bum filled the chair. – She was exactly what I wanted. – I never could wait long to talk with a woman whom I liked the look of, without proceeding to see, if not to feel, some of her hidden charms. – A burning desire to see what she had hidden seized me. I don't know if I spoke or not, but filled with desire, dropped on my knees and put my hand up her clothes, one round her thighs towards her bum, one towards her cunt.

As I touched her thighs, she put both hands down to stop me

ABOVE Sex, like Justice, should where possible be seen to be done. At the time when these girls were photographed, Alice was having her own rather different adventures through a looking-glass.

with a suppressed 'oh' – neither action or word, those of a woman who was shamming. – It wasn't the fierceness of a girl who first feels a man's hand about her privates, nor the sham modesty of a half-gay woman. It was the exclamation and manner of a woman not accustomed to strange hands about her privates. The next instant, I had reached both haunch and cunt. – She gave another start, my arms had lifted her petticoats, and I saw a big pair of legs in white stockings, and the slightest flesh above the knee nearly as white. – I placed my lips on it and kissed it – my hand slipped from her cunt round to her bum, and both hands now clasped one of the largest, and smoothest, and whitest backsides I ever felt. Then burrowing with my head under her petticoats, I kissed my way up her thighs till my nose touched her motte, and there I kept on kissing.

The warm close smell of her sweet flesh, mingled just with the faintest odour of cunt, rendered it impossible to keep my lips there long. The desire to enjoy her fully was unbearable – I withdrew my head and hands, and got up saying. 'Oh! – undress dear, I long to fuck you.' – They were the first words I had spoken to her, and she had not spoken at all. – She then rose up, and slowly began unbuttoning looking at Sarah. – 'Lord, what a hurry you are in,' said Sarah to me.

Off went the black silk dress, out flashed two great but beautiful breasts over the top of the stays – and a pair of large, beautifully white arms shewed. – Then I saw the size of the big bum plainly under the petticoats. Off went stays and petticoats all but one. – Then she, 'There, will that do?'

I wanted all off. – 'Oh – I cannot take off any more.' I appealed to Sarah, who said. 'Now don't be a fool, Eliza' – Eliza then undressed to her chemise, and positively declared she would keep that on – I had taken off my trowsers and was standing cock in hand. – My impatience to discharge my seed into the splendid creature before me, made me careless whether she stripped or not. – I had drawn near to her – was feeling all round her bum with one hand, and wetting the fingers of the other in her cunt. I placed my prick so that it rubbed against her thigh, and feeling her, was at the same time pushing her towards the bed.

When we touched the bed – 'I can't with Sarah there,' said the woman. – 'Go out,' said I to Sarah. She looked savagely and replied, 'Nonsense.' Then I had a moment's dalliance and no more, forget what more was said or what took place, but saw Eliza on the bed, threw up her chemise, saw a mass of white flesh and a thicket of light hair between a pair of thighs, the next instant was between them, and my prick was up her cunt.

It was an affair of half a dozen shoves, a wriggle, a gush, and I had enjoyed her. Then I became tranquil enough to think of the woman, in whose vagina I had taken my pleasure. Resting on one arm and feeling her all over with one hand, I looked at her, and she at me. I said a few endearing words, as she lay tranquilly with my cock still stiff and up her.

I could have done it again right off, but had not yet looked at her hidden charms, and desire to inspect her quim made me draw out my cock and rise on my knees between her legs. Few

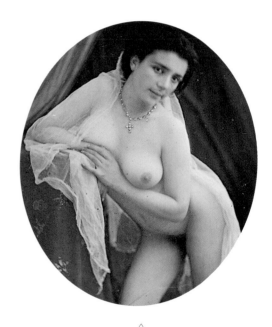

ABOVE The finest of several beautiful and evocative nude studies of this model which have survived. A coloured daguerreotype produced as a stereograph in Paris, c. 1855.

strange women like their cunt looked at, when sperm is running out of it. She pushed down her chemise, I got off her, and then without saying a word she washed. When I had washed my cock it was as stiff as ever. I went to the side of the bed where she had just begun piddling, and held my stiff one in front of her eyes. For the first time she smiled.

She began to dress, but I told her I had only begun my amusement. I had brought bottles of champagne, for I knew how that liquor opens the hearts and the legs of women. – We got glasses and began drinking. – She drank it well and soon began to talk and laugh. When I again brought her to the bed she was an altered woman, but still did not seem to like fucking before Sarah. 'Why I have seen all you have got to show often enough,' said Sarah angrily. – On the bed now for a good look at the cunt. – It was a big one. – An inch of fat at least covered the split, stoutish middle-aged women get I think fat cunt lips, and hers was very large. – She had a very strongly developed clitoris, and such a lot of light hair. Large and fat as the cunt was, I do not

RIGHT The expression denoting the lovemaking technique illustrated in this lithograph is 'la diligence de Lyon', so called because the woman imitates the back-and-forth, side-to-side jogging once enjoyed by passengers in a horse-drawn mail coach.

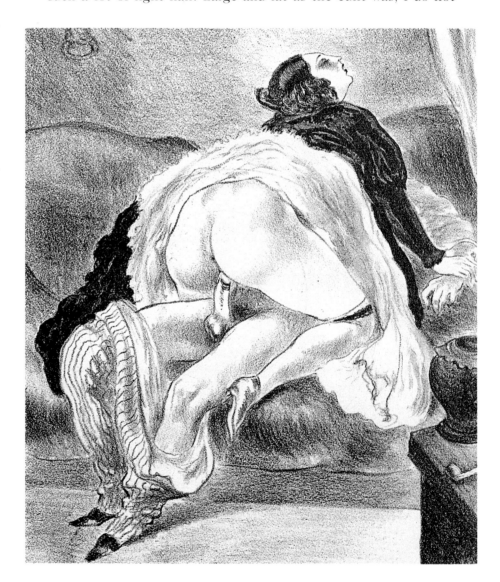

recollect if the prick hole was large or little but know that I enjoyed her as much as a man possibly could. I delighted in laying my hand between two, long, fat cunt lips – I rolled over her, played with and kissed her from her thighs to her eyes, frigged her clitoris till she wriggled, and as at length my prick slipped up her cunt again, she whispered, 'What a devil you are.' She pushed her tongue out, mine met it, and then all was over. – She wagged her big arse vigorously when spending.

Ballocks and cunt again cleared of sperm, to the champagne we again went. – Sarah had not yet undressed, I had almost forgotten her. Now I made her strip, and my two big women were nearly naked together. – A little more pfiz and we were all on the spree. – Eliza still had the manner of a woman not accustomed to expose her charms, but insisted on by me and Sarah who seemed to have control over her, off went her chemise at last. – Off went my shirt – and there we all stood naked.

I never before had two such big women together and did with them all that my baudy fancy prompted. – I put them belly to belly, then bum to bum. – Then standing up before the glass, I put my prick between their two bums, making them squeeze it between their buttocks whilst I groped both cunts, and frigged at once both of them. Then putting Eliza at the side of the bed with open thighs, I put Sarah between them as if she were a man – and pushing my prick between her thighs just touched her split. – She laid hold of my prick and slipped it up her own cunt. – But I did not mean that, and pulled it out. – Then I had them both side by side on the bed and scarcely knew which of the gaping cunts to put into, but the fair-haired one again had my attention. Then I put Sarah upside down on the bed so that her arse and cunt were near the pillow, one leg partly doubled up, and one cocked up against the back of the bed, and looking at her thus I fucked Eliza by her side. Sarah said she must frig herself and set to work doing it, whilst with the one hand stretched back she played round my prick stem in Eliza's cunt which was tightening under the pleasure of my shoving and probing. Eliza's amativeness had been awakened, she clasped me tightly with her large white arms, kissed and thrust her tongue into my mouth, in a state of the fullest voluptuous enjoyment.

We finished the champagne and sent out for sandwiches, stout, and brandy. – I had taken the room for the night. – Sarah never was, and her companion was not in a hurry now. We ate, drank, and got more erotic. – Eliza's fat bum was on my naked thighs. She put her hand on my prick, and grasping it for a minute whispered, 'Come and do it again.' – Sarah said, 'What are you whispering about?' – She had been looking at times annoyed at my taking no notice of her. – Again I put Eliza on the bed. – Sarah who had alternately been quiet and then baudy, said, 'It's my turn, why don't you poke me?' – 'You will have it another night.' – She then got on to the bed, and on to the top of Eliza, kissed her rapturously, got between her thighs, and my two big beauties were like man and woman in each other's arms. – Eliza threw up her legs until her heels were on Sarah's back. Sarah nestling her belly close up to her, the hair of their two

a silvertoed virgin
 was washing her body
 drenching the golden
apples of her breasts
 their flesh like yogurt
the plump cheeks of her bum
 tossed against one another
as she swung about
 flesh as lithe as water
a hand spread down
 to cover
 much swollen
 the fairflowing conduit
not the whole thing
 but as much as she could

RUFINUS (c. SECOND CENTURY AD)

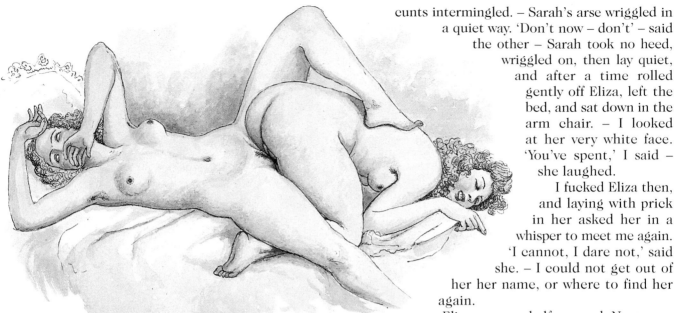

cunts intermingled. – Sarah's arse wriggled in a quiet way. 'Don't now – don't' – said the other – Sarah took no heed, wriggled on, then lay quiet, and after a time rolled gently off Eliza, left the bed, and sat down in the arm chair. – I looked at her very white face. 'You've spent,' I said – she laughed.

I fucked Eliza then, and laying with prick in her asked her in a whisper to meet me again. 'I cannot, I dare not,' said she. – I could not get out of her her name, or where to find her again.

Eliza was now half screwed. No sooner had I fucked her than she began squeezing my prick. – She opened her large thighs, placed my finger on her clitoris, kissed my prick, thrust her tongue in my mouth, and did every thing which a randy-arsed woman does to get more fucking. – I fucked her four or five times, perhaps more, and till neither she nor Sarah could make my cock stand. The house was closed, off I went, but not until Eliza had gone long. – Sarah insisted on that. – Then said Sarah, 'I'm not going without a poke.' With infinite trouble she got a fuck out of me, and both of us groggy, we separated.

Some nights after talking of Eliza, whose legs in boots and silk stockings had charmed me, Sarah laughed. – 'Why, they were mine, I lent them to her.' Then I recollected that Sarah had not had her usual boots on.

I wished her to get me Eliza again. She refused. I said I would find her out. – She was sure I should not! – I went to one or two places on the chance of finding her, and Sarah laughed when I told her. – I used to get awfully randy when I thought of the two big women naked together. 'She is not gay, altho you may think so, it was only because she was so dreadfully hard up that she came,' Sarah averred. . . .

Two or three weeks after . . . Sarah said she had met the man with the titanic prick. – We had by that time got so intimate, that she told me any funny adventures she had with men. – He had behaved in just the same manner to her, and was to meet her that day week. – 'Oh! I long to see him with you – bring him to the next room,' – and it was so arranged. – The spying room was to be kept for me – the back room I was to pay a pound for, and it was to be kept for Sarah. The old baud knew what we were up to. – I told Sarah to keep the man as long as she could, whether he paid much or little (he gave her treble what I did), and above all to manage so that I could see his prick well.

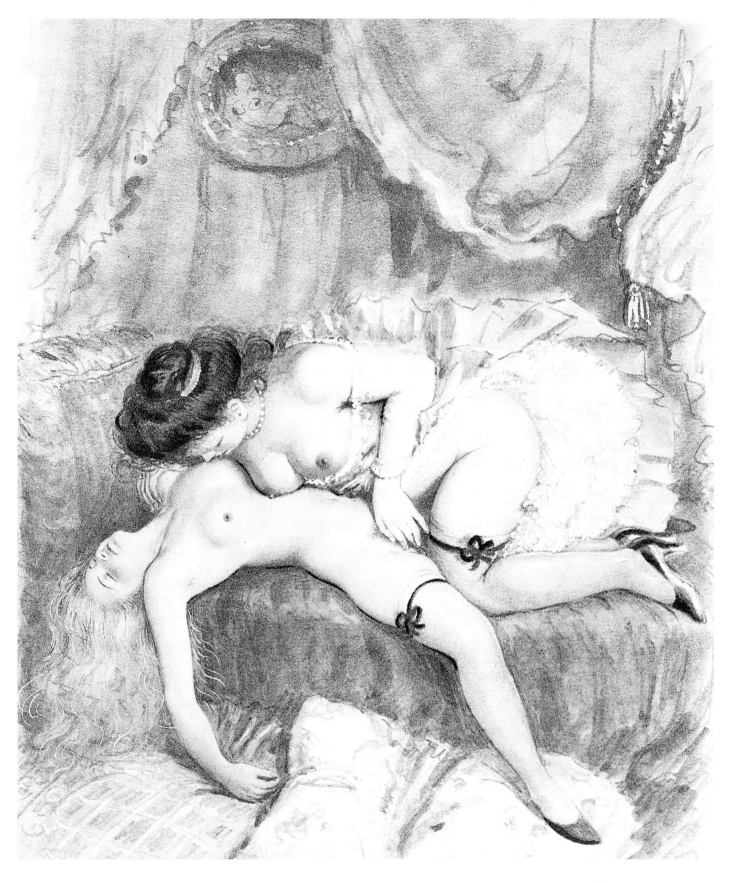

The evening came, I was there before the time, and thought that they were never coming. – At length I saw them enter. – I had been in a fever lest it should not come off. – The whole evening's spectacle is photographed on my brain. – I recollect almost every word that was said. – What I did not hear, Sarah told me afterwards, tho that was but little.

'Take off your things,' said he. – Sarah undressed to her chemise. – His back was towards me, his hand was evidently on his prick. – 'Ain't you going to take *your* clothes off, you had better – you can do it nicer.' – He evidently had not intended that, but yielded to her suggestion. – When in his shirt he went up to her, she gradually turned round so that her back and his face were towards me, and her movement was so natural that no one could have guessed her object, altho I did. – Moving then slightly on one side, she put her hands on his shirt, lifted the tail, and out stood the largest prick I ever saw. 'Oh what a giant you've got,' said she. – He laughed loudly. – 'Is it not, did you ever see a bigger?' 'No, but your balls are not so big.' 'No, but they are *big*.' 'No,' she said. 'You can't see them,' – and he put one leg on a chair, – Sarah stooped and looked under them. – Whilst doing so, he tried to give her a whack on her head with his prick – and laughed loudly at his own fun. – 'Why,' said Sarah, 'if your balls were equal in size to your prick, you wouldn't be able to get them into your trousers.' – He laughed loudly, saying, 'They're big enough – there is plenty of spunk in them.'

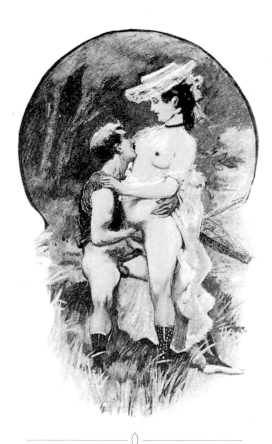

Sarah went on admiring it, smoothing it with her hand, pulling up and down the foreskin and keeping it just so that I had a full view. 'You are hairy,' said she, rubbing his thigh. – Then I noticed he was hairy on his legs, which was very ugly. – 'Yes, do you like hairy-skinned men?' 'I hate a man smooth like a woman – take off your shirt and let me see.' 'It's cold.' 'Come close to the fire then.' – She talked quite loudly purposely, tho it was scarcely needed. His voice was a clear and powerful one. – Without seeming anxious about it, but flattering him, she managed to get his shirt off and he stood naked. – He was a tall man, very well-built, and hairy generally. Masses hung from his breasts, it darkened his arms. It peeped out like beards from his armpits, it spread from his balls half way up his belly, he had a dark beard, and thick black hair. – In brief he was a big, powerful, hairy, ugly fellow, but evidently very proud of his prick, and all belonging to him. Her flattering remarks evidently pleased him highly, and he turned round as she wished him, to let her see him well all over. – His prick which had been stiff had fallen down, for instead of thinking of the woman, he was now thinking of himself; but it was when hanging, I should say, six inches long, and thick in proportion. 'Dam it, it's cold, we are not so accustomed to strip like you women.' – Then he put his shirt on and began business.

He made her strip and told her to go to the bedside. She went to the end and leaned over it with backside towards him. – He tucked his shirt well up, came behind her, and with his prick which had now stiffened and seemed nine inches long (I really think longer), hit her over her buttocks as if with a stick. It made a spanking noise as it came against her flesh. Then he shoved it

between her thighs, brought it out again, and went on thwacking her buttocks with it. – 'Don't it hurt you?' she asked him turning her head round towards the peep hole. – 'Look here,' said he. Going to a round small mahogany table and taking the cloth off it – he thwacked, and banged his prick on it, and a sound came as if the table had been hit with a stick. – 'It does not hurt me,' he said. – I never was so astonished in my life.

'I mean to fuck you,' said he. 'That you shan't, you will hurt any woman.' – Again he roared with laughter. – 'Suck it.' 'I shan't.' – Again he laughed. – Then he made her lean on a chair, and again banged his prick against her arse. – Then he sat down, and pulled her on to him, so that his prick came up between her thighs just in front of her quim. – 'I wish there was a big looking-glass,' said he. 'Why did you come here, there was one at the other house.' – Sarah said this was nicer and cleaner, and he had said he wanted a quiet house. – 'Ah, but I shan't come here again, I don't like the house.'

'Get on to the chairs – the same as before.' But the chairs in the room were very slight, and Sarah was frightened of them slipping away from under her. – So she placed one chair against the end of the bed, and steadied it; and against another which she put a slight distance off, she pushed the large table. Then mounting on the chairs, she squatted with one foot on each as if pissing. I could not very well see her cunt for her backside was towards me, and shadowed it.

He laid down with his head between the chairs, and just under her cunt. He had taken the bolster and pillows from the bed for his head, and there he laid looking up at her gaping slit, gently frigging his prick all the time. At length he raised himself on one hand, and licked away at her cunt for several minutes, his big prick throbbing, and knocking up against his belly whilst he did it.

Said he again, 'I wish there was a glass,' Sarah got down, and put on the floor the small glass of the dressing table, and arranged it so that he could see a little of himself as he lay. – But he was not satisfied. – He recommended cunt-licking, and self-frigging, and all was quiet for a minute. – Then he actually roared out, – 'Oh – my spunk coming, my spunk, – my spunk, – spunk – oho. – Come down – come over me.' – Off got Sarah, pushed away the chairs, stood over him with legs distended, her arse towards me so that I lost sight of his face, but could see his legs, belly, and cock as he lay on the floor. – 'Stoop, – lower, – lower' – She half squatted, he frigged away, her cunt was now within about six inches of his prick, when frigging hard and shouting out quite loudly – 'Hou – Hou – Hou,' his sperm shot out right on to her cunt or thereabouts, and he went on frigging till his prick lessening, he let it go, and flop over his balls.

Sarah washed her cunt and thighs, and turning round before doing so, stood facing me and pointed to her cunt. His spunk lay thick on the black hair tho I could barely see it. – She smiled and turned away. He lay still on the floor with eyes closed for full five minutes, as if asleep. Sarah washed, put on her chemise and sat down by the fire, her back towards me partly. . .

ABOVE The Sugar Plum Fairy displaying unexpected skills.

Rhodope, Melite and Rhodoklea
 contested
to see who possessed
 the best quim
I was the judge
 and like those three
 famous seraphs
they stood naked
 damp with wine
between Rhodope's thighs
 gleamed the one eye
like a rosepatch cut
 by a foaming stream
(and Melite's
 like watered silk
between frills folded
 an aching dark)
while Rhodoklea's
 was like clear glass
 its wet surface
like a newly minted
 temple carving
but I knew what Paris
 suffered for his choosing
so I at once did the honours
 to all three angels

RUFINUS (c. SECOND CENTURY AD)

That lady knew her game, and had thrown up her chemise so as to warm her thighs – and after he had paid her, he put his hand on to them. – She at the same time put her hand on to his tool. 'Oh what a big one.' – nothing evidently pleased him so much as talking about the size. – 'Did you ever see so big an one,' said he for the sixth time I think. 'Never – let's look at it well. – Hold up your shirt.' – He did as told. – Sarah pulled his prick up, then let it fall, handled his balls, pulled the foreskin up and down, and shewed him off again for my advantage. – 'Why don't you sit down, are you in a hurry?' Down he sat, his tool was becoming thicker and longer under her clever handling, and hung down over the edge of the chair. He was sitting directly under the gas light, and I could see plainly, for Sarah cunningly had even stirred the fire into a blaze. He was curious about other men's cocks – what their length and thickness was. – She shewed him by measuring on his own, and kept pulling it about, her object being to get it stiff again for me to see his performances. – My delight was extreme – I could scarcely believe that I was actually seeing what I did, and began to wish to feel his prick myself. How large it must feel in the hand I thought, how small mine is compared with it, and I felt my own. – As Sarah pulled down his prepuce, I involuntarily did so to mine, and began to wish she were feeling mine instead of the man's.

Then only I noticed how white his prick was. His flesh was brownish – and being so sprinkled with hair it made it look dark generally. – His prick looked quite white by contrast. Sarah must have been inspired that night, for no woman could have better used her opportunity for giving me pleasure and instruction. Repeating her wonder at the size, she said, 'Let's see how it looks when you kneel.' – He actually knelt as she desired. I saw his prick hanging down between his legs. Soon after in another attitude, I noticed that hair crept up between his bum cheeks, and came almost into tufts on to the cheeks themselves. – I saw that his prick was now swelling. – Sarah taking hold of it, 'Why it's stiff again.' He grasped it in the way I had first seen him, and said eagerly. – 'Let's see your cunt again.'

Sarah half slewed her chair round towards him, opened both legs wide, and put up one of her feet against the mantelpiece, as I have often seen her do when with me. He knelt down and I lost sight of his head between her legs – but saw his hand gently frigging himself as before, and heard soon a splashy, sloppy, slobbery sort of suck, as his tongue rubbed on her cunt now wetted by his saliva. Then he got up and pushed his prick against her face. – 'Suck, and I will give you another sovereign.' 'It will choke me – I won't,' said Sarah.

Then he began to rub her legs and said he liked silk stockings, that few wore silk excepting French women whom he did not like, – but 'they all suck my prick.' – Again Sarah put up her leg – again he licked her cunt, and then said she must frig him, which she agreed to on his paying another sovereign. . . .

I had passed an intensely exciting couple of hours by myself, watching this man with his huge fucking machine. Sarah in her attitudes, altho I had seen them fifty times, looked more inviting

than ever. My prick had been standing on and off for an hour. – I would have fucked anything in the shape of cunt if it had been in hand, and nearly groaned for want of one. As I saw her legs open to receive his squirt, heard his shout of pleasure, and saw his violent, frig, frig, frig, I could restrain myself no longer, but giving my cock a few rubs, spent against the partition, keeping my eye at the peephole all the while.

He wiped his cock on her cunt hair, washed, and went away seemingly in a hurry. – Sarah came in to me. – 'Don't you want me,' said she. – I pointed to my spunk on the partition. 'You naughty boy, I want it awfully.' – Soon after I was fucking her. – With all her care to save her silk stockings, sperm had hit her calf, and while I fucked her at the bed side, I made her hold up her leg that I might look at it. – It excited me awfully. What a strange thing lust is.

———————— ◊ ————————

In the theatre of erotica we, the readers, have the title 'principal voyeur'. We are, after all, spying upon the real or imagined sexual encounters of others for our own enjoyment. In presenting us with these scenes writers of erotica often introduce secondary voyeurism, as we have seen. The anonymous author of the next excerpt invents the clever idea of making the secondary voyeur, and narrator, a flea. Who better to hop promiscuously from

———— ◊ ————

BELOW *Soixante-neuf*: a sensitive contemporary drawing with flesh and linen made luminous in the colouring.

———— ◊ ————

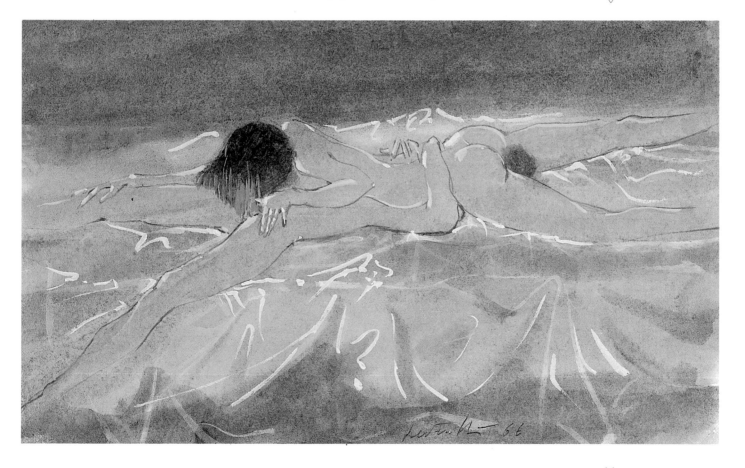

one sexual skirmish to another, taking plot, narrative (and reader) with him? *Souvenirs d'une Puce* ('Memoirs of a Flea') is a brilliantly salacious literary device. We have of course jumped species rather dramatically. But what intimacies and secrets the reader can enjoy vicariously from a flea's-eye view in exchange for the willing suspension of disbelief!

I will not say I followed, but I 'went with her,' and beheld the gentle girl raise one dainty leg across the other and remove the tiniest of tight and elegant kid-boots.

I jumped upon the carpet and proceeded with my examinations. The left boot followed, and without removing her plump calf from off the other, Bella sat looking at the folded piece of paper which I had seen the young fellow deposit secretly in her hand.

Closely watching everything, I noted the swelling thighs, which spread upwards above her tightly fitting garters, until they were lost in the darkness, as they closed together at a point where her beautiful belly met them in her stooping position; and almost obliterated a thin and peach-like slit, which just shewed its rounded lips between them in the shade.

Presently Bella dropped her note, and being open, I took the liberty to read it.

'I will be in the old spot at eight o'clock to night,' were the only words which the paper contained, but they appeared to have a special interest for Bella, who remained cogitating for some time in the same thoughtful mood.

My curiosity had been aroused, and my desire to know more of the interesting young being with whom chance had so promiscuously brought me in pleasing contact, prompted me to remain quietly ensconced in a snug though somewhat moist hiding place, and it was not until near upon the hour named that I once more emerged in order to watch the progress of events. . . .

It has been said, 'e n'est que le premier coup qui coute' ['it is only the first blow which costs'], but it may be fairly argued that it is at the same time perfectly possible that 'quelquefois il coute trop' ['sometimes it costs dear'], as the reader may be inclined to infer with me in the present case.

Neither of our lovers, however, had, strange to say, a thought on the subject, but fully occupied with the delicious sensations which had overpowered them, united to give effect to those ardent movements which both could feel would end in ecstasy.

As for Bella, with her whole body quivering with delicious impatience, and her full red lips

BELOW A couple enjoy *cuissade* lovemaking, drenched in reflected, nocturnal light: a contemporary colour study.
OPPOSITE The same artist, and the same couple, but this time cunnilingus.

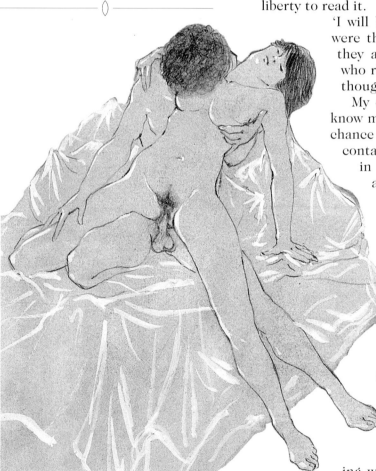

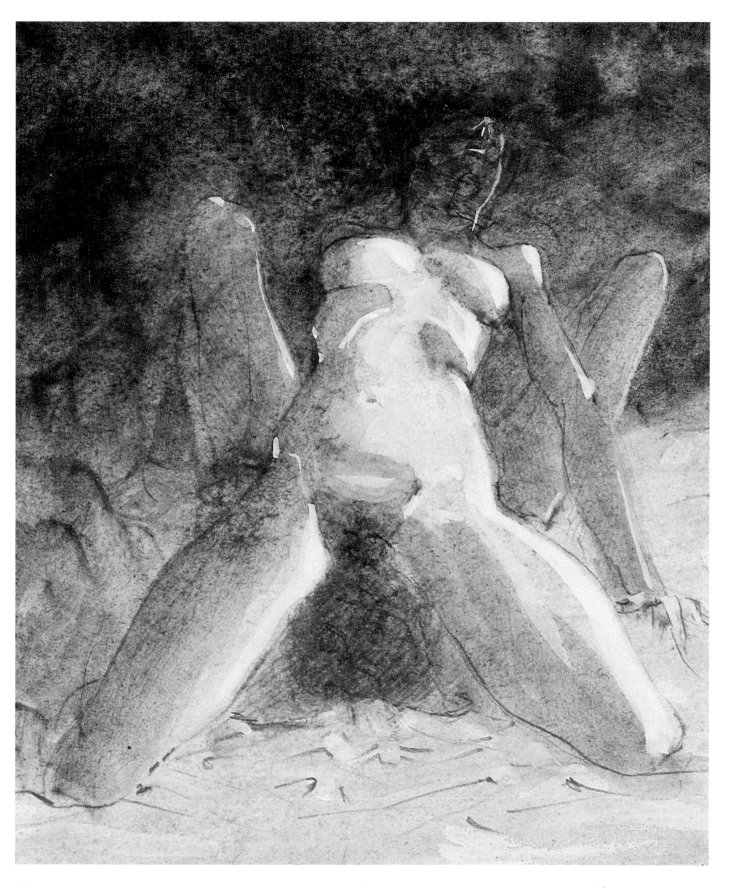

giving vent to the short excursive exclamations which announced the extreme gratification, she gave herself up body and soul to the delights of coition. Her muscular compressions upon the weapon which had now effectually gained her, the firm embrace in which she held the writhing lad, the delicate grip of the moistened, glove-like sheath, all tended to excite Charlie to madness. He felt himself in her body to the roots of his machine, until the two globes which tightened beneath the foaming champion of his manhood, pressed upon the firm cheeks of her white bottom. He could go no further and his sole employment was to enjoy – to reap to the full the delicious harvest of his exertions.

But Bella, insatiable in her passion, no sooner found the wished for junction completed, than relishing the keen pleasure which the stiff and warm member was giving her, became too excited to know or care further aught that was happening, and her frenzied excitement, quickly overtaken again by the maddening spasms of completed lust, pressed downwards upon the object of her pleasure, threw up her arms in passionate rapture, and then sinking back in the arms of her lover, with low groans of ecstatic agony and little cries of surprise and delight, gave down a copious emission, which finding a reluctant escape below, inundated Charlie's balls.

No sooner did the youth witness the delivering enjoyment he was the means of bestowing upon the beautiful Bella, and became sensible of the flood which she had poured down in such

BELOW The last in a series of brilliant drawings of lovemaking postures: here the couple and their bed glow like an island caught in a lighthouse beam.

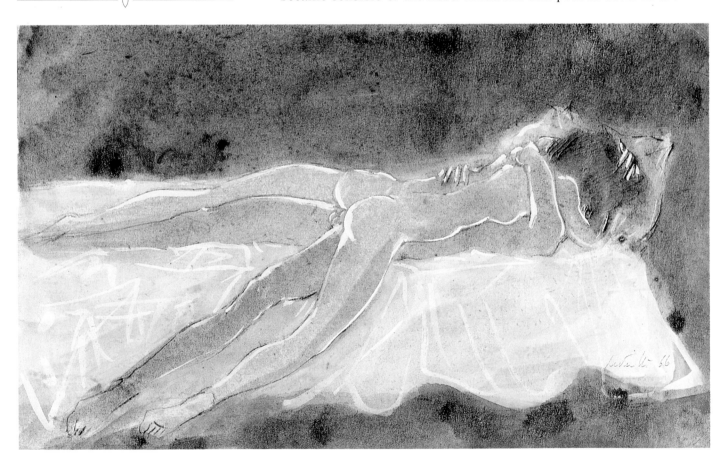

profusion upon his person, than he was also seized with lustful fury. A raging torrent of desire seemed to rush through his veins; his instrument was now plunged to the hilt in her delicious belly, then, drawing back, he extracted the smoking member almost to the head. He pressed and bore all before him. He felt a tickling, maddening feeling creeping upon him; he tightened his grasp upon his young mistress, and at the same instant that another cry of rapturous enjoyment issued from her heaving breast, he found himself gasping upon her bosom, and pouring into her grateful womb a rich tickling jet of youthful vigour.

A low moan of salacious gratification escaped the parted lips of Bella, as she felt the jerking gushes of seminal fluid which came from the excited member within her; at the same moment the lustful frenzy of emission forced from Charlie a sharp and thrilling cry as he lay with upturned eyes in the last act of the sensuous drama.

Writers exploring the possibilities of voyeurism without the assistance of educated fleas must rely upon traditional stage machinery. The lonely hero of *Passion's Apprentice* has a well-crafted peep-hole in his wardrobe.

Naturally he succumbs to temptation, but in this tale of the watchers and the watched retribution comes swiftly in the unlikely guise of his fellow tenant – the equally lonely and passionately homosexual Samuel Simpson.

The doors closed quietly behind him. In the darkness he moved his fingertips carefully over the back of the wardrobe until he found the curling edge of paper which concealed a knot hole in the wood. Lifting this revealed a spy hole into Nellie Porter's room through which countless tenants had enjoyed 'poses plastiques' which outdid any performance she had ever given on the stage. This unsuspected extension of her career – albeit to limited audiences – had been made possible by the carpenter who decided to make two back-to-back cupboards out of what had been a connecting passage between the two rooms. As Nellie kept her bath in the larger cupboard on her side, and generally left the doors open to have access to the other toiletries on the shelves, her audience was seldom disappointed.

The sense of shame experienced by even the most callous man who found his way to this illicit camera obscura, always fled at the first sight of the woman's naked body. Her beauty was extraordinary. It is doubtful if any man could have torn himself away from the sight, once he had yielded to the temptation to look – or seek to look – in the first place. Saints could have been tested in that wardrobe, had there been a need for such a service in Kennington.

Nellie Porter had high full breasts of a dazzling whiteness: her coral red nipples were so long they protruded between her fingers when she cupped her hands over herself and lifted the weight of her bosom. Her belly and buttocks shone with a golden hue.

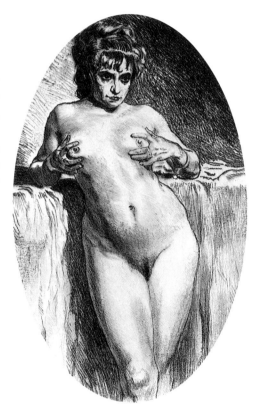

ABOVE An etching by Leon Richet made to illustrate Jules Barbey d'Aurévilly's collection of Decadent tales, *Les Diaboliques*.

The preliminary to her bath was always to run her hands all over her body: often this stroking and caressing took a long time. She liked the scent of herself, and often brought her searching fingertips up to her nostrils. Her sex was deep set, invisible under the froth of black hair at the front but crimson and pouting when she bent forward over the bath.

Tonight she sat dreamily in the chair watching the steam rise from the bath. Raising one leg over the arm, she reached down and parted the lips of her sex, beginning a slow, insistent rhythm with her middle finger.

'Yes she would do it tonight, even though he was coming soon. There was time.' She thought of the first time with him, and of the things they had done, and the movement of her hand quickened. She delved deep into herself and then brought her fingertips up to the very front rubbing with a fury. 'Yes! Yes there it was!'

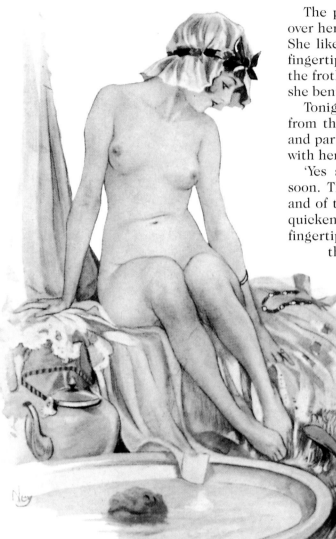

Her hair had come unpinned and had fallen down over her shoulders. Her eyes were closed as in sleep but the rhythm of her breathing had not yet slowed. Her chest, as it rose and fell, gleamed with perspiration.

Suddenly there was a light knock at the door. She started. Quickly taking up a towel she went to the door.

'Who is it?'

A deep voice said something and she opened the door.

The man laughed when he saw her and pulled her to him. His hand found her breast and then moved down. He laughed again. 'Well you are good and ready! It's just as well, I can't stay but a minute.'

She pulled herself away from him. 'Don't be a beast and wait 'til I've had my bath!'

'Oh no my lady, no time for that.'

In a moment her eager suitor had pushed Nellie forward over the chair and had released from his breeches a fiercely erect member which would have done credit to a dray horse. Looking back from her bending position she hardly had time to wonder at this familiar battering ram before its shining head had disappeared between the full globes of her bottom.

She gasped involuntarily as the monster found the moist notch and pushed on without mercy until it was buried in her up to the hilt. For a moment all was still. Then began the slow, remorseless, steam engine rhythm.

His voice was thick with lust. 'You are wet tonight.' At each inward thrust her sex made a low sound as she received him, followed by another much louder noise as her lips sucked at the withdrawing shaft. As the pace became more urgent and the thrusts shorter, the sounds of moist suction were replaced by the slapping of his belly against her buttocks.

She began to moan and then made a guttural sound deep in her throat as her pleasure came. Suddenly Nellie shouted 'Oah,

ABOVE A detail of an early twentieth-century coloured postcard.
OPPOSITE Adolfo Magrini made this illustration for his book *Erotici* in 1921.

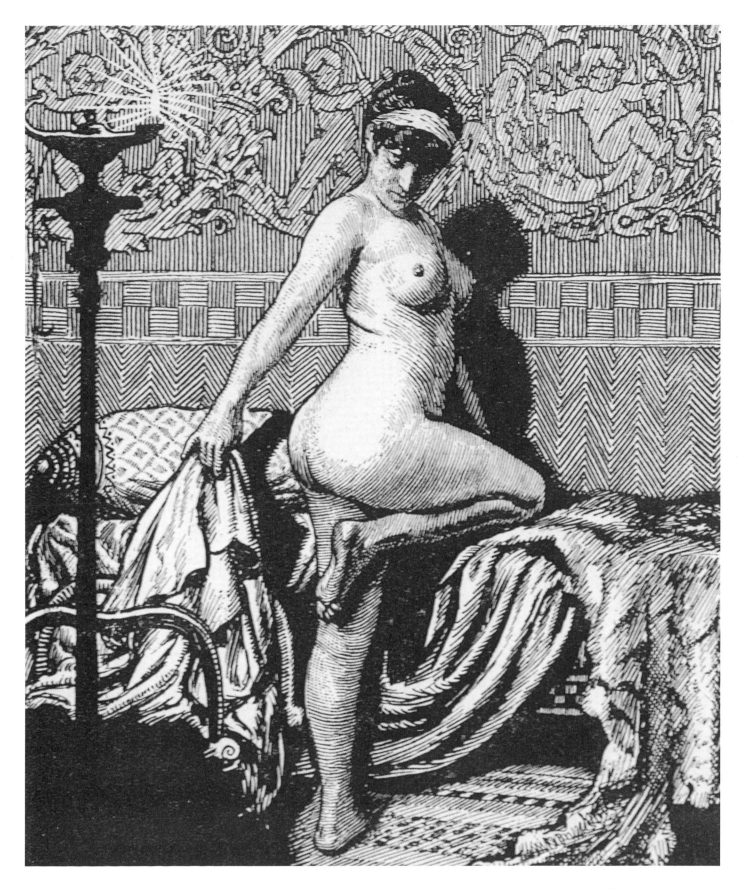

I'm going!' This finished him. Pulling out of her he worked his great shining weapon up and down in the crease of her bottom, crushing her buttocks against it while jet after jet of white spouted over her back from its straining head.

Stumbling from his wardrobe in the other room the reprehensible witness of these proceedings stood for a moment like a man recently disembarked after a stormy channel crossing. We would be correct in surmising that his conscience was in turmoil. It is not a proper thing to spy upon others (although both victims in this case had, as a matter of fact, based their professional careers upon satisfying that very appetite). The young man's senses were also inflamed to a state of lustful delirium which those who have never witnessed such sights may find it difficult to imagine. The priapic testimony of his excited condition was all too evident, having struggled to find its own way into the light from among the folds of his dressing gown. . . . Moralists may take satisfaction from the fact that William Ashton's own nudity and private actions were at this very moment spied upon by Samuel Simpson. The latter had for some months gradually eased the jamb of the permanently closed door which separated his own eau de cologne-scented chamber from that of his neighbour. Tonight his labours were rewarded. His eyes, applied to the chink he had worked so furtively to open, feasted upon the Ganymede of his imagination at last made flesh.

Unfortunately for our latter-day Pyramus and Thisbe, the flimsy door which Samuel Simpson had himself weakened could not bear the enormous weight of his lustful body pressed so eagerly against it. With an explosion like an artillery piece he was suddenly propelled into the adjoining room: a nude, pink cannon ball. Ashton, taking this terrifying and unexpected appearance as a ferocious assault upon his person, uttered a cry so bloodcurdling that everyone in the house – except the lady in the second floor back who was stone deaf – was soon at his door.

Some of his fellow tenants no doubt believed his explanation of 'nightmare'. Perhaps they were also touched that Mr. Simpson had rushed to comfort the young man with such unexpected agility. Others muttered darker explanations, but none guessed the exact nature of the nightmare.

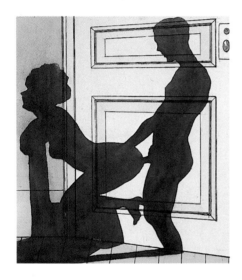

Nellie Porter's 'poses plastiques' are a recurring motif in erotic art and literature. Male interest in female masturbation has no real counterpart in women. The ragtime song of the Twenties is right – everybody's doin' it. Or, more precisely, eighty-five per cent of females and ninety-five per cent of males are doin' it, doin' it. But it seems that males also have a tendency to include masturbation among their spectator sports. 'Pauline Réage' explores the topic in *Story of O*.

Then Sir Stephen approached and, taking her by the shoulders, made her lie down upon the carpet: she found herself on her back, her legs drawn up, her knees flexed. Sir Stephen had seated

Her father gave her dildos six,
Her mother made 'em up a score;
But she loves nought but living pricks,
And swears by God she'll frig no more.

JOHN WILMOT, EARL OF ROCHESTER
(1647–80)

himself on the same spot where, a moment ago, she had been leaning upon the couch; he caught her right knee and dragged her to him. As she was squarely opposite the fireplace, the nearby fire shed an intense light upon the two well-opened cracks of her womb and her behind. Without letting go of her, Sir Stephen curtly bade her caress herself, but not to close her legs back together. Numb, she obediently stretched her right hand down towards her sex and her fingers encountered, between the already parted fleece, the already burning morsel of flesh placed above where the fragile lips of her sex joined together. She touched that morsel of flesh, then her hand fell away, she stammered: 'I can't.' And she actually could not. She had never caressed herself except furtively, in the warmth and covering obscurity of her bed, when she had been alone; and never had she pursued her pleasure through to a crisis. She'd stopped, gone to sleep, sometimes found the crisis in an ensuing dream, and had

BELOW 'Nudo Seduto Addormentato' by the contemporary photographer Giovanni Zuin.

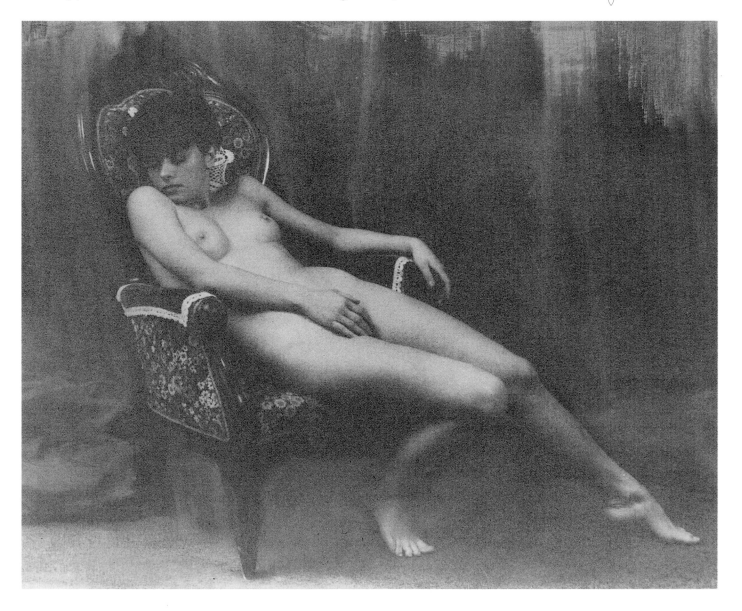

waked, disappointed that it had been simultaneously so strong and so transitory. Sir Stephen's stare was obstinate, compelling. She couldn't withstand it and, repeating her 'I can't,' shut her eyes. For she saw it again, and couldn't get it out of her head, and every time she saw it she had the same nauseous sensation she'd had when she'd actually witnessed it when she was fifteen years old: Marion slumped in a leather armchair in a hotel room, Marion, one leg flung over an arm of the chair and her head sagging down towards the other arm: caressing herself, and moaning, in front of O. Marion had told her that she'd once caressed herself that way in the office where she worked and at a time when she thought there was no one else there; and the boss had suddenly walked in and caught her smack redhanded in the middle of the act. O had a recollection of Marion's office: a room, a bare room, pale green walls, light coming in from the North through dusty windows. One chair in the room, it was intended for visitors and was opposite the table. 'Did you run away?' O had asked. 'No,' Marion had replied, 'he asked me to go ahead and start again, but he'd locked the door and had made me take off my panties and he'd moved the chair over by the window.' O had been overwhelmed with admiration for what she'd considered Marion's courage, and with horror, and had shyly but stubbornly refused to caress herself in front of Marion, and had sworn that she'd never caress herself in front of anyone else. Marion had laughed and said: 'You'll see when your lover asks you to.'

BELOW 'Donna Addormentata' by Giovanni Zuin.

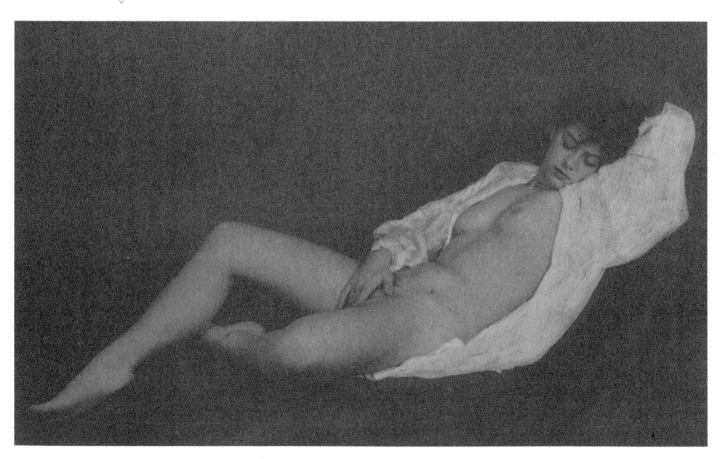

The candid heroine of *Memoirs of a Venetian Courtesan* gives a consumer's report on that aid to female masturbation and object of male fantasy, the dildo. In this extract the only voyeurism is ours.

Her description of buying it from the shop where all Murano glass products are sold had us both curled-up with mirth. The shopkeeper asked her what size she required and she was so startled by the question that she blurted out 'the largest you have.'

He then re-appeared from the storeroom with a corked receptacle of such proportions that Alina could not believe her eyes. She said it was more like something designed to warm the feet, and fashioned in the shape of a penis for whimsical reasons, than a dildo. She then told the shopkeeper that she had not asked for the tower of San Giorgio and would he bring one of the small to middle size.

It is lying on the table beside me and even this size looks daunting. It is beautifully fashioned in strong smooth glass with a life-like helmet and a small testicle-like protruberance to hold it by where the cork is inserted.

Most women piss into them. But Alina has brought me hot water instead. We laughed again when she told me she had added the provision of hot water for my dildo to the list of daily tasks she personally undertakes. Dear Alina.

Faustolla has a whole collection of these things, made in wood, leather and ivory as well as glass. But she still prefers her hand when a cock is not available – which is not often.

Well, I have twice masturbated with my glass dildo. The first time I enjoyed the novelty and the feel of something hard in my sex again. I even gave a little cry when my crisis came, the pleasure was so intense.

Later, I wanted it again. This time I pissed into it: difficult to achieve without accident even if the sex is held open.

Dildos are not for me. There is something I do not care for in the use of one. Not only are the preparations absurd, there is a sadness in it which is not there when you use your hand.

The eponymous hero of *Gus Tolman* – a rattling yarn written in America early this century – makes his own observations on, and of, female auto-erotism.

I entered my room and for the first time noticed the very thin partition between it and Miss Taylor's room. I later heard strange sounds like moans from a woman in distress. Then I distinctly heard a one-sided conversation; she was apparently talking to herself and this is what I heard: 'Oh – Oh – if I could only have a lover like that man,' she said trembling. 'He – he – is so big and handsome.'

ABOVE Dildo in a basket: the ultimate take-away. Early twentieth-century etching.

ABOVE This extraordinary erotic artefact was made for the wife of a wealthy merchant. Venetian, eighteenth-century.

RIGHT An amusing artistic
conundrum: has she been
discovered, or spied upon
masturbating among the scatter
cushions? Is the figure of a
powerful Renaissance man the
focus of her excitement?

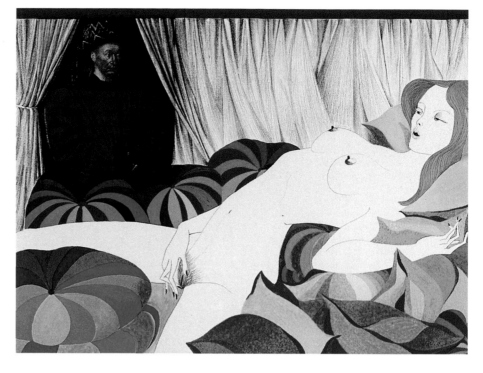

The device of the two copper plums
With silver in them
Slowly and very slowly
Satisfies.
Just as all finishes
Dew falls on my clenched hand.

I would rather the bean flowered
* yellow*
And he were here!

GEISHA SONG
ANONYMOUS EIGHTEENTH-CENTURY

I could hear her voice shake, as if she was under some great strain or emotion. I remember the sensual expression on her face as the dreamy, pathetic eyes swept over me. Surely, I thought, the poor girl is in heat and apparently craves relief. While I was preparing for bed, and removing my shoes, my eye caught sight of a register in the partition, evidently used in the winter to allow a circulation of warm air. Upon examining it, I found that it opened very easily and through the grill frame I had a wide view of Miss Taylor's room. In my range of vision I saw the bed and an upholstered chair of generous capacity. Opposite this was a bureau with a large tilting mirror.

Miss Taylor was standing before the mirror, slowly removing the belt from her waist and gazing intently with that same languorous look at some pictures on the wall on either side of the mirror. Peering intently, I discovered that they were pictures of men, three of a stalwart pugilist in different poses stripped, but with a sash to hide his bulging genitals. Other pictures were of actors, presumably matinee idols, but the girl's eyes lingered on the muscular figure of the pugilist.

I saw her full red lips move as if she were talking to the fighter. Lifting up a pair of pretty white bubbies out of her corset, she bounced them up and down, then spoke in a low hysterical voice: 'Oh, Jack, see my titties – come – to – me – and – fondle them.'

I was no longer puzzled. The girl was hot and she was calling to Jack, the pugilist, as an imaginary lover. Her thoughts were lustily centred on the fleshy pleasures such a body would impart if she could but hold it in her arms and feel the strong sexual embrace and enjoyment that might result. In her impulsive emotions the girl tore off her corsets and then slipped out of her dress and drawers. She stood there revealed in nothing but her

stockings and under-vest, which she quickly removed. When I saw what a finely built young girl she was, that settled it. She had to be gratified. I lay on my back so I could better contemplate with ease what might transpire in the girl's room.

She was about twenty and I could plainly see her white nude body, rich in lovely contours and graceful curves, together with a very disturbing view of her dark thickly haired pussy and her white cherry-tipped bubbies. They made me rampant, and my tool was standing straight up. I doubtless would have made a rush through the door to the girl if my curiosity had not gotten the better of me. I gasped when I saw her press her hand to her pussy and insert a finger and again gaze at the picture of the pugilist as she vigorously rubbed and worked her finger in and out.

Her feelings were getting the better of her and as she worked herself up to a pitch of passionate frenzy, a wave of erotic emotion spread a lovely glow over her shapely charms. As if suddenly thinking of something, she unlocked the bureau drawers and extracted a book and a small packet from which she selected several pictures, evidently an obscene book, as I later discovered.

Reclining on the edge of the bed, with one leg hanging over the side, she switched on a reading lamp over her head, which gave me a brilliantly lighted view of the girl's tempting and sensual body in a voluptuous pose. The line of my vision took in every detail of a plump and well defined cunnie between a pair of lovely white thighs. The contrast of the dark thick curls made her belly and thighs appear like alabaster.

Adjusting her pillow, the girl began reading, holding two of the pictures on the edge of the book, leaving her right hand free. Occasionally she would gloat on her own charms reflected in the tilting mirror. At the same time she would pinch and titillate the stiff red nipples of her firm round bubbies.

The swelling, curly mound and pretty round belly began to rise and fall with convulsions and erotic longings as she gloated over the book and pictures. Inflamed to a frenzy the girl's hand slipped down and covered the restless pussy. Then with her middle finger she sought to appease her passions with a rapid nervous thrust and pressure on the burning clitty. Suddenly, apparently coming to a passage in

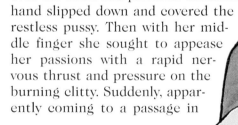

BELOW The convention of introducing animals as mute observers – particularly when auto-eroticism is the subject – increases the erotic charge in some mysterious way. For the same reason the Old Masters usually press-ganged petulant cherubs into watching the lovemaking of the gods in mythological paintings.

her book which inflamed the poor girl, she gasped aloud. I heard a smothered cry – 'Oh, how lovely – how I'd – like – to – be – in her place.' Then holding the pictures close she gazed with languorous eyes and clasped the whole of the plump curly cunnie in her hand with two fingers in it, squeezing it hard.

The heavy breathing and groans told me of her approaching crisis. Dropping the pictures, her head went back to the pillows. Her limbs twitched and quivered. The pretty bubbies trembled. Then with a convulsive heave and choking expressions of pleasure, as '– Oh – Oh – how – good,' spasm after spasm of voluptuous ecstasy swept over her in a thrilling orgasm.

She trembled and shivered terrifically, holding her hand very tightly over her cunnie for a short while, and then seemed to die away in a languorous doze for a few minutes. When she finally picked up her book and continued to read she was so worked up that she was as frantic for relief as before. All the time she had held her hand on her moist cunnie, though without moving it at all. Occasionally she would pick up the pictures again and look at them and then go back to her book. This she kept up for some little time, for the book was apparently very interesting.

Finally, however, she threw down the book and began irritating herself in real earnest. Her magnificent bubbies she could just pull up so as to make her lips grasp the nipples and these she sucked hard, at the same time playing her fingers around her cunnie. Then she used one hand to inflame her clitoris and with the other hand she inserted a finger deep in her cunnie until, judging by her emotions, she was coming, she frantically drove three fingers deep into it and worked them in and out fast until she died away in a glorious spend.

Gus Tolman is an eroticized cross between *Elmer Gantry* and *Superman*, although the prose style owes more to the latter. Our hero not only 'rescues' Madge from solitary pleasures, he persuades her to share the newfound delights – which only he can provide – with her friend Tessie. Sexual superman he may be but, given the nature of his crusading, Gus obviously feels that a cape and underpants worn on the outside would put him at a sartorial disadvantage.

I wore a Palm Beach suit over a sheer silk shirt with no underwear. I had, without a doubt, an attractive figure and my close-fitting trousers displayed my muscular limbs and abnormal sexual development to good advantage.

Promptly at eight o'clock I heard Madge in her room, and then a cheery voice: 'Gee, Madge, I'm just wild to meet your friend. How do I look?' asked Tessie as she threw off her cape. 'Say, Tess,' said Madge, 'he will go wild and eat you alive when he sees your bare back, it's lovely.' She had left her entire back exposed to her waistline with but a narrow line over each shoulder, the front being so thin that even the stiff red nipple points of a pair of the prettiest bubbies stuck out alluringly. Tessie was taller than Madge, with remarkably pretty arms and legs – not large

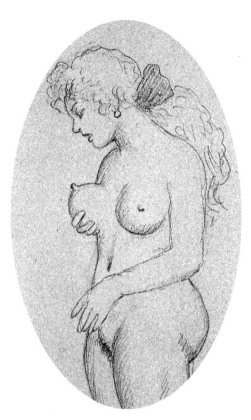

ABOVE Pencil sketch by an unknown artist: early twentieth-century.

but tempting in form and shape. She possessed a bottom that was ravishing in contour and agility. She wore nothing else but a lace petticoat and black silk stockings, gartered well above the knees.

When I answered the call to enter, the vision that met my gaze, startled me. 'Miss Tessie Bangs,' said Margery, introducing us, 'this is Mr Tolman.' I bowed low as I took Tessie's hand and kissed it. She shivered for she felt a thrill go through her. 'Surely,' I said, 'this is a refreshing pleasure.' Tess was speechless as her eyes swept over my figure and when she could speak, her voice was low and musical, 'I am equally delighted,' she said, 'I do hope your pleasure will be equal to mine.'

'Well,' I said, 'judging from appearance, when I see more of you, I know that my pleasure will know no bounds. You are the peachiest looking and most delectable looking chicken I've met in years.' She resented the term I gave her. Her big blue eyes flashed and with a vivacious but injured dignity she retorted: 'I beg your pardon Mister Tolman, I'm no chicken and you needn't think that because Margery Taylor fell for you and you happen to be a handsome brute, I shall fall, too.'

I saw that she meant every word and that I would be obliged to trim her claws as I had often done with others. I replied, looking steadily and smilingly into her flashing eyes, 'You are a chicken and a deucedly tempting bird to broil, and with proper seasoning you will make fine eating.' Tessie gasped, for she knew well what I meant.

'I never met up with such nerve before,' she said. Her practised eye caught sight of the bulging outlines of my abnormal sexual charm, already showing signs of vigour and life. She jumped back with a twist of her pretty shoulders and shaking her pendulous bubbies. 'My God, man, but you are immense,' she said, still gloating on my tool and balls, which showed plainly through my light trousers.

'Pshaw, Tess,' spoke up Margery, 'you ought to see it out and stiff. Take it out, Gus.' It was my plan to work Tess up until she was at the point of begging for it, but as she seemed curious and willing, I unbuttoned my trousers, but first I stepped up to her and without warning clasped her lithe and willowy form in my arms and pressed her mound to my rapidly stiffening tool by placing a convulsive hand on her plump bottom.

She tried to wriggle loose, but the more she wriggled the stiffer my penis became till it throbbed against her pussy. The sensation was so exciting to her that she just hung limp in my arms and shivered. I kissed her and then when my mouth closed over her ruby lips, I thrust my tongue into her mouth and squeezed her soft bottom with both my eager hands.

She returned my kisses almost unconsciously as she gazed at me with limpid, languorous eyes. Once or twice she half clung to me and when I began to run my tongue between her lips, it was too much for her. She just hung onto me enough to keep from falling.

All of a sudden, tearing her mouth loose, she cried out in a frantic appeal:

When Mexico Pete and Deadeye Dick
 Set out in search of fun,
It's Deadeye Dick who wields the prick
 And Mexico Pete the gun.

When Deadeye Dick and the greaser runt
 Were sore distressed and sad
'Twas mostly cunt that bore the brunt
 Though shootings weren't so bad.

When Deadeye Dick and Mexico Pete
 Went down to Deadman's Creek,
They'd had no luck, in the way of a fuck,
 For well nigh over a week,

Bar a moose or two or a caribou
 And a bison cow or so,
But Deadeye Dick was the king of pricks
 And he found such fucking slow.

So Deadeye Dick and Mexico Pete
 Set out for the Rio Grande;
Deadeye Dick with swinging prick,
 And Pete with gun in hand.

FROM *ESKIMO NELL*
ANONYMOUS

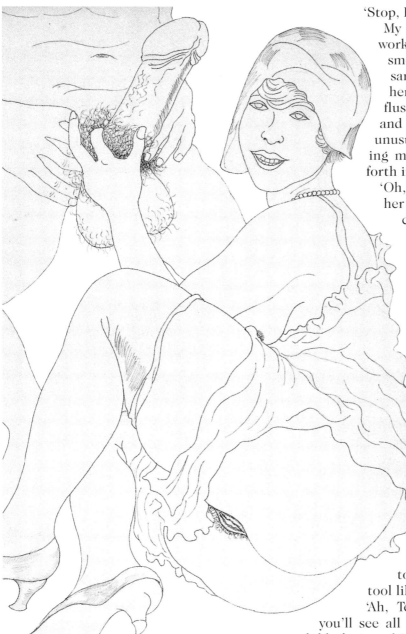

ABOVE The cloche hat, silk stockings and shoes identify the lady in this anonymous drawing as a fashionable flapper of the 1920s. Her companion's dress sense must remain a mystery, although he has other accessories which defy the vicissitudes of fashion.

'Stop, I don't mean to let you get fresh with me!'

My hands and touchings were doing their work, however. I slipped one hand all over her smooth bare back, tickling her spine at the same time and running my tongue around her neck under her chin and ears. Her eyes flushed, her bottom wriggled – she laughed and then began to scratch. I realized I had an unusually spiteful chicken to deal with. Shaking my trousers loose, my rampant penis came forth in all its passionate splendour.

'Oh, look Tessie,' said Margery, laughing. In her excitement and struggle one of her hands came in contact with it. Like oil on troubled waters, her flush of injured dignity subsided and she melted in my arms like jelly in a mould, and hung limp from surprise and suddenly aroused emotions. At first she couldn't speak, she seemed so dazed. Then with sudden curiosity, her hand went to the prodigious, throbbing weapon, her long tapering fingers closing about it. Gasping she drew back to look: 'Good God,' she exclaimed, 'what is it, a bone or a club?'

'The stick that you are going to be broiled on, my dear,' I said.

'Never, never!' cried the astonished girl, looking at it and squeezing the long hard shaft. 'Why that thing would kill me.'

'Aw, go on,' laughed Margery.

'I'll be,' said Tess to her, 'you never had that brute of a thing in you. You told a fib. I never heard of a man having a tool like that.'

'Ah, Tess, just you wait until it's in you, and you'll see all the stars in creation and go off like you never did before, and I'll bet that you'll never want anything else. Why Tess, it beats a finger or a candle a thousand ways. To be broiled on that darling cock is a treat you'll never forget.'

Then turning to me, Margery kissed me and said: 'Strip, Gus, and let Tessie see.' 'I will if she'll do the same,' I replied. Margery led the way and began to undress. She hadn't much on to be taken off. Tessie was now gay and festive, lively as could be. She and Margery were soon stripped to their stockings and I gazed with lustful enthusiasm on two of the most charming and fuckable damsels I ever laid my eyes on. Tessie was perfect in symmetry and shapeliness. Tall and graceful, she was exquisitely rounded with a pair of luscious, slightly drooping bubbies, not as large as Margery's but just as lovely to play with and mould in the hands. She had a prominent, protruding mound covered with a

profusion of thick blonde curly hair like silk, through which the pretty deep slit of a plump pussy could be seen.

I was now more than rampant to get at it. I stripped naked, to my socks. When Tessie's eyes swept over me, she gasped with carnal admiration, her eyes almost popping out of her head as she gloated on my penis, which she expected to be broiled upon.

'My God, Madge,' she exclaimed, 'I don't wonder that you fell for him, he is magnificent, but I'll have to see you take that tool before I'll believe you had it in your little cunnie,' she said, as she again felt of it with trembling hands, trying to pull it away from my belly, where it stood stiff as a bar of iron. It slipped from her hand and sprung back with a thud. Tessie giggled and continued to enjoy the unusual vigorous elasticity of the perky, obstreperous penis.

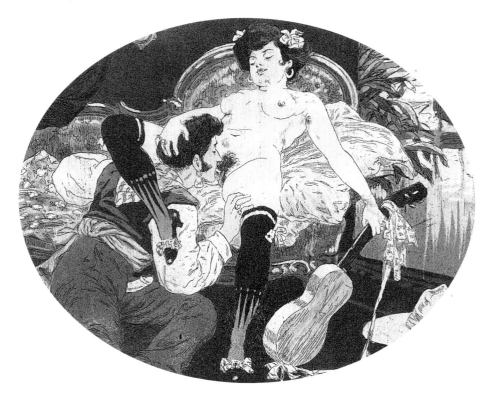

LEFT *Capriccio Espagnol*: a fine-quality lithographic book illustration.

'Let's get busy,' I said. 'I'm getting too hot for comfort and I'm anxious for a drink. We'll have a round, go out for a highball, and then go to a room I've engaged for the night. You two lovely chickens have to broil on both sides thoroughly, so let's get busy while the bone is in good form.'

'I want to see Madge take it first,' said Tessie with a mischievous and lustful thrust of her naughty handsome bottom. I arranged the table with cushions and directed Margery to lie on it as on the first night when she was initiated.

Margery looked most tempting and desirable as she lay with her legs wide open and her peachy, salacious pussy ready for the stick. Two firm milky bubbies, with their stiff red nipples pointing straight up and out, invited kisses.

Then entered in that hall of sin,
 Into that house of hell,
A lusty maid, no whit afraid,
 Her name – was Eskimo Nell.

Now Deadeye Dick had got his prick
 Well into number two
When Eskimo Nell let out a yell
 And called to him 'Hi You!'

He gave a flick of his muscular prick
 And the whore flew over his head,
He turned about with a snarl and a
 shout
 And his face and his knob were red.

Eskimo Nell she stood it well
 As she looked between his eyes.
She glanced with scorn upon his horn
 Steaming between his thighs.

She stubbed out the butt of her
 cigarette
 On the end of his gleaming knob,
And so utterly beat was Mexico Pete
 That he quite forgot his job.

It was Eskimo Nell who was first to
 speak,
 In accents clear and cool,
'You cuntstruck shrimp of a Yankee
 pimp
 Do you call that thing a tool?

And if this here town can't take it
 down,'
 She sneered at the cowering
 whores,
'Here's a cunt that can do the stunt:
 Eskimo Nell, for yours!'

She removed her garments one by one
 With an air of conscious pride
Till there she stood in her womanhood
 And they saw the Great Divide.

FROM *ESKIMO NELL*
ANONYMOUS

'Now, Gus,' laughed Tessie, 'do exactly what you did to her the other night. I want to see how you got that awful thing into her tight little cunnie.'

I seated myself directly in front of the voluptuous little pussy with Margery resting her pretty fat legs on each shoulder. 'My God,' exclaimed Tessie, all curious and getting hotter every minute, 'I've had some fun in my life but I was never kissed there.'

I began my feast with hot kisses on the pretty rounded belly and on the soft white insides of her thighs to arouse keener sensations of desire. I then titillated her with lively tongue play on her perky, red clitoris.

Madge began to moan, but when the ardent sweep of my tongue along the pouting slit penetrated the puckering orifice, she trembled and cried out: 'Oh – Tess – ie – wait – till he does this to you – Oh, it's so good – Oh.' When I thrust my tongue into the salacious meaty depths of her pussy and tickled her womb, Margery suppressed a scream, shook all over and cried: 'Oh, Tessie – suck my titties, quick – I'm – I'm – com – com – ing.' Tessie quickly took a big red nipple in her mouth and tickled the other one with her fingernails. As nothing excites a woman to spend as quickly as that, Margery just moaned and heaved and clutched at her friend and cried out: 'Oh, Tess! There – there – Oh – how good – OO – oo – Oh!'

I received her sweet, creamy spend on my tongue and sucked it up as it flowed freely. She being thoroughly lubricated, I got to my feet, and taking the bursting red tool in my hand I worked the swollen inflamed head all about in the juicy slit, while Tessie stood by holding apart the fat lips and watching the all-absorbing and lascivious act of broiling Madge. Her eyes wide, almost popping out, her snowy bosom heaving with excitement and her pussy itching and twitching, Tessie saw me plunge my frenzied penis into Margery to the hilt. Madge stuffed her fist into her mouth to smother her cries and screams of lustful pleasure. I worked my tool back and forth with sensuous effect and Tessie, watching as it went in and out, almost screamed herself.

'Hurry, Madge, I'm just dying for a piece,' Tessie again tickled the quivering red nipples. Madge cried out: 'Oh, God! It's coming – what a lovely – fuck.' Her voice died away. I pulled out my inflamed tool reeking with her pearly spend and lifting Madge up I laid her on the bed, telling Tessie to get on the table. I had not spent for I wanted to save it for the excited Tessie.

The table was before the mirror and when Tessie discovered that she could watch herself being fucked, she laughed in glee. I stood for a moment to gloat on the exquisitely lovely charms of this delectable girl, fondling every part of her. Then taking my place again in the chair between the prettily shaped legs outstretched for the kisses, I gazed lustfully at one of the prettiest most alluring pussies I ever saw. Profusely covered with silky blonde hair, it stood out plump and impudent. Tessie had what might be termed a real hardon, for the outer lips were hard and horny and her clitty stuck out its red nose stiffly. I noted the delectable, sweet scented, savoury condition of her private parts.

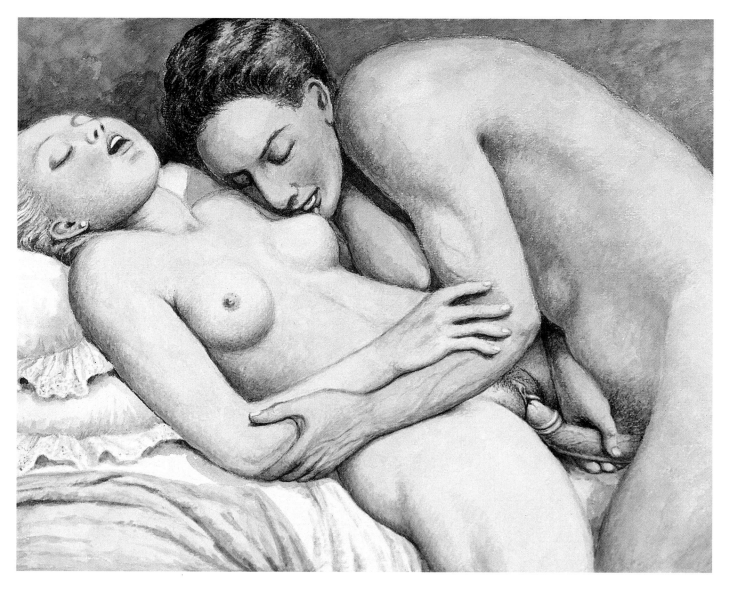

ABOVE An early twentieth-century
watercolour by an unknown artist.

Holding the soft cheeks of her fat bottom apart, I gazed fondly at all her beauties when she anxiously wound her fat legs around my neck and exclaimed, 'My God, what a lover you are!'

I now buried my nose in her slit and worked my tongue deep in. She bit her lips and exclaimed with a deep moan: 'Suck me.'

I then gave her the same tonguing I had just given Madge, but I fairly ate the mellow meaty interior with lively tongue thrusts.

I gathered all the ripe parts of her cunnie into my mouth and sucked like mad, with my tongue rubbing her stiffened clitty. Tessie was trembling and quivering all over. 'Wow! Oh! Ouch!' she cried. Her cry aroused Margery from her languor, and she came smiling to the side of the table.

'Oh, Madge,' she cried, 'he's sucking the life out of me – oo – oo – Oh, how I'm spending!'

'Isn't it great?' asked Madge, patting Tessie's titties and pinching the little stiff nipples.

'Oh, it's heavenly,' replied Tessie as she died away in another

OPPOSITE Troilism, where three people make love simultaneously, is also known as triolism: the vowels mimicking the reversal of positions available in triangular sex. Drawing by an unknown artist, early twentieth-century.

the wingless thing
man . . .

– e. e. cummings

Most men use their cocks
for two things only:
they stand up pissing
& lie down fucking.
The world is full of horizontal men –
or vertical ones –
& really it is all the same disease.

But your cock flies
over the earth,
making shadows
on the bodies of women,
making wild bird noises
from its tiny mouth,
making music
& food for thought.
It is not a wingless thing
at all.

We could call it Pegasus –
if it didn't make us think
of gas stations.
Or we could call it Icarus –
if it didn't make us think
of falling.

But still it dips & dives
through the sky like a glider,
in search of a meadow,
a field,
a sun-dappled swamp
from which (you rightly said)
all life begins.

THE WINGLESS & THE WINGED
ERICA JONG (b. 1942)

swoon of voluptuous ecstasy. I jumped up then with a terrible hardon that was actually painful. It was forbidding in appearance. Tessie had never seen nor dreamed of a penis like it before. Handsome it was, to say the least, with its splendid appendages like ripe fruit bursting with a wealth of rich juices.

Tessie's eyes, languorous with the sensual after effects of a copious spend, looked with fear as I stood beside her. In a voice trembling with apprehension, she said: 'Let – let me feel it, Gus, it's awful.'

I stepped closer to her, and she felt the awful thing from the balls to the tip of the turgid knob as if testing and measuring its size and power. I took it in my hand and moved the knob around in her neck, under her chin and ears. She murmured:

'Oh, you beauty. Now I'm ready – Oh, Gus, be careful, won't you?'

'Yes,' I answered.

'Then broil me and do it good, I'm hot as a blister,' and to Madge she said, 'don't leave me, Madge, and give me a handkerchief.'

I took a pretty leg under each arm and Madge stood by to assist. She pulled the inflamed fat lips apart, revealing its red meaty interior and puckering orifice from which oozed traces of her recent spending. I moved my tool up and down and rubbed the quivering inflamed clitty. 'Oh, God! that's exciting,' she cried out suddenly, 'put it in quick.'

I placed the almost bursting knob at the entrance and pushed. She gasped and stuffed the handkerchief into her mouth to smother a cry of pain. With the head just inside, I waited for her to get accustomed to the stretching. The nipping stricture was maddening to me. Tessie relieved her mouth long enough to say, 'All of it, Gus – I – I – want it all!' Replacing the wad of handkerchief in her mouth, she grabbed Margery. I braced myself and clutching the girl's squirming hips, I crammed my penis into the tight hot depths till it was completely sheathed. How she did squirm and writhe. I hollered myself with sensuous delight, exclaimed:

'Oh, Tes – sie – what a perfect cunt you have.'

Her pain had subsided, she removed the cloth from her mouth, her crimson lips parted in a smile of joy. Margery bit and sucked the stiff red nipples whilst I tickled her navel. 'What a pretty belly. What pretty legs. You two girls are the peachiest chickens to fuck that I ever knew,' I whispered as I moved my straining spear out and in, producing a fury of erotic thrills in us both. Tessie could not prolong the delightful indulgence long enough.

'Gee,' she gasped, 'I wish that it could last all night.'

Once her tongue was loosened she became obscene as her erotism increased. I was getting a royal feast of voluptuous sensation. The climax was approaching us both. Tessie's curly blonde head rolled from side to side – she clawed at her stomach and her milky panting bubbies as they rose and fell faster and faster with her quickened breath. I put my most masterful strokes to the frenzied girl with agonizing thrills.

She hollered in smothered gusts, 'Oh, God! I'm coming!' Her

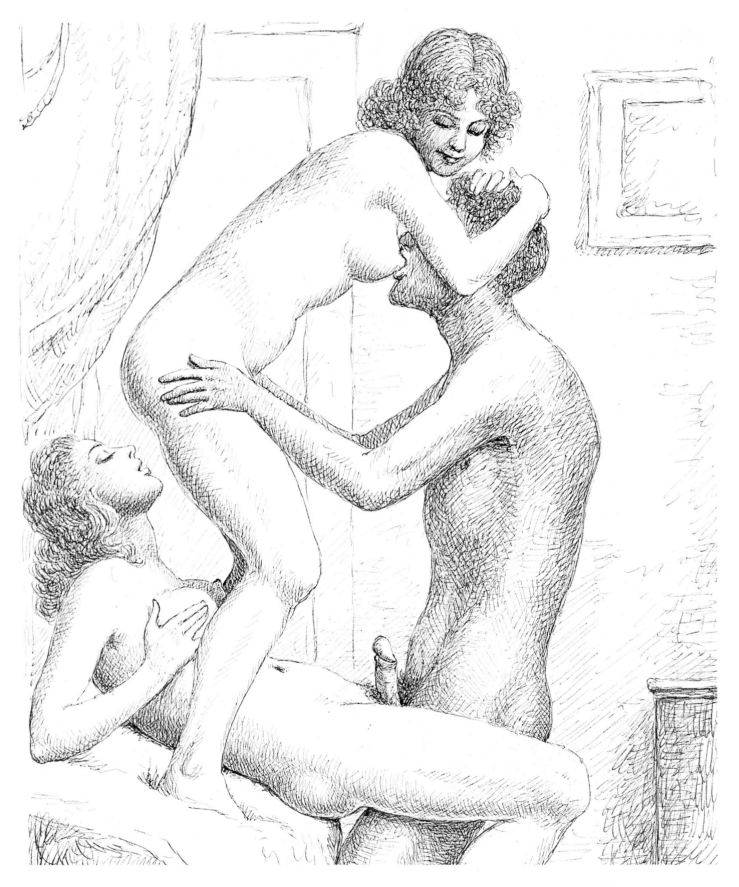

I do not enjoy
 an extortionate night
I prefer bedsit girls
 to your suave madams
the suave flesh reeks
 of arrogant scent
and a chauffeur escorts it
 to the gamy tussle
the other chicks
 have a look and smell
 that's at least their own
they're easy to make
 and do not cost
 a night on the town
I copy Pyrrhos
 who always preferred
to Hermione his wife
 the au pair girl

RUFINUS (c. SECOND CENTURY AD)

◊

BELOW An anonymous pen and ink drawing of girls locked together in the '69' position.

◊

arms dropped to her side.

'Somebody kiss me! Hold me! I'm dying! Oh – oo – oo.' Margery giggled. I grabbed the exploding girl in my arms, crushed a soft tittie in each hand and smothered her gasping cries with a tonguing kiss. She sucked the tongue almost out of me.

'There, you hot little cunt, take my sap, it's – good for you,' I said as I poured hot streams of delicious juice into the trembling girl, the jets piercing her like needles and bringing a secondary spend in which Tessie's eyes rolled back in erotic delirium. I laid her gently back and completed my own double spend in a blinding orgasm which shook me to my toes.

'Heavens,' cried Margery, 'you've got me so hot I can scarcely wait for another piece.' Tessie wriggled off the table and staggered as if drunk to the bed, where she laid in a half-faint from the effect of the frenzied orgy.

I quickly got a bottle of brandy. We all had a stiff drink and prepared to go out. After Tessie had had two drinks she was as lively as a cricket and ready for a frolic. Like a contortionist she writhed and displayed her enticing charms to excite the lewdest passions. Her sensual nature was thoroughly fired after getting a generous taste of my powers and my skillfully manipulated tool. She was wanton to the core. Before I had completed my toilet, Tessie kissed my penis. Being now soft and normal she drew it into her mouth and cuddled it with her tongue. 'Gee,' she exclaimed, 'I'd like to suck you off.' We were all hotter than blisters and ready for anything. We left the house unseen and were soon in the room I had engaged for the night. I ordered highballs with plenty of ginger. Both girls stripped, and jumping onto the table, they did a most exciting and lewd dance. Tessie was more agile than Madge, but Madge's movements were far more suggestive and voluptuous.

They had often practised together when under the influence of lecherous desire to indulge their wanton passion and to induce a spend would press their pussies together and rub and twist with their titties crushed together till a frenzied orgasm would reward their efforts. I watched the lascivious performance till I was so hot my turgid gun was standing cocky and purple and almost ready to go off. I grabbed both girls and fell with them on the bed. I was about to mount Tessie when she cried out:

'Hold on Gus. I'm hot, too hot for an old-fashioned fuck. I want a hootchie cootchie diddle.'

'How's that?' I asked.

She then directed me to lie across two chairs with my head on the bed and my knees hanging over the edge of the farthest chair while Madge was to straddle my head and press her cunnie to my mouth. This was a new trick but I liked the idea and at once arranged for it. I first drew both

girls to the edge of the bed, with their plump bottoms on the edge, with their legs wide apart and knees drawn up.

The quivering swollen cunnies were then gaping open, the orifice of each pouting for something stiff. I took a highball and holding Madge's little hole well open, I poured into it a goodly portion and then held the lips together so it wouldn't spill, to let it soak in and heat up the tight little box. Dropping to my knees, I deftly placed my mouth to the lips and sucked out the warmed up liquor. She screamed and wriggled her fat bottom. She was consumed with longing. I gave Tessie the same treat and when I had sucked out the last drops she writhed and screamed.

'My God, that was brutal. I was hot enough without that. Hurry up and get on the chairs and I'll screw the balls off you while you lap Madge.' I got awful randy as Tessie took her position while I lay as she directed, with my erect penis standing straight and rigid, ready to burst. Tessie cuddled it in her soft bubbies and kissed it again with thrusts of her tongue in the little orifice.

Our passions spent, we fell back on the bed. I was asleep as was Tessie. Madge, in her state of erotic feelings, began working her fingers in her moist slit, but was so passionate and eager for another piece, she knew that she had first to get it stiff. Following descriptions she had read, of a way to get a man's penis to stand, Madge hung over me and lifted my seemingly dead penis into her mouth with her tongue after tickling the wrinkled balls. When she got half of the soft mass into her mouth she slipped her tongue around and around the head as she gently chewed the soft root. I stirred, woke up and not thinking which of my partners was at me, clutched Tessie and kissed her, feeling and moulding her titties, now firm after a rest. She, too, awoke.

'Oh, Gus, do you want me again so soon?' I then perceived that it was Madge who was eating it up.

'Look Tess,' I said. 'Madge wants it. Poor girl, she's hungry.' When Tessie saw Madge frantically chewing the mouthful, she rolled the splendid reservoir of sap in her one hand. 'That's right, Madge,' she said. 'That'll make it come up if you want a piece. I'm ready for one myself.' Tess tickled me, sucked my hard nipples and between the two amorous girls, I began to get stiff. My penis got too big for Madge's mouth. Letting it languidly out, she said:

'I do want a piece. I'm hot from my toes to my hair.'

I handled both quivering cunnies, sticking a finger into each. This would always make me hot. My tool swelled and stiffened to grand proportions till I had one of my characteristic morning hardons.

'Give it to Madge first,' cried Tess. 'She found it first.' I got on top of the plump, passionate girl and gave her the liveliest, hottest fuck I ever put to a girl, till she groaned and screamed in an ecstatic satisfying orgasm. I finished her off and left my rigid tool in her till she swooned off in a sensuous die-away, having restrained my own desire to spend.

I preferred my morning feast between Tessie's soft, shapely

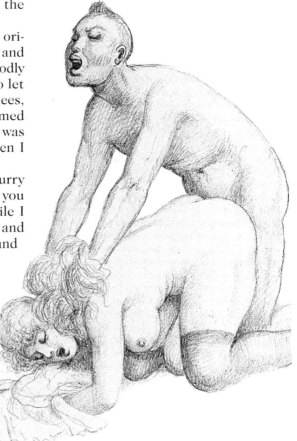

ABOVE The mathematically inclined have coined the term '99' for *croupade* lovemaking. Early twentieth-century pencil sketch.

legs in her tight excitable little box. I wanted to feel Tessie's long lithe limbs wind about me and once more experience the ecstatic spend by her wriggling bottom and toe-curling, sucking cunnie.

'Heavens, you're bigger than ever,' she exclaimed. 'It's just grand. Oh, Gee, how lovely, umm.' She groaned with each straining thrust and throb. Tessie twined her pretty legs around me and thus braced, she not only met my thrusts with effective bucking up motions but could wriggle and twist with a screwing motion that thrilled me with lustful zeal.

Her cries and shuddering frame told of the delightful spends she was having. When I could no longer restrain myself to prolong the voluptuous feast, I gathered the trembling plump form of Tessie in my arms and gazing down in her misty rolling eyes, groaned out:

'Oh, Tessie – there – it – comes – Oh, God! how exquisite!'

Our delicious feeling was ravishing after I shot a long charge of creamy spend into the hungry depths of Tessie's cunnie.

She quickly jumped off the bed and let the stuff escape in a morning pee. Returning to the bed we all had a nap. At six o'clock we all arose and went our way. Tessie remarked: 'Oh, Gus, I never had such a treat in all my life. Madge picked a star performer when she picked you.'

---◇---

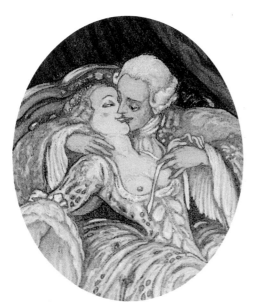

Any man that cannot find what he is looking for in a hundred women is really looking for a boy.

TRADITIONAL SAYING

For participants, the voyeurism inherent in troilism is presumably as much a part of the fun as the additional sensory permutations which become possible with sex *à trois*.

Giacomo Casanova, Chevalier de Seingalt, was particularly fond of sexual triangulation. In this extract from *History of My Life* we are worlds away from Gus Tolman; the sex and the gastronomy are real, and the ladies are nuns.

They returned with their arms around each other, laughing over their state of undress. I had the strength to conceal all the emotion which this enchanting costume aroused in me, and even to refrain from fixing my eyes on their bosoms while they were complaining that they had neither fichus around their necks nor jabots at the top of their shifts. I said nonchalantly that I would not look at them, for the sight of a bosom left me perfectly indifferent. Knowing nature, I had to lie. I was sure that they could no longer set much value on what I valued so little. The two girls, who knew that they had very beautiful bosoms, were astonished by my disdain; they had to suppose that I had never seen beautiful bosoms; and the truth is that in Rome beautiful breasts are scarcer than pretty faces. Despite their good morals, Armellina and Emilia could not but undertake to convince me that I was wrong; it was my part to put them at their ease and in a frame of mind to feel ashamed of nothing. I delighted them by saying that I wanted to see them make the punch themselves. The lemon juice had already been squeezed into a big goblet. They were charmed when I told them that I found the punch better than the one I had made the first time they drank it.

At the game of passing oysters from mouth to mouth I chided Armellina for swallowing the liquid before I took the oyster. I admitted that it was difficult to do otherwise, but I undertook to show them how to go about keeping both the oyster and the liquid in their mouths by raising a rampart behind it with the tongue to stop it from entering the throat. Having to set them the example, I taught each of them to insert the oyster and the liquid into the other's mouth as I did by simultaneously inserting the full length of the tongue. I did not object when they took no offense at my extending mine, nor did Armellina object when I lingered over sucking hers, which she gave me most generously, laughing heartily afterward at the pleasure afforded by the game, than which they agreed with me nothing could be more innocent.

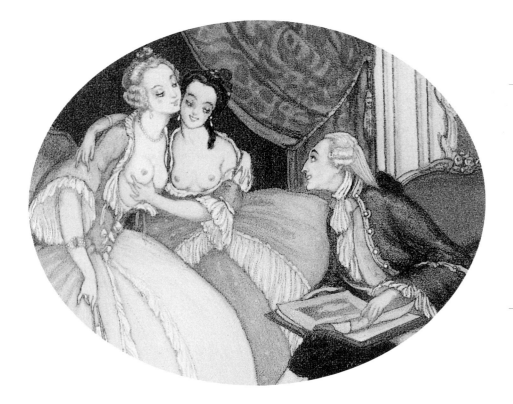

It was by chance that a fine oyster which I gave Emilia, putting the shell to her lips, dropped into her bosom; she made to recover it; but I claimed that it was mine by right, and she had to yield, let me unlace her, and gather it with my lips from the depth to which it had dropped. In the course of this she had to bear with my uncovering her bosom completely; but I retrieved the oyster in such a way that there was no sign of my having felt any pleasure except that of having recovered, chewed, and swallowed it. Armellina watched the whole procedure without smiling, surprised that I appeared to show no interest in what I must have seen. Four or five oysters later I gave one to Armellina, who was sitting on my lap, and I cleverly dropped it into her bosom, which brought a laugh from Emilia, who at bottom was annoyed that Armellina had escaped a test of an intrepidity such as she

ABOVE and OPPOSITE Although Casanova experimented with most forms of sexual pleasure, he had a particular liking for troilism. Early twentieth-century watercolour, artist unknown.

had shown me. But I saw that Armellina was delighted by the mishap, though she refused to give any sign of it.

'I want my oyster,' I said.

'Take it.'

I unlace her whole bodice, and, the oyster having dropped as far down as possible, I complain that I shall have to bring it up with my hand. Good God! What torment for a man in love to have to hide the excess of his delight at such a moment! Armellina had not the slightest pretext to accuse me of anything, for I did not touch her beautiful breasts, hard as marble, except in searching for the oyster. After retrieving and swallowing it, I took hold of one of her breasts, demanding the liquid from the oyster which had spilled on it; I seized the rosebud with my avid lips, surrendering to all the voluptuous feelings inspired in me by the imaginary milk which I sucked for a good two or three minutes. I saw that she was surprised and moved; but when I let her go, it was only to recover my soul, which my great pleasure had made to exhale where I did not know if she could suspect it. But when she saw me fix my eyes on hers as if in a stupor, she asked me if I had very much enjoyed imitating the babe at the breast.

'Yes, for it is an innocent game.'

'I do not believe so, and I hope you will say nothing about it to our Superioress; what you did is not innocent for me, and we must retrieve no more oysters.'

Emilia said that such little weaknesses were wiped out with holy water.

'We can swear,' she added, 'that we have not given one another a single kiss.'

They went into the next room for a moment, and, after I went there myself, we moved the table away and sat down by the fire on a sofa which we pulled up to it, with a stand on which were the bowl of punch and glasses beside us. We had no more oysters.

Sitting between them, I spoke of our legs, which were exactly alike yet which women insisted on concealing under their skirts, and, so saying, I touched their legs, adding that it was just as if I were touching my own, and seeing that they had not opposed my examining them up to the knee, I told Emilia that I wanted no reward from her but her permission to judge the thickness of her thighs in comparison with Armellina's.

'Hers,' said Armellina, 'must be thicker than mine, though I am the taller.'

'There's no harm in letting me see.'

'I think there is.'

'Then I will just measure them with my hands.'

'No, for you would look, too.'

'No, on my word of honor.'

'Let us blindfold you.'

'Gladly. But you must let me blindfold you as well.'

'Very good. We'll play blindman's-buff.'

After drinking, we all three blindfolded one another, and then the great game began and, standing in front of me, they let me measure them several times, falling on me and laughing each time I measured too far up. Having taken off my handkerchief, I saw everything, but they had to pretend they had no idea of it. They must have cheated me in the same way too, to see what it was that they felt between their thighs when they laughed so hard that they fell on me. The charming game did not end until nature, overcome with pleasure, deprived me of the strength to go on. I then restored myself to a state of decency before they took off their blindfolds, which they did when they heard my decision.

'Emilia,' I said to Armellina, 'has her thighs, her hips, and everything more developed than yours, but you have still to grow.'

Speechless and laughing, they sat down beside me again, thinking, I know not how, that they could disavow all they had let me do. It seemed to me, though I said nothing, that Emilia had had a lover, but Armellina was untouched in every way. She seemed more humiliated than Emilia, and there was a look of far greater gentleness in her big black eyes. I wanted to take a kiss from her beautiful lips, and I found it very strange that she turned away her head, though at the same time holding my hands with all her strength.

Until the age of forty, or thereabouts, I never saw an ugly woman . . .

FRANK HARRIS (1856–1931)

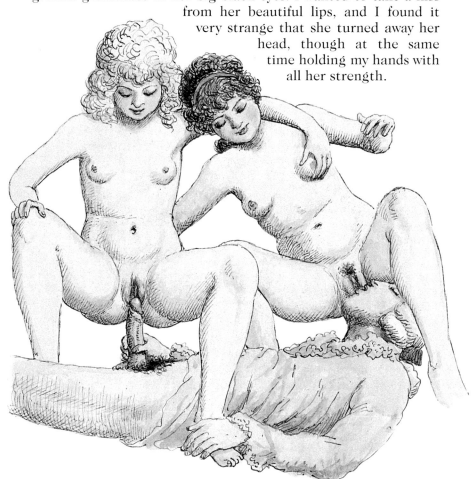

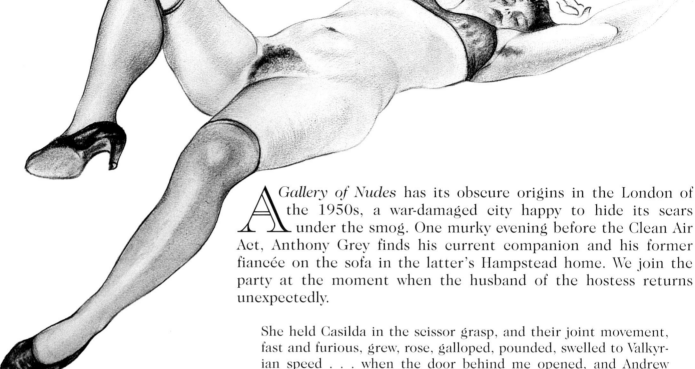

ABOVE A languid drawing by an unknown artist with a good eye for the man-made delights of silk stockings as well as for Nature's own erotic landscaping.
OPPOSITE *The Tribades*, a coloured lithograph by André Provot.

I used to be Snow White – but I drifted . . .

MAE WEST (1892–1980)

A *Gallery of Nudes* has its obscure origins in the London of the 1950s, a war-damaged city happy to hide its scars under the smog. One murky evening before the Clean Air Act, Anthony Grey finds his current companion and his former fiancée on the sofa in the latter's Hampstead home. We join the party at the moment when the husband of the hostess returns unexpectedly.

She held Casilda in the scissor grasp, and their joint movement, fast and furious, grew, rose, galloped, pounded, swelled to Valkyrian speed . . . when the door behind me opened, and Andrew walked in.

He must have used the back way. He stopped dead in his tracks and stared at the scene that confronted him, but said nothing. I handed him a drink off the mantelpiece, which one of our women had sipped and left. We stood side by side in front of the fire, watching with all eyes. Still he did not speak. I was glad. Only brute force could have separated them. It would not take long . . . suddenly there was a single loud, sharp cry from both their throats – followed, seconds later, by a choking, breathless rattle of joy that fell away in the lost, heavy silence. Languidly Janet withdrew, as a man does, quitting the flattened body that has received the gift of his sperm. She staggered slightly and dropped into a chair. I passed her the rest of my cognac. We gazed at Casilda, lying motionless and spent, lax and spread-eagled on the sofa, as uncovered and starkly indecent as a corpse. When she moved at last, and looked at us, it was to clutch at her fork, her throbbing parts, with a quick shiver and a broad, quiet smile; but not to shield the wound or hide her trembling flesh from view. Her playful fingers parted it in fact, lightly toying with the matted curls, stroking the flushed red rim all round, as though applying an oily balm to soothe a gently tickling sore, and skimming down its blatantly bare, gaping length, as in a quick canoe between bushy banks, she sighed, arched her back lazily, with yearning, and rolled her tousled head upon the cushions. We knew what she wanted – a different, immediate and deeper solace. She had made that plain enough.

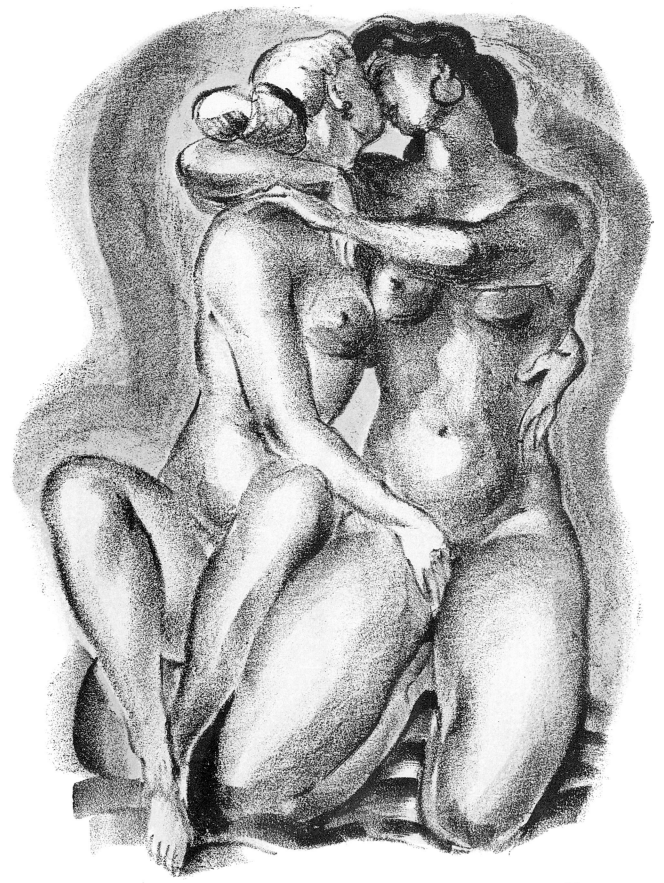

ABOVE An imaginative use of watercolour technique: our eyes respond strongly to the dark areas of stocking and hair, so that the search for the other pigments which define the moulding of her body is almost like tactile exploration.

'Take pity on her,' I said to Andrew, 'since she's asking for it. You have my permission.'

He glanced at Janet, who nodded. 'And mine,' she said.

'No – that won't quite do.' It was Casilda who spoke, to our surprise, as though she could not yet have revived sufficiently to communicate with us directly by word of mouth, but must continue to employ her more expressive sign language.

'Both men – I'll have you both,' she said, sitting up. 'That's it, that's what I want – and always did. Hurry, can't you – get undressed! One in front and one behind. We can manage that if we try . . .'

It took some managing. Andrew had already torn off his clothes, before I could work out what Casilda meant or how she proposed to set about it. She sat huddled demurely on her tail now, a caricature of modesty, waiting. She studied us carefully although of course she didn't need to examine me, it all depended on Andrew. He was enormous. The tool he carried was a long, gnarled, hefty great club – a bludgeon. I was astonished. Casilda's eyes opened wide. She wet her lips. For such a little fellow, upon my soul, you would scarcely believe it possible – the most lavish endowment, and considering that it did not show up to advantage, under that bulging stomach, frankly excessive, an outsized monstrosity. How women can contemplate such repulsive objects without flinching in horror at the sight, they alone know! It had a curve on it like a rhinoceros horn or a hockey stick – and no less vast were the balls, slung in a hideous, wrinkled sack, as big as a cantaloupe. The corona itself was a dark, bursting ripe red plum, stuck on at the end of a thick, knotted bare branch – nothing short of grotesque. There we were, standing to attention, with weapons at the ready, presenting arms for Casilda's inspection. She leaned forward, putting out a hand to each of us, in an unconscious, ribald parody of a royal command soiree, assessing our offers – medium and immoderate – with judicious concentration on the big problem that faced or otherwise intimately concerned her.

In point of fact the choice was obvious; but she anointed us both for her own ends, when Janet's sisterly perception had sent her post-haste from the room, to the medicine chest, on an errand of mercy. The sofa looked a bit cramped, I thought, for the three of us, but Casilda shook her head when I beckoned her to the wide, woolly hearthrug, and, firmly drawing the two members of her party towards the couch, she lay down on her side, without letting go of us, as we loomed above her, wondering what to do next. There was only one solution, which Janet, the idle spectator, promptly advised, though it probably dawned on us all simultaneously. We turned Casilda on her back. Andrew got up into position with some effort and misguided vigour, yet not so precipitately as the pawing stallion who needs assistance to put him into a proper fix, oddly enough, rather than to pull him out of a hole – and they settled down to it straightaway, going great guns, hard on the job with everything they had.

It was a sight to see, and thrilling to overhear, for they made the deuce of a noise, rootling like stoats, though neither of them said a word. None of us had a stitch on. A lurid light shone in Janet's eyes, as she hovered and circled around the inebriate pair, like a referee. I hopped, in sheer torture, from foot to foot, torn between fiendish impatience and jealousy. . . . I'd shoot some decent good sense up her leching, bawdy bum and fill my lovely lady with a jolt from a prick every bit as rich and randy as his . . . but when? Would they never stop? She was carried away completely, curse her, she had forgotten all about me. He'd spend, and spoil half our fun in a minute, if she didn't watch out . . . ought I to take the risk and cut in? Where was Janet? She'd serve, at a pinch. It was then, praise be, that Casilda rolled over, pushing the chap with her, jabbing him in the ribs, shoving them around, both of them, to lie, still copulating like monkeys, on their sides, with him facing out towards the fireplace, his back against the sofa, and she, in reverse, showing me her buttocks, the white, milky full moon of her bottom turned to me. There it was at last, beaming, big, broad and beautiful, in all its innocence or insolence, bland or crass, according to how one looked on it, delivered into my power as a hostage, meat indeed for the slaughter, rakish and docile, the sinful flesh . . .

It was worth a further fleeting delay, a moment's scrutiny. I bent over the two-back beast, ran my hand along the steep ravine between the smooth, cool cheeks, which jounced about distractingly under stern orders from in front, though Casilda thrust her tail outwards as far as she dared while I probed the pursed little brown buttonhole, like the bud of a tiny wild-flower, with my fingertip at first, and then, flinging myself on the sofa behind her, and prising the massive mounds apart, with an inch or so of the old codger himself. Easy does it, in he goes – just as slippery and sweet as you please . . . no trouble at all – for a couple of split seconds, that is, until we got the warhead in place,

When I am sad and weary,
When I think all hope has gone,
When I walk along High Holborn
I think of you with nothing on.

CELIA CELIA
ADRIAN MITCHELL (b. 1932)

LEFT As the pen is mightier than the sword so the pencil is ruder than the camera. The anonymous creator of this sketch set out to make an erotic confection with carefully chosen ingredients. The result is completely artificial but astonishing – the erotic equivalent of a soufflé.

Oh my darling Flo I love you so,
I love you in your nightie;
When the moonlight flits
Across your tits
Jesus Christ Almighty!

O MY DARLING FLO
ANONYMOUS

BELOW An illustration of Carnival
from Casanova's *History of My
Life*.

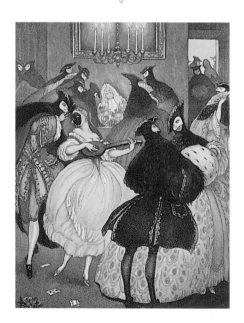

truly embedded, streaking up her fundament like a dentist's drill
through a temporary stopping, an express train roaring full-on
into a tunnel, a bull-dozer boring a trench in a stiffly packed
squelch of clay. But then, ye gods, what a to-do! What shrill yelps
and yells, what wriggling, tugging and dodging, what tearful
entreaties, elbowings, fisticuffs, and ghastly oaths! I held on to
her grimly by one hip, with the other arm around her neck, and
ploughed on, regardless of the cloudburst, which passed and was
gone in a few more shakes at the crucial base of the triangle . . .

The last of this trio, however, was the first to quit. It wasn't my
fault. I had shot my bolt a little while before the others finished –
which apparently they did, bringing it off very adroitly, together. I
might have lasted out, too, if Janet had not seen fit to chip in as
an auxiliary to our already somewhat overcrowded act by prod-
ding me from the rear and swiping at my backside with her open
palm, just when we were all approaching the terrific climax of
our intricate threefold exercise. It's true that I was teetering on
the sofa's edge the whole time, and nearly got butted off on to
the floor once or twice, because there simply wasn't room for
three on it: Casilda had her arms and legs coiled around Andrew
in a ferocious hug to keep him in place, the couch was far too
short, we stuck out in every direction like a cactus patch. But
Janet's well meant intervention hastened my undoing.

I started to dress, and Andrew was about to follow suit, but his
wife would not hear of it. She had snuggled up next to Casilda,
cooing affectionately, but her hackles rose on the instant when
she saw what was afoot.

'Hey, no you don't!' she cried with comic indignation,
although quite seriously. 'That's all jolly fine – but what about
me?'

At what point does troilism become a fully fledged orgy? Presum-
ably when the triangle becomes a square and three becomes four.
In the last extract in this section, although troilism and many
other permutations of coupling are included, there is no doubt
that it is an orgy. Indeed that is specifically what Angela Ruberta is
commissioned to provide in *Memoirs of a Venetian Courtesan*.

Carnival is not only a time when every licence is permitted, it is a
time when those with a taste for such things plan new excesses
and delights which they can enjoy.

The orgy which the senator wished me to arrange was to know
no limitations in behaviour. His only stipulations were that four
others, two men and two women, whose integrity I could vouch
for, would be involved in addition to himself and his wife. Natur-
ally all would remain masked throughout.

Before agreeing, and before indicating the price of such lavish
entertainments, I outlined certain rules of my own. The orgy
would take place in my house. It would be restricted to the large
room and would begin at sunset and end at dawn. No servants
but mine would be allowed to enter and my own would be
restricted to the other floors. Lastly, although no other control

would be exercised, nothing violent or cruel in any way would be permitted.

The senator agreed to both rules and price – which was considerable – without quibble.

My chosen participants were Faustolla and her lover, a nobleman who owned a theatre; myself, the senator and his wife of course; and Fabrizio. Although he had taken to drink since his marriage Fabrizio was a loyal friend; he was also a considerable asset in an enterprise of this sort! During the days before the orgy I was frequently moved to mirth at the thought of Fabrizio and the senator's slight, blonde wife.

The preliminary meal was, as I had feared, a little strained. The wine helped and I was very attentive to the glasses. The inevitable result was frequent traffic to the chamberpots which I had had situated at the far end of the room. The men, as ever, were less decorous than the ladies in this procedure, and we were treated to several glimpses of those parts which were later to perform their other and more enjoyable function.

It was after just such an incident that the senator's wife grew suddenly more attentive to Fabrizio. She repeatedly caught his glance across the table, smiling and hooding her blue-grey eyes. This was all very well, but as director and *première danseuse* this seemed to me to be a slow beginning. I was reflecting on various

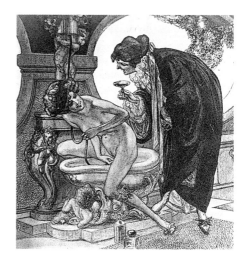

ABOVE An engraving that could only be by Franz von Bayros. BELOW A finely executed drawing by an unknown artist.

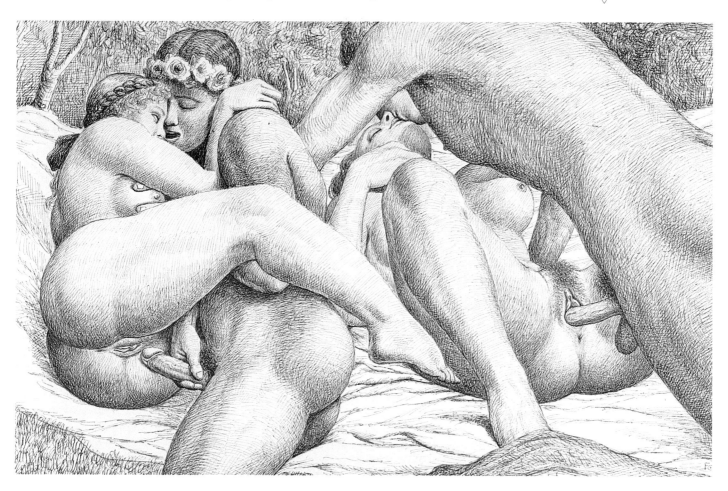

ways to warm-up the proceedings when the senator's wife became the spark which started a conflagration.

Fabrizio was moved to walk once again to the chamber pot. The sight of his gigantic penis, turgid with its present activity, was too much for the senator's wife. The stream had barely ceased when she rushed across the room and crammed what she could of him into her mouth. Frigging and sucking him in a frenzy, she soon had Fabrizio's cock looming over her like the arm of a crane. Whimpering in her excitement, and still kneeling, she tore off her clothes and presented her naked posterior to him.

Fabrizio's clothes followed hers and he was soon rutting on her like a wild animal. How she was receiving the full length of this monster in her delicate body was a mystery to all of us, but her squeals were not those of discomfort or disapproval.

The effect of this tableau on the rest of the gathering was immediate and surprising. It seemed we had all chosen not only the subject but also the manner of our first encounter. There was no disagreement and the minimum of confusion. In a span of

RIGHT The orgy takes its name from a Greek word meaning 'secret rites'. Orgies are religious in origin: in the Ancient World there were many cults, especially those associated with Dionysus, where worship involved drinking, dancing and group sex. Drawing by an unknown artist.

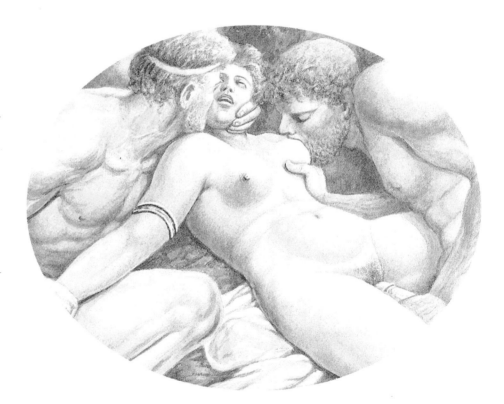

time so short as to seem almost instantaneous, clothes were removed and the coupling achieved.

Faustolla's lover had his head between my legs and his cock in my mouth. The senator was already clenching and unclenching his buttocks between Faustolla's open legs in a manner allowing no ambiguity of interpretation.

The more leisurely beginning which my partner and I had made meant that we had only begun to enjoy the main course when the others were already searching for sweetmeats. The

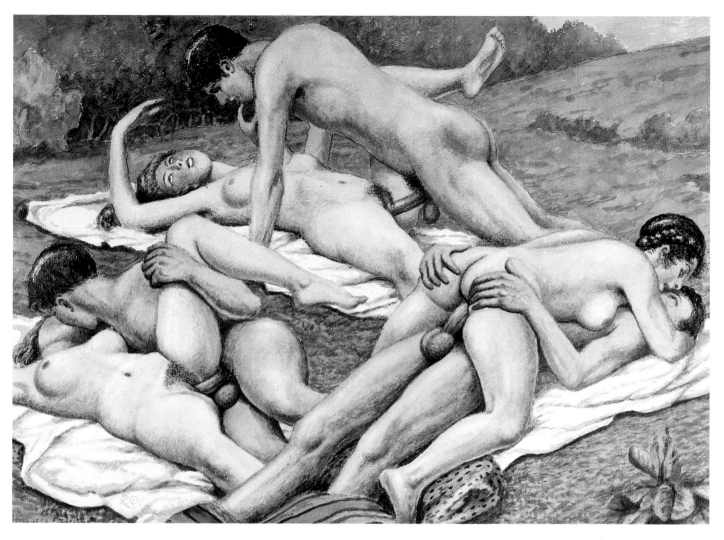

consequence of this was that they gathered around us just as he began his first long strokes into me.

The senator's wife, who proved to have the appetites and sensuality of a feral cat, seized upon my partner's sex as he thrust into me. When he withdrew I could feel her fingers around my lips and his slippery shaft.

Faustolla was not slow to investigate the mystery between the senator's wife's legs as an opportunity now presented itself. I could see her exploring with fingers and tongue.

As the senator and Fabrizio were momentarily at a loss to know quite where to join the game I took matters in hand: the one new, and interesting for that reason, the other familiar but having lost none of its charm. Having been prepared by me for further adventures the senator then knelt behind his former partner and began fucking her again. I have no doubt that he was moved to do this not only by a wish to explore the beauty of Faustolla's arse but by the novelty of her having her auburn head buried in the more familiar contours of his wife's bottom.

At this point my intrepid partner reached his crisis, each spasm of which was also enjoyed by the senator's wife who had

ABOVE In this anonymous watercolour the participants have reached that moment in their group encounter when each couple no longer cares what anyone else is doing.

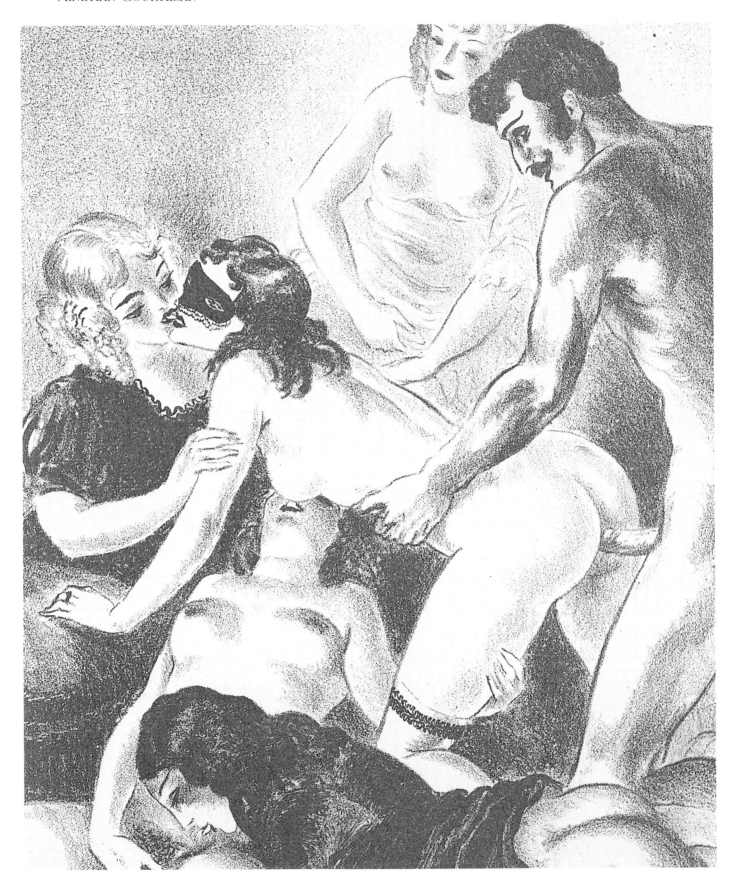

one hand down between his buttocks and the other clutching his testicles.

As he softened and withdrew the senator's wife hungrily took him in her mouth. Soon he was lying on his back beside me, begging her to let him recover a little. She silenced him by straddling his face and pressing her sex down onto his mouth. Then, leaning forward, she resumed her sucking.

My own pleasure was not complete. Sensing this, Fabrizio knelt between my legs and pushed slowly into me. I begged him not to thrust too hard. He whispered in my ear that he had locked-up often enough to know how to insert the key. Nor did he need to use up his oil, a few movements were all it took to make the mechanism work.

Soon after there began what resembled a children's game more closely than anything else. As soon as Faustolla's lover was ready to participate, the men coupled with us, but changed partners after only a few thrusts. Men retain more of the child in them than us, and this new game was more to their taste than ours.

We tried to make of it what we could while we waited for our turn with Fabrizio. Then there was always one indignant man standing for his turn while the next woman complained that her time with Fabrizio had come. As this was leading to disharmony Fabrizio suggested a variation where all lights were extinguished and we had to guess which man we were receiving each time. We told him not to be foolish.

This and similar games took us through to the dawn, sustained by periods of rest and refreshment. All possible groupings of men with women and women with women were tried, but not men with men. Except that the senator asked if he might masturbate Fabrizio. By this time Fabrizio was quite drunk. He agreed, provided he was all the while given clear view of the senator's wife and Faustolla who were then enjoying each other before the fire.

There were no other noteworthy revelations, except perhaps that Faustolla's lover took great delight in watching the women make water. We all indulged him in this innocent pleasure, and tried to make it as interesting as possible for him. The women agreed that the activity seemed to us to lack the spectacle which is the essence of theatre. But he seemed pleased enough.

An orgy is both voyeuristic and atavistic: an erotic group encounter, a sexual package holiday to a primitive animalistic past. We are back at our beginning. The distance from the sophistication and decadence of an elegant Venetian palazzo on the Grand Canal to the Rift Valley, a million years of human evolution, is rather less than we might suppose.

ABOVE Lesbianism takes its name from the Greek island of Lesbos, home of the poet Sappho and her followers around 600 BC. Sappho's sexual tastes have tended to obscure the fact that she was one of the greatest poets of the classical world. Plato – who also suffered at the hands of dictionary compilers – called her 'The Tenth Muse'. Unsigned watercolour, early twentieth-century.
OPPOSITE A lithograph from *Mémoires d'une Chanteuse*, published in Paris in 1933.

Shades of light and dark

... he above the rest
In shape and gesture proudly eminent
Stood like a tower; his form had yet not lost
All her original brightness, nor appeared
Less than archangel ruined, and the excess
Of glory obscured: as when the sun new risen
Looks through the horizontal misty air
Shorn of his beams, or from behind the moon
In dim eclipse disastrous twilight sheds
On half the nations, and with fear of change
Perplexes monarchs. Darkened so, yet shone
Above them all the archangel: but his face
Deep scars of thunder had intrenched, and care
Sat on his faded cheek, but under brows
Of dauntless courage, and considerate pride
Waiting revenge ...

FROM *PARADISE LOST*, BOOK I
JOHN MILTON

BELOW An engraving from the series *Les Diableries*: neither technique nor catch will be found in *The Compleat Angler*.
OPPOSITE A nineteenth-century oil painting imaginatively reconstructs the in-flight entertainment of the rebel angels after they had been 'hurled headlong flaming from the ethereal sky'.

A paradox is not in itself an answer, but in wrestling with a paradox – as Luther wrestled with the Devil – we may find our own answers. In *Paradise Lost* Milton presents us with a magnificent paradox (so magnificent that the anti-hero almost gets up and walks off with the greatest religious poem in the English language): a Prince of Darkness who is also Lucifer, the 'Light-Bringer'.

In the first part of this erotic anthology we visited the geographical Garden of Eden, the Rift Valley which was home to the first of our species. Let us now visit the mythological Eden: a place no less important. Satan has of course been to the Garden before us: his horticultural contribution was to plant sin and to scatter the seeds of guilt. We would like to think that it was not all gardening for Adam and Eve before his visit, but only afterwards is there any mention of sex. By then, sex is inextricably bound up with the concept of good and evil.

This unfortunate confusion, this bundle of paradoxes, is our erotic inheritance. Sex is good but it can also be evil: the misuse

of sexuality, the misuse of power, is a serious issue. Sex is creative but some psychologists maintain that it is ultimately the same as violence. We enjoy sex, as we should, but it does not take much to make us ashamed of it. One thing is certain: sex is the *sine qua non* of human existence and we cannot understand it by ignoring it. It is our ambivalence towards sex – and the ambiguity of sex itself – that makes it useful to explore the literature and art of sex in terms of black and white or 'shades of light and dark'.

One aspect of the dark side of erotic literature concerns the personage who hauled sex into the good-versus-evil debate in the first place: Satan. Surely the Prince of Darkness has no more loyal follower than the vampire: certainly none more sensitive on the issue of light versus dark. Bram Stoker's novel *Dracula* began the modern myth and unknowingly founded a major industry. This extract lays bare the erotic symbolism of vampirism in what amounts to a fairy tale about oral sex.

ABOVE In 1514, when Hans Baldung Grien made this magnificent drawing, it was advisable for artists wishing to deal with sexual subjects to ascribe to witches the activities depicted – in this case a young witch is enjoying cunnilingus as only the Devil can do it. Artists failing to follow the convention of blaming witches for everything were liable to share their unpleasant fate.

I suppose I must have fallen asleep; I hope so, but I fear, for all that followed was startlingly real – so real that now, sitting here in the broad, full sunlight of the morning, I cannot in the least believe that it was all sleep.

I was not alone. The room was the same, unchanged in any way since I came into it; I could see along the floor, in the brilliant moonlight, my own footsteps marked where I had disturbed the long accumulation of dust. In the moonlight opposite me were three young women, ladies by their dress and manner. I thought at the time that I must be dreaming when I saw them, for, though the moonlight was behind them, they threw no shadow on the floor. They came close to me and looked at me for some time, and then whispered together. Two were dark, and had high aquiline noses, like the Count, and great dark, piercing eyes, that seemed to be almost red when contrasted with the pale yellow moon. The other was fair, as fair as can be, with great, wavy masses of golden hair and eyes like pale sapphires. I seemed somehow to know her face, and to know it in connection with some dreamy fear, but I could not recollect at the moment how or where. All three had brilliant white teeth, that shone like pearls against the ruby of their voluptuous lips. There was something about them that made me uneasy, some longing and at the same time some deadly fear. I felt in my heart a wicked, burning desire that they would kiss me with those red lips. It is not good to note this down, lest some day it should meet Mina's eyes and cause her pain; but it is the truth. They whispered together, and then they all three laughed – such a silvery, musical laugh, but as hard as though the sound never could have come through the softness of human lips. It was like the intolerable, tingling sweetness of water-glasses when played on by a cunning hand. The fair girl shook her head coquettishly, and the other two urged her on. One said:–

'Go on! You are first, and we shall follow; yours is the right to begin.' The other added:–

LEFT A steel engraving after William Blake's illustration of Adam and Eve, when everything in the Garden was lovely.

'He is young and strong; there are kisses for us all.' I lay quiet, looking out under my eyelashes in an agony of delightful anticipation. The fair girl advanced and bent over me till I could feel the movement of her breath upon me. Sweet it was in one sense, honey-sweet, and sent the same tingling through the nerves as her voice, but with a bitter underlying the sweet, a bitter offensiveness, as one smells in blood.

I was afraid to raise my eyelids, but looked out and saw perfectly under the lashes. The fair girl went on her knees, and bent over me, fairly gloating. There was a deliberate voluptuousness which was both thrilling and repulsive, and as she arched her neck she actually licked her lips like an animal, till I could see in the moonlight the moisture shining on the scarlet lips and on the red tongue as it lapped the white sharp teeth. Lower and lower went her head as the lips went below the range of my mouth and chin and seemed about to fasten on my throat. Then she paused, and I could hear the churning sound of her tongue as it licked her teeth and lips, and could feel the hot breath on my neck. Then the skin of my throat began to tingle as one's flesh does when the hand that is to tickle it approaches nearer – nearer. I could feel the soft, shivering touch of the lips on the supersensitive skin of my throat, and the hard dents of two sharp teeth, just touching and pausing there. I closed my eyes in a languorous ecstasy and waited – waited with beating heart.

Sometimes, after an hour of apathy, my strange and beautiful companion would take my hand and hold it with a fond pressure, renewed again and again; blushing softly, gazing in my face with languid and burning eyes, and breathing so fast that her dress rose and fell with the tumultuous respiration. It was like the ardor of a lover; it embarrassed me; it was hateful and yet overpowering; and with gloating eyes she drew me to her, and her hot lips traveled along my cheek in kisses; and she would whisper, almost in sobs, 'You are mine, you *shall* be mine, and you and I are one forever.' Then she has thrown herself back in her chair, with her small hands over her eyes, leaving me trembling.

FROM *CARMILLA*
JOSEPH SHERIDAN LE FANU (1814–73)

The elements of the vampire story which appeal to us are worth examining individually. There is of course the perverse glamour of evil. A decade before the publication of *Dracula*, in 1886, Robert Louis Stevenson wrote about this in *The Strange Case of Dr Jekyll and Mr Hyde*.

> There was something strange in my sensations, something indescribably new, and, from its very novelty, incredibly sweet. I felt younger, lighter, happier in body; within I was conscious of a heady recklessness, a current of disordered sensual images running like a mill-race in my fancy, a solution of the bonds of obligation, an unknown but not an innocent freedom of the soul. I knew myself, at the first breath of this new life, to be more wicked, tenfold more wicked, sold a slave to my original evil; and the thought, in that moment, braced and delighted me like wine.

RIGHT A disturbing drawing of the predator and his prey. Artist and date unknown.

Stevenson also understood that the thrill of evil can come from abandoning ourselves to the animal and primitive forces within our own natures.

> . . . I learned to recognise the thorough and primitive duality of man; I saw that, of the two natures that contended in the field of my consciousness, even if I could rightly be said to be either, it was only because I was radically both . . . I had learned to dwell with pleasure, as a beloved daydream, on the thought of the separation of these elements.

The abandonment of ourselves to animality is – not surprisingly – a recurring motif in erotic literature. The metaphor of a tiger or panther is often used to denote a voracious woman. This sexual safari is by Anaïs Nin.

His room was like a traveler's den, full of objects from all over the world. The walls were covered with red rugs, the bed was covered with animal furs. The place was close, intimate, voluptuous like the rooms of an opium dream. The furs, the deep-red walls, the objects, like the fetishes of an African priest – everything was violently erotic. I wanted to lie naked on the furs, to be taken there lying on this animal smell, caressed by the fur.

I stood there in the red room, and Marcel undressed me. He held my naked waist in his hands. He eagerly explored my body with his hands. He felt the strong fullness of my hips.

'For the first time, a real woman,' he said. 'So many have come here, but for the first time here is a real woman, someone I can worship.'

As I lay on the bed it seemed to me that the smell and feel of the fur and the bestiality of Marcel were combined. Jealousy had broken his timidity. He was like an animal, hungry for every sensation, for every way of knowing me. He kissed me eagerly, he bit my lips. He lay in the animal furs, kissing my breasts, feeling my legs, my sex, my buttocks. Then in the half-light he moved up over me, shoving his penis in my mouth. I felt my teeth catching on it as he pushed it in and out, but he liked it. He was watching and caressing me, his hands all over my body, his fingers everywhere seeking to know me completely, to hold me.

I threw my legs up over his shoulders, high, so that he could plunge into me and see it at the same time. He wanted to see everything. He wanted to see how the penis went in and came out glistening and firm, big. I held myself up on my two fists so as to offer my sex more and more to his thrusts. Then he turned me over and lay over me like a dog, pushing his penis in from behind, with his hands cupping my breasts, caressing me and pushing me at the same time. He was untiring. He would not come. I was waiting to have the orgasm with him, but he postponed and postponed it. He wanted to linger, to feel my body forever, to be endlessly excited. I was growing tired and I cried out, 'Come now, Marcel, come now.' He began then to push violently, moving with me into the wild rising peak of the orgasm, and then I cried out, and he came almost at the same time. We fell back among the furs, released.

———————◊———————

The other feature of the vampire myth which strikes a chord in the dark side of our personality is the idea of enslavement, the willing subordination of self to another. Count Dracula demands everything of his female victims and – although he must have been one of the worst halitosis sufferers of all time – he usually gets it. The same is true of his equally unpleasant fellow aristocrat in *Story of O*.

Of lust frightful, past belief,
 Lurking unforgotten,
Unrestrainable endless grief
 In breasts long rotten.

A song? What laughter or what song
 Can this house remember?
Do flowers and butterflies belong
 To a blind December?

FROM *THE HAUNTED HOUSE*
ROBERT GRAVES (1895–1985)

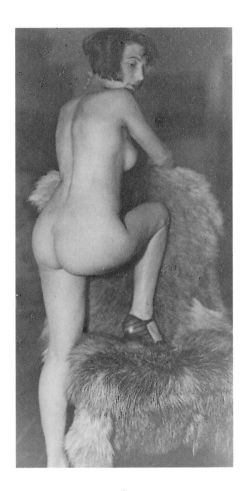

———————◊———————

ABOVE The tactile qualities of flesh and fur are explored in this photograph from the 1920s.

———————◊———————

He followed her; but, on the other side of the door, immediately thrust up against the wall, her sex and breasts seized by Sir Stephen, her mouth forced open by his tongue, O moaned from happiness and deliverance. The tips of her breasts stiffened beneath Sir Stephen's hand. He dug his other hand so roughly into her belly that she thought she might faint. Would she ever dare tell him that no pleasure, no joy, nothing she even imagined ever approached the happiness she felt before the freedom wherewith he made use of her, before the idea that he knew there were no precautions, no limits he had to observe in the manner whereby he sought his pleasure in her body. Her certitude that when he touched her, whether it be to caress or beat her, that when he ordered her to do something it was uniquely because he wanted her to do it and for his sole pleasure, the certitude that he made allowances for nothing, was concerned for nothing but his own desire, so overwhelmed O that, every time she had proof of it, and often even when she simply thought about it, a fiery vestment, a red-hot corselet extending from shoulders to knees seemed to descend over her. As she was there, standing pinned against the wall, eyes shut, murmuring I love you, I love you when there was breath in her to murmur, Sir Stephen's nevertheless cool hands, cool as well-water in contact with the fire consuming her, the fire which traveled up and down within her, burned her still more. He quit her gently, smoothing the skirt down over her wet thighs, shutting the bolero over her quivering breasts.

O is of course masochistic and it is that element within a balanced personality which may resonate to Pauline Réage's simple but powerful writing. But there is something else which disturbs about this novel, which appeared mysteriously in Paris in 1954 and which Graham Greene described as 'a rare thing, a pornographic book well written and without a trace of obscenity'. Let us look at the clues: the subordination of self; total obedience; O's serenity, which is constantly echoed in the writing. At the beginning of the novel O is prepared for her new life.

And then I know that they released O's hands, until that point still tied behind her back, and told her to undress. They were going to bathe her and make her up. But they made her stand still; they did everything for her, they stripped her and laid her clothes neatly away in one of the cupboards. They did not let her do her own bathing, they washed her themselves and set her hair just as hairdressers would have, making her sit in one of those big chairs that tilt backwards when your hair is being washed and then come up again when the drier is applied. That took at least an hour. She was seated nude in the chair and they prohibited her from either crossing her legs or pressing them together. As, on the opposite wall, there was a mirror running from floor to ceiling and straight ahead of her, in plain view, every time she glanced up she caught sight of herself, of her open body.

When she was made up, her eyelids lightly shadowed, her

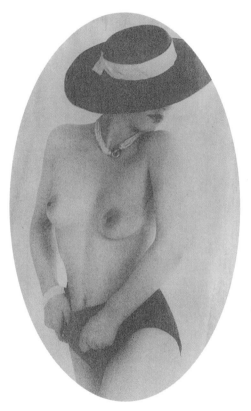

ABOVE 'Donna con Capello Nero' by Giovanni Zuin.

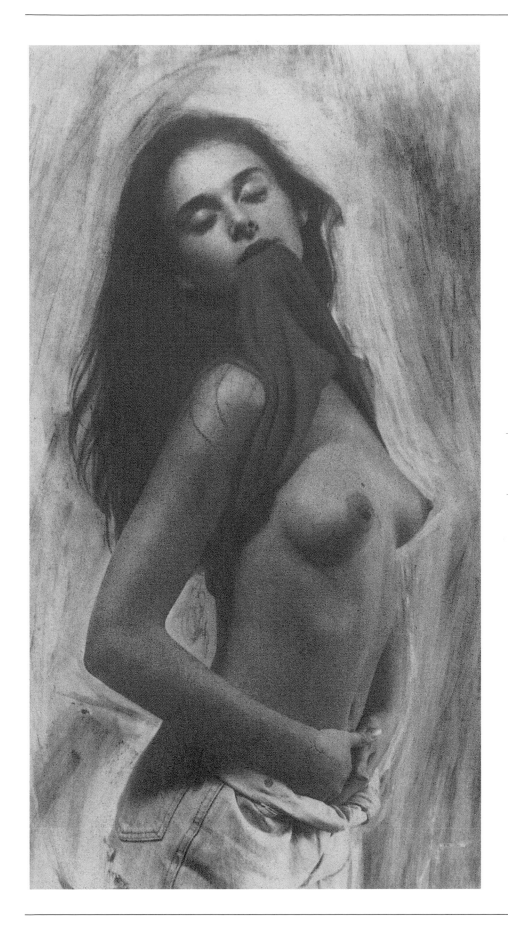

LEFT 'Seminudo in Piedi' by
Giovanni Zuin.

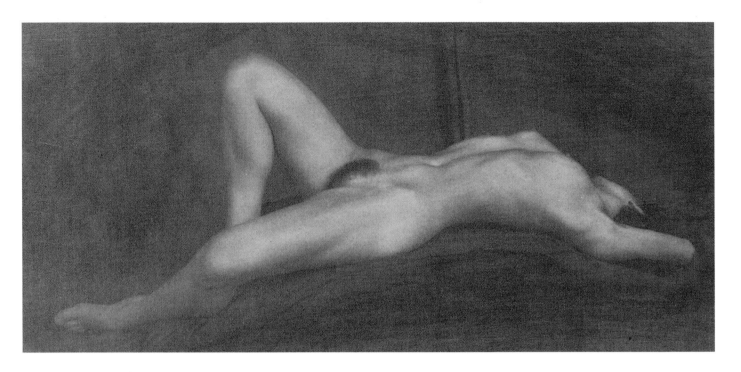

ABOVE 'Nudo in Rosso': another magnificent nude by Giovanni Zuin.

mouth very red, the point and halo of her nipples rouged, the sides of the lips of her sex reddened, a lingering scent applied to the fur of her armpits and her pubis, to the crease between her buttocks, to beneath her breasts and the palms of her hands, she was led into a room where a threesided mirror and, facing it, a fourth mirror on the opposite wall enabled, indeed obliged, her to see her own image reflected. She was told to sit on a hassock placed between the mirrors, and to wait.

Story of O is not an unpleasant parody of a nun's initiation. It is a novel full of cruelty but it is not anti-religious or blasphemous. It is simply the dark equivalent of what happens in the light.

Before looking at erotica which is intended to be anti-clerical, it is worth looking at a light-hearted piece from *Memoirs of a Venetian Courtesan*, where the involvement of the Church is impromptu – and unexpected.

There is in my house a small opening or window at the top of the main staircase. The house is very old and the original function has been long forgotten, though I imagine it was to allow light from what is now my dressing room onto the stairs.

Since some of the great and noble who visit me are apt to brush aside the servants who greet them at the door and make immediately towards the upper rooms, this opening now serves the purpose of preventing unhappy meetings. I am able to duck under the curtain and engage the impetuous or arrogant on the stairs. I can then give whatever excuse comes into my mind, divert them to another room, and make all smooth. No visitor of

a courtesan imagines that he is her only caller – but all hate to be reminded of it in an unseemly way.

The servants are well-used to sounding bells when visitors arrive. These signals, together with the window, have saved the day on numerous occasions. Never by so narrow a margin as on the day I shall presently describe.

At this time I was receiving the attention of two scions of powerful families who were bitter rivals for an important position on the Great Council. Both had asked for my help in securing votes for them in the election. On the day in question I was bringing up to its first stiffness the penis of one candidate when his rival came running headlong up the stairs. Abandoning my first guest I just managed to waylay my second – and unexpected – visitor on the stairs in the way I have already described. (Their families are too well-known, they must remain First and Second visitor.) The Second boy then begins his often repeated plea for me to bring my influence to bear in the election. It is too much! He drones on while his rival can hear every word from the other side of the little window behind the curtain. I should add that the First has the sight of my naked posterior as I bend forward to address his unsuspecting rival.

The humour of my predicament, the chance to mock his rival and my bare arse are too much for him. While the Second complains that his rival, the First, lacks integrity I can feel the First open the lips of my sex and push his tongue into me. I am trapped. I can say nothing and do nothing. My feeble attempt to push the First away with my foot is easily thwarted for he now has me pressed against the wall and unable to move. Nor can I shift the Second who is determined to make me hear him out.

It was as I felt the First tickling my anus with his tongue that the Head of the Capuchins arrived (in reality another religious order). Seen before he could retreat, he mounts the stairs. Although we all know that it is full balls and not a full heart which has brought the Abbot, he adopts a suitably benign expression and enquires earnestly after my well-being. Years of practice have perfected the Abbot's manner and expression. Had I not at this moment had a suitably wetted finger pushed up my bottom to remind me of the true nature of my calling, I could have almost believed that the Abbot called on courtesans and asked after their health.

There was no indication of any lull in the conversation, which had now taken a religious turn, when I felt the First's finger withdrawn and his stiff cock against my rump for the first time. He soon has the head pushing at the portal of my sex. No doubt finding me a little dry, he withdraws, wets himself with spittle and presses on again.

The first lunge took him right up to the hilt and exacted an involuntary gasp from me. The Abbot, interpreting this as disagreement with the point he has just made, begins to quote from the Scriptures to add weight to his argument.

The rhythmic in-and-out movements of the First's cock had just begun when my next guest arrived. Although of exceptionally short stature and given to unduly tall wigs, my French visitor is

ABOVE An engraving by Franz von Bayros.

Q: Wanting to know what love is, Livia had
Someone over to screw her for a bit.
A doubt arose, right in the midst of it:
Could having a mere taste, like this, be bad?

A: No, tasting is no sin, one understands.
But all the same, the sin she probes is lust:
A girl who wants to try a cock out must
Keep cool, or have a cock-up on her hands.

PIETRO ARETINO (1492–1557)

very charming and I should under any other circumstances have been pleased to see him. As it is, I begin to wonder if I must entertain the greater part of Venetian society while endeavouring to conceal the fact that I am being fucked behind the curtain.

The Frenchman may to this day believe that it is normal to receive people in this manner in Venice since the Abbot made a considerable effort to lend an air of everyday sociability to this bizarre gathering. I was now resigned to having to wait for the inevitable conclusion to my predicament. The conversation was spirited and intelligent and would ordinarily have held my attention. But as intellectual concentration was difficult it seemed logical to enjoy what was happening in the unseen world behind me.

This lasciviousness was the author of the next problem. As my

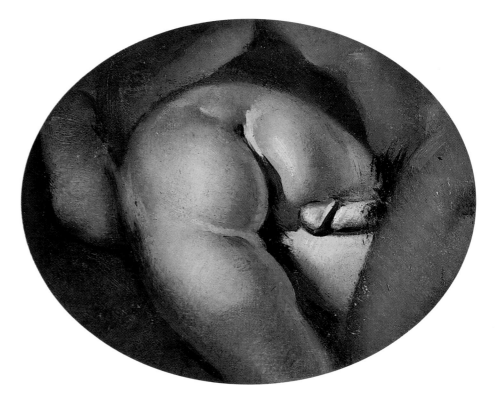

RIGHT The drama of chiaroscuro – the effect of light and shade – is used to heighten the eroticism of this remarkable anonymous oil painting.

body responded to the in-and-out movement of the First's cock, I began to emit what seemed to me at least to be an unmistakable sound.

The Frenchman, perhaps because his stature brought him nearer to the origin of the sound, was the first to notice it. I saw his eyes moving around the landing in search of possible causes. The Second then detected it and began to look about him. This loss of interest in the conversation had the unfortunate effect of making the gathering quieter just as the loudness and pace of the mysterious noise were increasing.

Thank God for the Abbot! In his determination to see normality even in the plainly abnormal – believing that this somehow made his presence in my house less suspicious – he launched into

explanations of what all could now plainly hear. The sound of his voice helped towards concealment even if 'swallows nesting' and 'the rising tide' did not.

Although my middle was firmly pressed against the wall – minimizing any reciprocal movement – the Frenchman now took an interest in the tendency of my partly exposed breasts to move in time with the noise.

Sensing that the loss of his oil was not far away, the First chose this moment to extract the maximum sensory, auditory and theatrical enjoyment by removing his cock completely from its moist sheath at the end of each stroke, before plunging in again. The combination of moisture and air brought forth a sound so lascivious, so unmistakable, so loud that all three visitors together bade me good morning and ran down the stairs.

───────────◊───────────

Much of the anti-clerical erotica produced from the Age of Enlightenment onwards makes poor reading. The frequently used formula which combined cruel invective and crueller sexual deviation automatically excludes it from this anthology. More interesting is the far older, and more successful, tradition which uses humour to lampoon the excesses of the ecclesiastical establishment.

Boccaccio di Chellino di Buonaiuto was born in 1313, probably in Paris where his father, who was to become Prior of Florence in 1321, first seduced and then abandoned his mother. Apprenticed to a merchant at the age of ten, Boccaccio soon rebelled. His father then tried to interest him in canon law, but this too failed. A period in Naples at the tolerant and enlightened court of King Robert allowed Boccaccio's genius to flourish. His most famous work, *The Decameron*, was written under the patronage of Queen Joan after 1348, although Boccaccio had clearly been gathering material for some time. It is an extraordinary work which was to have a considerable influence on European literature (Chaucer borrowed widely from it). Many of the stories ridicule contemporary Church morals. As he and Boccaccio shared a common agenda, it is ironic that *The Decameron* was among the 'vanities' consigned to the flames by the pious reformer Savonarola in 1497 (ironic also that his own bonfire was arranged by indignant Church officials only a year later, when he was burnt at the stake). 'The Tale of Masetto', who pretends to be a dumb simpleton in order to work in a nunnery, is typical of Boccaccio's humour.

Now it so befell that after a hard day's work he was taking a little rest, when two young nuns, who were walking in the garden, approached the spot where he lay, and stopped to look at him, while he pretended to be asleep. And so the bolder of the two said to the other:– 'If I thought thou wouldst keep the secret, I would tell thee what I have sometimes meditated, and which thou perhaps mightest also find agreeable.' The other replied:–

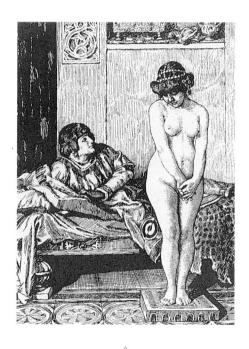

───────────◊───────────

ABOVE Another illustration from *Erotici* (see overleaf).

───────────◊───────────

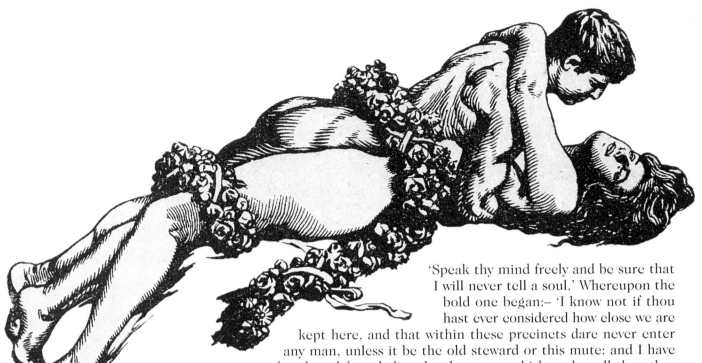

Dô hete er gemachet
alsô rîche
von bluomen eine bettestat.
des wirt noch gelachet
innecliche,
kumt iemen an daz selbe pfat.
bî den rôsen er wol mac
tandaradei,
merken wâ mirz houbet lac.

I watched him
As he made a bed
From sweetest meadow flowers.
Now anyone who finds the place,
Our blissful place,
Will laugh:
Seeing from the roses
Where we lay!

FROM *UNDER THE LINDEN TREE*
WALTHER VON DER VOGELWEIDE
(1170?–1230)

'Speak thy mind freely and be sure that I will never tell a soul.' Whereupon the bold one began:– 'I know not if thou hast ever considered how close we are kept here, and that within these precincts dare never enter any man, unless it be the old steward or this mute: and I have often heard from ladies that have come hither, that all the other sweets that the world has to offer signify not a jot in comparison of the pleasure that a woman has in connexion with a man. Whereof I have more than once been minded to make experiment with this mute, no other man being available. Nor, indeed, could one find any man in the whole world so meet therefor; seeing that he could not blab if he would; thou seest that he is but a dull clownish lad, whose size has increased out of all proportion to his sense; wherefore I would fain hear what thou hast to say to it.' 'Alas!' said the other, 'what is 't thou sayst? Knowest thou not that we have vowed our virginity to God?' 'Oh,' rejoined the first, 'think but how many vows are made to Him all day long, and never a one performed: and so, for our vow, let Him find another or others to perform it.' 'But,' said her companion, 'suppose that we conceived, how then?' 'Nay but,' protested the first, 'thou goest about to imagine evil before it befalls thee: time enough to think of that when it comes to pass; there will be a thousand ways to prevent its ever being known, so only we do not publish it ourselves.' Thus reassured, the other was now the more eager of the two to test the quality of the male human animal. 'Well then,' she said, 'how shall we go about it?' and was answered:– 'Thou seest 'tis past none; I make no doubt but all the sisters are asleep, except ourselves; search we through the kitchen-garden, to see if there be any there, and if there be none, we have but to take him by the hand and lead him hither to the hut where he takes shelter from the rain; and then one shall mount guard while the other has him with her inside. He is such a simpleton that he will do just whatever we bid him.' No word of this conversation escaped Masetto, who, being disposed to obey, hoped for nothing so much as that one of them should take him by the hand. They, meanwhile, looked carefully all about them, and

satisfied themselves that they were secure from observation: then she that had broached the subject came close up to Masetto, and shook him; whereupon he started to his feet. So she took him by the hand with a blandishing air, to which he replied with some clownish grins. And then she led him into the hut, where he needed no pressing to do what she desired of him. Which done, she changed places with the other, as loyal comradeship required; and Masetto, still keeping up the pretence of simplicity, did their pleasure. Wherefore before they left, each must needs make another assay of the mute's powers of riding; and afterwards, talking the matter over many times, they agreed that it was in truth not less but even more delightful than they had been given to understand; and so, as they found convenient opportunity, they continued to go and disport themselves with the mute.

Now it so chanced that one of their gossips, looking out of the window of her cell, saw what they did, and imparted it to two others. The three held counsel together whether they should not denounce the offenders to the abbess, but soon changed their mind, and came to an understanding with them, whereby they became partners in Masetto. And in course of time by divers chances the remaining three nuns also entered the partnership. Last of all the abbess, still witting nought of these doings, happened one very hot day, as she walked by herself through the garden, to find Masetto, who now rode so much by night that he could stand very little fatigue by day, stretched at full length asleep under the shade of an almond-tree, his person quite exposed in front by reason that the wind had disarranged his clothes. Which the lady observing, and knowing that she was alone, fell a prey to the same appetite to which her nuns had yielded: she aroused Masetto, and took him with her to her chamber, where, for some days, though the nuns loudly complained that the gardener no longer came to work in the kitchen-garden, she kept him, tasting and re-tasting the sweetness of that indulgence which she was wont to be the first to censure in others. And when at last she had sent him back from her chamber to his room, she must needs send for him again and again,

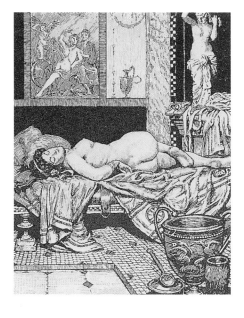

ABOVE, BELOW and OPPOSITE
Illustrations from the collection
Erotici published by Quintieri in
Milan in 1921 and drawn by Adolfo
Magrini.

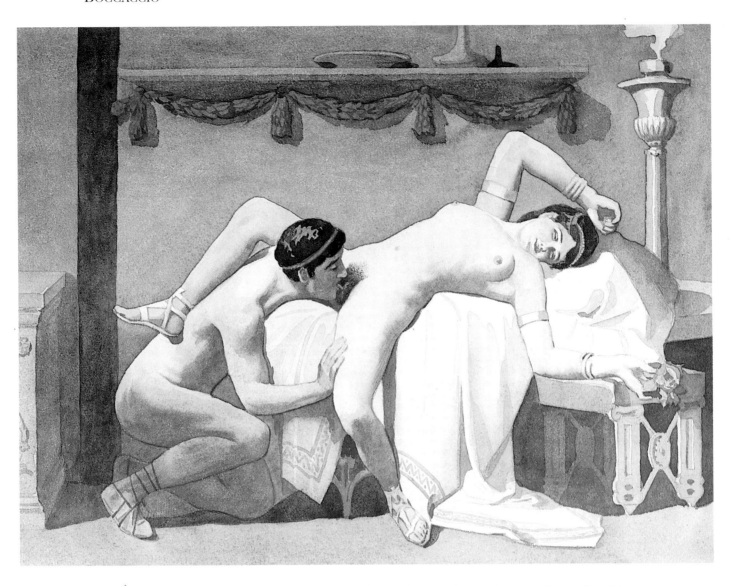

and made such exorbitant demands upon him, that Masetto, not being able to satisfy so many women, bethought him that his part of mute, should he persist in it, might entail disastrous consequences. So one night, when he was with the abbess, he cut the tongue-string, and thus broke silence:– 'Madam, I have understood that a cock may very well serve ten hens, but that ten men are sorely tasked to satisfy a single woman; and here am I expected to serve nine, a burden quite beyond my power to bear; nay, by what I have already undergone I am now so reduced that my strength is quite spent; wherefore either bid me Godspeed, or find some means to make matters tolerable.' Wonder-struck to hear the supposed mute thus speak, the lady exclaimed:– 'What means this? I took thee to be dumb.' 'And in sooth, Madam, so was I,' said Masetto, 'not indeed from my birth, but through an illness which took from me the power of speech, which only this very night have I recovered; and so I praise God with all my heart.' The lady believed him; and asked him what he meant by saying that he had nine to serve. Masetto told her how things

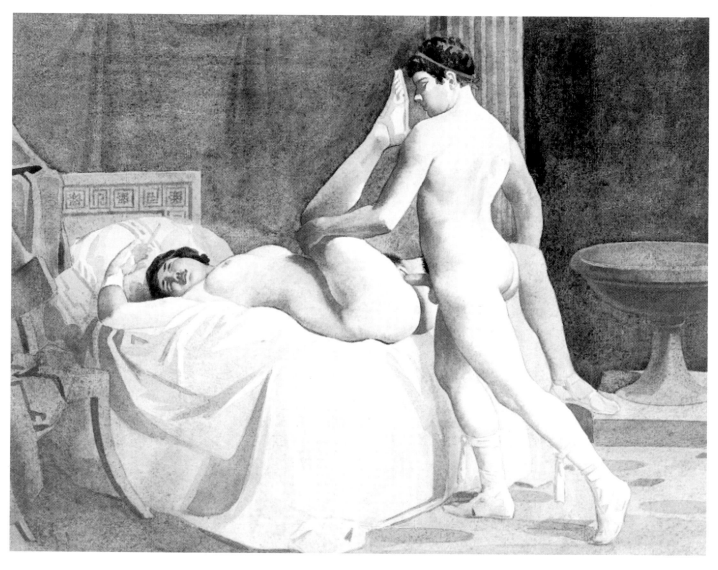

stood; whereby she perceived that of all her nuns there was not any but was much wiser than she; and lest, if Masetto were sent away, he should give the convent a bad name, she discreetly determined to arrange matters with the nuns in such sort that he might remain there. So, the steward having died within the last few days, she assembled all the nuns; and their and her own past errors being fully avowed, they by common consent, and with Masetto's concurrence, resolved that the neighbours should be given to understand that by their prayers and the merits of their patron saint, Masetto, long mute, had recovered the power of speech; after which they made him steward, and so ordered matters among themselves that he was able to endure the burden of their service. In the course of which, though he procreated not a few little monastics, yet 'twas all managed so discreetly that no breath of scandal stirred, until after the abbess's death, by which time Masetto was advanced in years and minded to return home with the wealth that he had gotten; which he was suffered to do as soon as he made his desire known.

Place your leg, dearest, on my
 shoulder here,
And take my truncheon in your tender
 grasp,
And while I gently move it, let your
 clasp
Tighten and draw me to your bosom
 dear.

FROM *SONNET NO. 4*
PIETRO ARETINO (1492–1557)

Church morals had clearly not improved three centuries later when Casanova visited Spain.

At Saragossa I saw the great devotion paid to Nuestra Señora del Pilar. I saw processions in which gigantic wooden statues were carried. I was taken to receptions where I found monks. I was introduced to a very fat lady who, I was told, was a cousin of the Blessed Palafox, at which I was expected to fall into a transport of reverence; and I made the acquaintance of a Canon Pignatelli, who was the presiding judge of the Inquisition and who every morning sent to prison the bawd who on the previous evening had arranged for him to sup with a whore, who had then spent the night with him. He woke up, and, after thus exercising his judicial authority, he went to confession, he said mass, then he dined, the devil in the flesh overcame him, another girl was procured for him, he enjoyed her, and the next morning he did over again what he had done the day before; and it was the same thing every day. Always struggling between God and the devil, the Canon was the happiest of men after dinner and the unhappiest in the morning.

RIGHT Rembrandt's famous *Monk in a Cornfield*: made with no particular anti-clerical intention that we know of, it probably records an incident he had seen during his walks in the countryside.

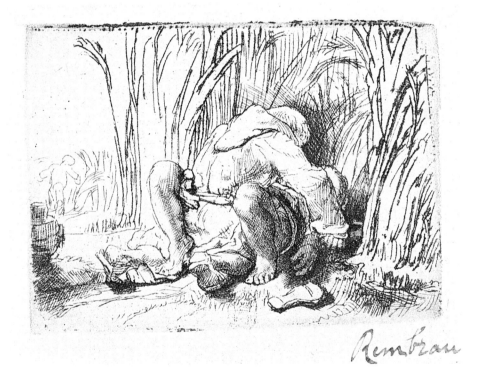

One of the most remarkable and successful anti-clerical erotic works is *Thérèse Philosophe*, written by the Marquis d'Argans and published with numerous highly explicit engravings in 1748. This urbane creation of the Enlightenment is a highly spiced amalgam of sexual instruction and libertine propaganda served up as a picaresque novel. This extract is a clever but disgraceful satire on holy relics in which Thérèse spies upon her

friend. Her homily at the end of the chapter is typical of the tone of the book.

. . . I suddenly noticed to my utter surprise that the venerable Father Dirrag opened his fly. A throbbing arrow shot out of his trousers which looked exactly like that fateful snake about which my former father confessor had warned me so vehemently.

The monster was as long and as thick and as heavy as the one about which the Capuchine monk had made all those dire predictions. I shuddered with delightful horror. The red head of this snake seemed to threaten Eradice's behind which had taken on a deep pink colouration because of the blows it had received during the Bible recitation. The face of Father Dirrag perspired and was flushed a deep red.

'And now,' he said, 'you have to transport yourself into total meditation. You must separate your soul from the senses. And if my dear daughter has not disappointed my pious hopes, she shall neither feel, nor hear, nor see anything.'

And at that very moment this horrible man loosened a hail of blows, letting them whistle down upon Eradice's naked buttocks. However, she did not say a word; it seemed as if she were totally insensitive to this horrendous whipping. I noticed only an occasional twitching of her bum, a sort of spasming and relaxing at the rhythm of the priest's blows.

'I am very satisfied with you,' he told her after he had punished her for about five minutes in this manner. 'The time has come when you are going to reap the fruits of your holy labours. Don't question me, my dear daughter, but be guided by God's will which is working through me. Throw yourself, face down, upon the floor; I will now expel the last traces of impurity with a sacred relic. It is a part of the venerable rope which girded the waist of the holy Saint Francis himself.'

The good priest put Eradice in a position which was rather uncomfortable for her, but extremely fitting for what he had in mind. I had never seen my girl friend in such a beautiful position. Her buttocks were half-opened and the double path to satisfaction was wide-open.

After the old lecher had admired her for a while, he moistened his so-called rope of Saint Francis with spittle, murmured some of the priestly mumbo-jumbo which these gentlemen generally use to exorcise the devil, and proceeded to shove the rope into my friend.

I could watch the entire operation from my little hideout. The windows of the room were opposite the door of the alcove in which Eradice had locked me up. She was kneeling on the floor, her arms were crossed over the footstool and her head rested upon her folded arms. Her skirts, which had been carefully folded almost up to her shoulders, revealed her marvellous buttocks and the beautiful curve of her back. This exciting view did not escape the attention of the venerable Father Dirrag. His gaze feasted upon the view for quite some time. He had clamped the legs of his penitent between his own legs, and he dropped his trousers, and his hands held the monstrous rope. Sitting in this

Q: The Abbess woke up frantic after she
Had dreamed all night of eating gooseberry fool,
To find her mouth full of the abbot's tool.
How had she sinned, though? Greed? Or lechery?

A: She didn't sin, as far as we make out,
In either way. It was an accident –
Although, if she had found it in her cunt
Or up her arse, there might have been some doubt.

PIETRO ARETINO (1492–1557)

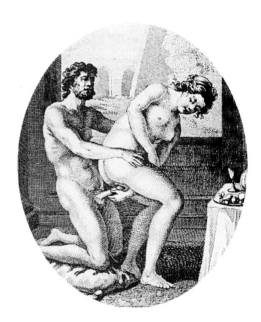

position he murmured some words which I could not understand.

He lingered for some time in this devotional position and inspected the altar with glowing eyes. He seemed to be undecided how to effect his sacrifice, since there were two inviting openings. His eyes devoured both and it seemed as if he were unable to make up his mind. The top one was a well-known delight for a priest, but, after all, he had also promised a taste of Heaven to his penitent. What was he to do? Several times he knocked with the tip of his tool at the gate he desired most, but finally he was smart enough to let wisdom triumph over desire. I must do him justice: I clearly saw his monstrous prick disappear the natural way, after his priestly fingers had carefully parted the rosy lips of Eradice's lovepit.

The labour started with three forceful shoves which made him enter about halfway. And suddenly the seeming calmness of the priest changed into some sort of fury. My God, what a change! Imagine a satyr. Mouth half-open, lips foam-flecked, teeth gnashing and snorting like a bull who is about to attack a cud-chewing cow. His hands were only half an inch away from Eradice's full behind. I could see that he did not dare to lean upon them. His spread fingers were spasming; they looked like the feet of a fried capon. His head was bowed and his eyes stared at the so-called relic. He measured his shoving very carefully, seeing to it that he never left her lovepit and also that his belly never touched her arse. He did not want his penitent to find out to whom the holy relic of Saint Francis was connected! What an incredible presence of mind!

I could clearly see that about an inch of the holy tool constantly remained on the outside and never took part in the festivities. I could see that with every backward movement of the priest the red lips of Eradice's love-nest opened and I remember clearly that the vivid pink colour was a most charming sight. However, whenever the good priest shoved forward, the lips closed and I could only see the finely curled hairs which covered them. They clamped around the priestly tool so firmly that it seemed as if they had devoured the holy arrow. It looked for all the world like both of them were connected to Saint Francis' relic and it was hard to guess which one of the two persons was the true possessor of this holy tool.

What a sight, especially for a young girl who knew nothing about these secrets. The most amazing thoughts ran through my head, but they all were rather vague and I could not find proper words for them. I only remember that I wanted to throw myself at least twenty times at the feet of this famous father confessor and beg him to exorcise me the same way he was blessing my dear friend. Was this piety? Or carnal desire? Even today I could not tell you for sure.

But, let's go back to our devout couple! The movements of the priest quickened; he was barely able to keep his balance. His body formed an 'S' from head to toe whose frontal bulge moved rapidly back and forth in a horizontal line.

'Is your spirit receiving any satisfaction, my dear little saint?' he asked with a deep sigh. 'I, myself, can see Heaven open up.

God's infinite mercy is about to remove me from this vale of tears, I . . .'

'Oh, venerable Father,' exclaimed Eradice, 'I cannot describe the delights that are flowing through me! Oh, yes, yes, I experience Heavenly bliss. I can feel how my spirit is being liberated from all earthly desires. Please, please, dearest Father, exorcise every last impurity remaining upon my tainted soul. I can see . . . the angels of God . . . push stronger . . . ooh . . . shove the holy relic deeper . . . deeper. Please, dearest Father, shove it as hard as you can . . . Ooooh! . . . ooh!!! dearest holy Saint Francis . . . Ooh, good saint . . . please, don't leave me in the hour of my greatest need . . . I feel your relic . . . it is sooo good . . . your . . . holy . . . relic . . . I can't hold it any longer . . . I am . . . dying!'

The priest also felt his climax approach. He shoved, slammed, snorted and groaned. Eradice's last remark was for him the signal to stop and pull out. I saw the proud snake. It had become very meek and small. It crawled out of its hole, foam-covered, with hanging head.

Everything disappeared back into the trousers; the priest dropped his cowl over it all and wavered back to his prayer stool. He kneeled down, pretended to be in deep communication with his Lord, and ordered his penitent to stand up, cover herself and sit down next to him to thank God for His infinite mercy which she had just received from Him.

What else shall I tell you? Dirrag left, Eradice opened the door to the alcove and embraced me, crying out, 'Oh, my dearest Thérèse. Partake of my joy and delight. Yes, yes, today I have seen paradise. I have shared the delights of the angels. The incredible joy, my dearest friend, the incomparable price for but one moment of pain! Thanks to the holy rope of Saint Francis my soul almost left its earthly vessel. You have seen how my good father confessor introduced the relic into me. I swear that I could feel it touch my heart. Just a little bit deeper and I would have joined the saints in paradise!'

Eradice told me a thousand other things, and her tone of voice, her enthusiasm about the incredible delights she had enjoyed left no doubt in my mind about their reality. I was so excited that I was barely able to answer her. I did not congratulate her, because I was unable to talk. My heart pounded in wild excitement, I embraced her, and left.

So many thoughts are racing through my mind right now that I hardly know where to begin. It is terrifying to realize how the most honourable convictions of our society are being misused. How positively fiendish was the way in which this cowl-bearer perverted the piety of his penitent to his own lecherous desires. He needled her imagination, artfully using her desire to become a saint; he convinced her that she would be able to succeed, if she separated her mind from her body. This, however, could only be achieved by means of flagellation. Most likely it was the hypocrite himself who needed this stimulation to repair the weakened elasticity of his flagging member. And then he tells her, 'If your devotion is perfect, you shall not be able to feel, hear, or see anything!'

Restoration comedy: Samuel Pepys (1633–1703) witnessed a riot in Bow Street when Sir Charles Sedley, nude, urinated on a watching crowd after enacting 'all the postures of lust and buggery that could be imagined, and abusing of Scripture . . . preached a mountebank sermon from that pulpit, saying that there he hath to sell such a powder as should make all the cunts run after him – a thousand people standing underneath to see and hear him. And that being done he took a glass of wine and drank the King's health.'

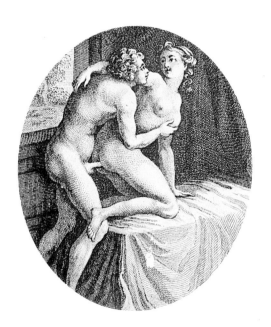

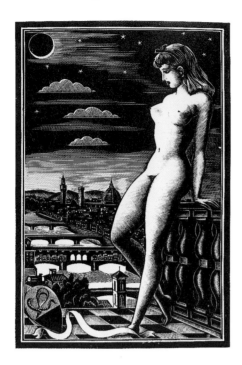

That way he made sure that she would not turn around and see his shameless desire. The blows of the rod upon her buttocks not only increased the feeling in that part which he intended to attack, but they also served to make him more horny than he already was. And the relic of Saint Francis which he shoved into the body of his innocent penitent to chase away impurities which were still clinging to her soul, enabled him to enjoy his desires without any danger to himself. His newly-initiated penitent mistook her most voluptuous outburst of carnal climax for a divinely inspired, purely spiritual ecstasy.

◊

Our last anti-clerical piece is from *Josefine Mutzenbacher* (*oder Jugent-Geschichte einer wienerischen Dirne* ['Story of a Young Viennese Maiden']). This novel, written in the Viennese vernacular – which includes borrowings from Serbian and Yiddish as well as Bavarian – is generally thought to be the work of Felix Salten (1869–1945), and he certainly never denied authorship. Born in Hungary, Salten was working as a journalist in Vienna in 1906 when *Josefine Mutzenbacher* was first published. Josefine is the archetypal heroine of the dark erotic novel: a voracious nymphomaniac who proceeds through a catalogue of sexual encounters and perversions 'with the inevitability of a sleepwalker' to borrow a phrase from her Viennese contemporary, Adolf Hitler. In the following episode Josefine's confessor exacts a form of penance which will come as no surprise.

Still standing he advanced his sacred candle, all warm, to the opening. Feeling this I could not resist thrusting myself towards him. Slowly, very slowly he penetrated me. He groaned loudly but I couldn't see his face. I clasped his stalk – which had penetrated quite a long way – firmly in my mussel.

By now I wanted to be fucked properly. Especially as it wasn't a

ABOVE, BELOW and OPPOSITE Woodcuts by Italo Zetti designed to be used as bookplates.

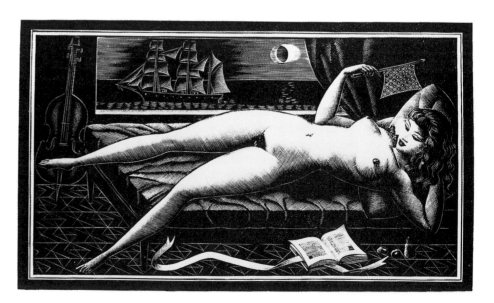

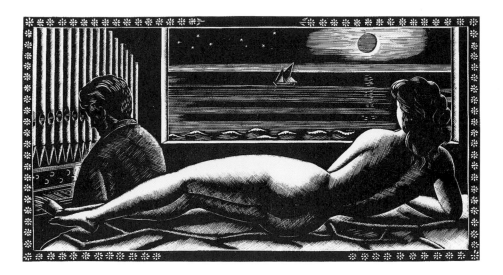

sin. I lay there feeling a mixture of amazement, desire, pleasure and the urge to laugh which finally dissolved my inhibitions. I began to realize that the Kooperator was play-acting and had all along had the intention of powdering me. But I resolved to play along and not give the game away – I still believed the priest had the power to grant absolution. He stayed with his pole lodged in my flesh without moving, breathing heavily. I began to waggle my popo up and down, which made him groan.

'Father,' I whispered. 'What?' 'It wasn't like this,' I said softly. 'How was it then?' 'Back and forth, in and out, that's how he went.' He started pushing carefully but fast and strong. 'Like that, maybe?' 'Ah, ah, yes,' I cried, shuddering in an ecstasy of pleasure, 'but faster, Father, faster!' 'Good girl, good girl,' he roared, 'tell me exactly how it was . . . tell me . . . ,' he couldn't carry on speaking, he was breathing so stormily and ramming so violently.

I needed no further encouragement. 'Ah, ah, that's how it was, it's good like this, better; Father, shoot now, I'm coming, I'm coming, I can't help it, oh Father your cock is so good – it's so very good!'

He propped himself on his hands, bending over me as far as his fat belly allowed. His round, red face was suffused with blue. He looked at me with wild eyes, rammed like a billy goat and whispered, 'Take the hammer of mercy, it will do you no harm, take it, girlie, shall I shoot, do you want that too? Good, I'll shoot, I'll anoint you.'

'Father,' I interrupted, 'Father, I sinned with my breasts too.' 'What do you mean?' he asked, eyes bulging. 'Ah, ah, I'm coming again . . . when I was screwing I always had my tits stroked and kissed and sucked.' I said this to make him do the same.

But his corpulent figure prevented him from getting at my breasts. He leant his hands on the bed and still he couldn't reach. 'That will come later, I'll touch your tits later,' he gasped, 'Let me shoot first . . . I . . . move, sweetie. I like that, your little cunt, your sweet cunt up and down . . . ah, you're good at that, very good, let me shoot, then I'll take your pretty little breasts . . .

Vows can't change nature, priests are only men,
And love likes stratagem and subterfuge

FROM *THE RING AND THE BOOK*
ROBERT BROWNING (1812–89)

Do not confuse the priesthood with the Church or there is no hope for the world!

AGATHIAS (SIXTH CENTURY AD)

I'm coming . . . that's so sweet,' and stammering like this his seed shot out and a great jet spurted out all over me.

When he had finished, he said with great dignity, 'You heard what I said, my daughter; you see that I have mimicked the words of the arch-enemy and seducer in your interest so that the unchaste words you heard in your lascivious embraces will lose their power over you.'

I sat on the edge of the bed and wiped away with my handkerchief the flood the priest had left between my legs. I was well aware of the deception behind his words, but I said nothing. Screwed was screwed, after all, and for me now the Kooperator was just another Mr. Horak or Mr. Ekhardt – except that he interested me more because he was refined and because I still felt in awe of him. I was on the priest's side because he gave me the advantage of a twofold pleasure, firstly by means of his hammer of mercy and secondly by his absolution of my sins, which I still believed in.

He had seated himself in the armchair again and called me to him. 'Come now,' he said, still panting, 'now I'll do what you wanted with your breasts.' He unbuttoned my bodice and pulled out my small round breasts. They stood out like ivory balls with a nipple like a raspberry on each one. The priest must have been a great lover of fresh fruit for he took each raspberry in his mouth in turn and sucked it until it was shiny, as some fruitsellers in Capri lick their strawberries to give them an appetizing sheen with their spittle.

When he had done this with much grunting and panting for some time he said, 'Is that how it was?' 'Yes, that's how it was.' 'And were you this lazy while your breasts were being played with?' he asked, as he made my nipples throb. 'Didn't you do anything, didn't you play with him?' Realizing what he wanted I began to swing the incense burner but it was limp and couldn't be raised. 'Sit up,' he said. I sat in front of him on his desk with my feet on his knees. 'Now for the best, the main thing,' he said. I didn't know what he meant and smiled. 'Yes, my daughter,' he gasped, 'now I myself will purify you and remove all that sullies you.' So saying, he lifted up my clothing so I was again completely uncovered. He put my legs on his shoulders and his head between my thighs, so that I had to prop myself on the desk top with my elbows. He brought his mouth close to my cunt and I could

feel his hot breath. I didn't know what the Kooperator intended to do but I hoped it was something pleasant.

Oh how I felt, as his thick hot lips touched my lips and his soft wet tongue scoured my crack from the bottom to the top. I trembled with a feeling I had never experienced before. Never had I felt such delight. Before, I had pleasured men with my mouth but this bold priest was the first to lend me his tongue. My buttocks twitched and my man-trap closed as if to grasp his thrusting cock. The Kooperator raised his head and asked, 'Do you like that?' Trembling with desire and wanting more I answered quickly, 'Yes, Father.' He drew his tongue across the entrance again so delicately that the pleasure was at once tormenting and delightful. Then he asked, 'Has anyone done that to you before?' 'No,' I said and raised my popo – so that it was like a beaker proffered to his lips. 'This will purify you, this will take all your sins away,' he said. I grasped his head and caught hold of his tonsure, pulling him down to make better use of his mouth than talking.

Now he began to work my button. I felt as if all feeling was suddenly focused there, my mouth, my nipples, the inner recesses of my cunt. Where the tip of his tongue touched me electricity seemed to shoot into my body. I couldn't breathe, the room spun round and I closed my eyes. Then the Kooperator thrust his tongue deep into me. My cunt danced a czardas on the desk. What was screwing compared with this ecstasy? I drew my crack all over his face by jerking my arse up and down. I felt his tongue sometimes deep inside me, sometimes beating on my trembling clitoris, sometimes sucking everything with his lips. I came so that I felt my insides were being emptied. It was better than the best fucking and yet I had only one thought throughout – that of a gigantic cock looming before me, a cock I wanted inside me – penetrating deep into me.

'I'm coming – I keep coming,' I cried – 'Oh, this is like Heaven, Father, it's never been so good, please fuck me, Father, give me your cock, screw me, no, stay, ah,' I'm shrieking.

I had suddenly thrown myself backward, my head on the inkwell, but the priest had risen, and his face, bluish, with foam round his mouth, appeared before me.

'Come – sit on my legs – then you can mount my cock again.'

He lay back in the chair. I held both arms and rode on the tip of the steeple – for no more could be seen below his fat belly. So that I didn't fall he held my breasts fast and we did our second number with great enjoyment on both sides.

Then he let me off his lap and handed me a towel. As I wiped myself he said, 'Wait, mousie, you'll want to piss now,' and fetched me the huge blue chamberpot himself. I pissed water along with all the holy oil with which I had been so freely anointed. The Kooperator stood up and fastened his trousers. I got myself in order and when my dress was buttoned – not without some farewell caresses of my breasts by the priest – I awaited to see what would follow.

But nothing did. The Kooperator said, 'Go now, my daughter; I shall pray for you and early tomorrow morning come to me for confession in church.'

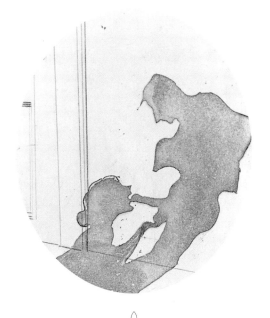

ABOVE Fellatio: French engraving c. 1930.

Josefine Mutzenbacher has humour, but its chief attraction is the language. The text is peppered with an extraordinary variety of sexual words and metaphors, some created by the author, others clearly in common currency in Vienna at the time. There are more than two hundred different terms for the penis! But does this make the descriptions of sex any better?

In his novel *G* John Berger writes a beautiful description of a sexual encounter between a teenage boy and his aunt. He then goes on to question the limitations of language in relation to the experience.

I see a horse and trap drawn up by the front door of the farmhouse. In it is a man in black with a bowler hat. He is portly and unaccountably comic. The horse is black and so too is the trap except for its white trimming. I am looking down on the horse and trap and the man who is so comically correct and regular, from the window of Beatrice's room.

On the table between the window and the large four-poster bed is the vase of white lilac. The smell of it is the only element that I can reconstruct with certainty.

She must be thirty-six. Her hair, usually combed up into a chignon, is loose around her shoulders. She wears an embroidered wrap. The embroidered leaves mount to her shoulder. She is standing in bare feet.

The boy enters and informs her that the papers for the man in the trap were the correct ones.

He is fifteen: taller than Beatrice, dark-haired, large-nosed but with delicate hands, scarcely larger than hers. In the relation between his head and shoulders there is something of his father – a kind of lunging assurance.

Beatrice lifts an arm towards him and opens her hand.

Pushing the door shut behind him, he goes towards her and takes her hand.

She, by turning their hands, ensures that they both look out of the window. At the sight of the man in black on the point of leaving they begin to laugh.

When they laugh they swing back the arms of their held hands and this swinging moves them away from the window towards the bed.

They sit on the edge of the bed before they stop laughing.

Slowly they lie back until their heads touch the counterpane. In this movement backwards she slightly anticipates him.

They are aware of a taste of sweetness in their throats. (A sweetness not unlike that to be tasted in a sweet grape.) The sweetness itself is not extreme but the experience of tasting it is. It is comparable with the experience of acute pain. But whereas pain closes anticipation of everything except the return of the past before the pain existed, what is now desired has never existed.

From the moment he entered the room it has been as though the sequence of their actions constituted a single act, a single stroke.

Our kisses
Rhodope
let us steal,
and slip
with furtive ease
like burglars
into bed.

To cheat the eyes
of stern
leering prudes
adds honey to
love's cup.

PAULOS (c. SIXTH CENTURY AD)

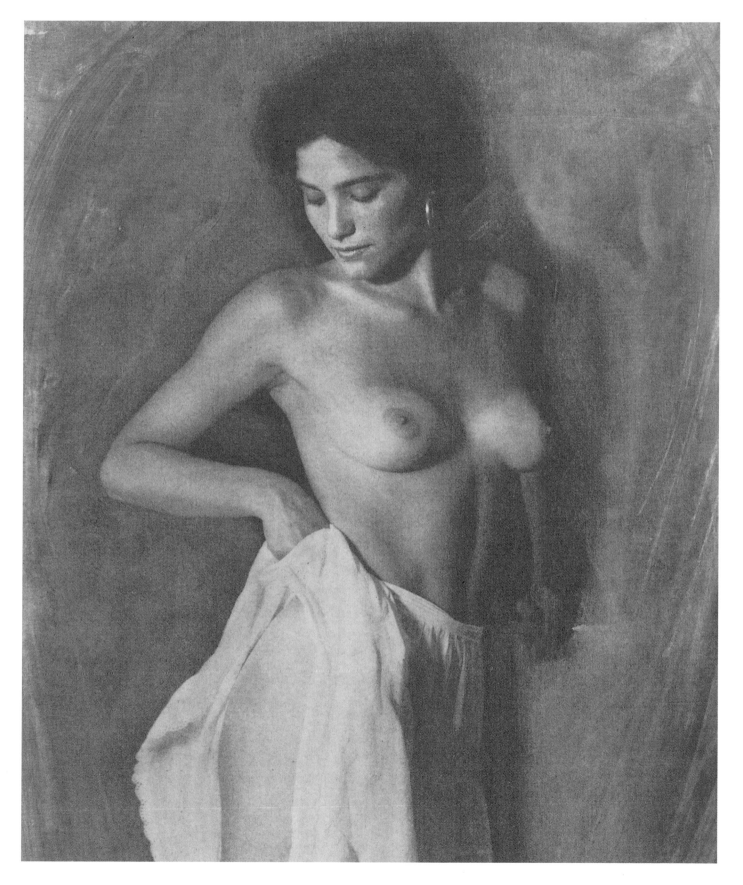

Beatrice puts her hand to the back of his head to move him closer towards her.

Beneath her wrap Beatrice's skin is softer than anything he has previously imagined. He has thought of softness as a quality belonging either to something small and concentrated (like a peach) or else to something extensive but thin (like milk). Her softness belongs to a body which has substance and seems very large. Not large relative to him, but large relative to anything else he now perceives. This magnification of her body is partly the result of proximity and focus but also of the sense of touch superseding that of sight. She is no longer contained within any contour, she is continuous surface.

He bends his head to kiss her breast and take the nipple in his mouth. His awareness of what he is doing certifies the death of his childhood. This awareness is inseparable from a sensation and a taste in his mouth. The sensation is of a morsel, alive, unaccountably half-detached from the roundness of the breast – as though it were on a stalk. The taste is so associated with the texture and substance of the morsel and with its temperature, that it will be hard ever to define it in other terms. It is a little similar to the taste of the whitish juice in the stem of a certain kind of grass. He is aware that henceforth both sensation and taste are acquirable on his own initiative. Her breasts propose his independence. He buries his face between them.

Her difference from him acts like a mirror. Whatever he notices or dwells upon in her, increases his consciousness of himself, without his attention shifting from her.

BELOW 'Seminudo di Spalle' by Giovanni Zuin.

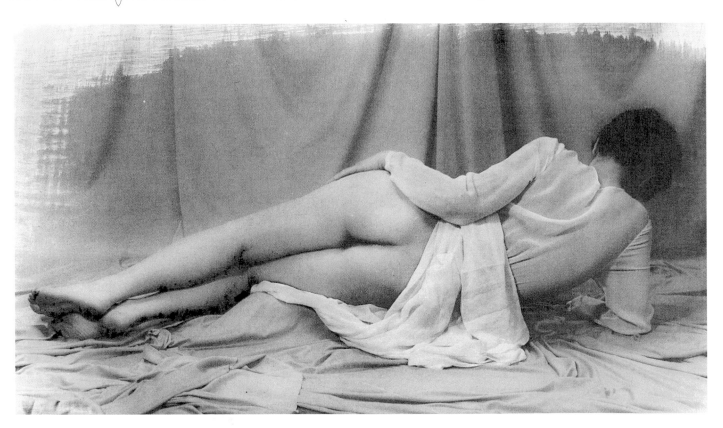

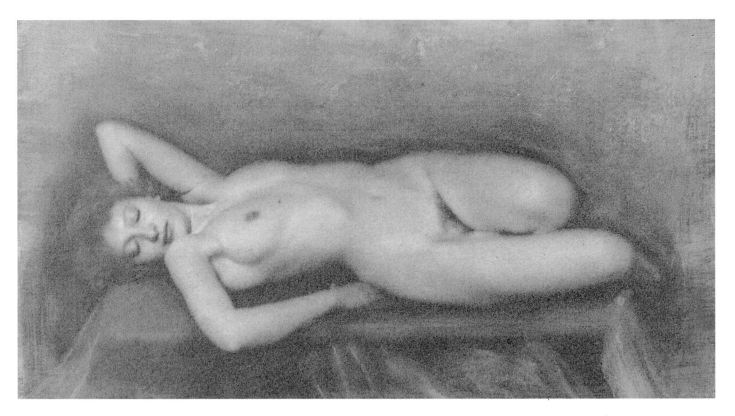

She is the woman whom he used to call Aunt Beatrice. She ran the house and gave orders to the servants. She linked arms with her brother and walked up and down the lawn. She took him when he was a child to church. She asked him questions about what he had learnt in the School Room: questions like What are the chief rivers of Africa?

Occasionally during his childhood she surprised him. Once he saw her squatting in the corner of a field and afterwards he wondered whether she was peeing. In the middle of the night he had woken up to hear her laughing so wildly that he thought she was screaming. One afternoon he came into the kitchen and saw her drawing a cow with a piece of chalk on the tiled floor – a childish drawing like he might have done when younger.

On each of these occasions his surprise was the result of his discovering that she was different when she was alone or when she believed that he was not there.

This morning when she had asked him to come to her bedroom, she had presented a different self to him, yet he knew this was no longer a matter of chance discovery but of deliberate intention on her part. Her hair was loose around her shoulders. He had never seen or imagined it like that before. Her face seemed smaller, much smaller than his own. The top of her head looked unexpectedly flat and her hair over the flatness very glossy. The expression of her eyes was serious to the point of gravity. Two small shoes lay on their sides on the carpet. She was barefoot. Her voice too was different, her words much slower.

I cannot remember, she said, any lilac ever having a scent like this lot.

This morning he was not surprised. He accepted the changes. Nevertheless this morning he still thought of her as the mistress of the house in which he had passed his childhood.

She is a mythical figure whom he has always been assembling part by part, quality by quality. Her softness – but not the extent of its area – is more familiar than he can remember. Her heated sweating skin is the source of the warmth he felt in Miss Helen's clothes. Her independence from him is what he recognized in the tree trunk when he kissed it. The whiteness of her body is what has signalled nakedness to him whenever he has glimpsed a white segment through the chance disarray of petticoat or skirt. Her smell is the smell of fields which, in the early morning, smell of fish although many miles from the sea. Her two breasts are what

RIGHT 'Donna Addormentata' by Giovanni Zuin.

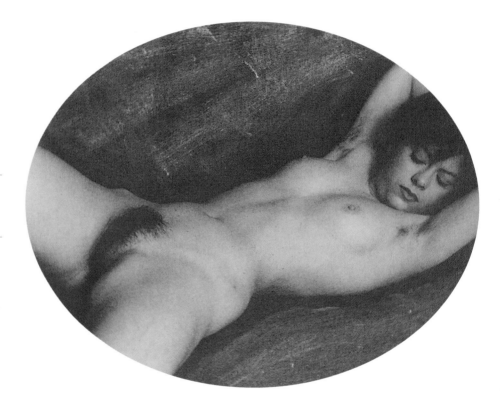

his reason has long since granted her, although their distinctness and degree of independence one from the other astonish him. He has seen drawings on walls asserting how she lacks penis and testicles. (The dark beard-like triangle of hair makes their absence simpler and more natural than he foresaw.) This mythical figure embodies the desirable alternative to all that disgusts or revolts him. It is for her sake that he has ignored his own instinct for self-preservation – as when he walked away, revolted, from the men in sack-cloths and the dead horses. She and he together, mysteriously and naked, are his own virtue rewarded.

Mythical familiar and the woman he once called Aunt Beatrice meet in the same person. The encounter utterly destroys both of them. Neither will ever again exist.

He sees the eyes of an unknown woman looking up at him. She

looks at him without her eyes fully focusing upon him as though, like nature, he were to be found everywhere.

He hears the voice of an unknown woman speaking to him: Sweet, sweet, sweetest. Let us go to that place.

He unhesitatingly puts his hand on her hair and opens his fingers to let it spring up between them. What he feels in his hand is inexplicably familiar.

She opens her legs. He pushes his finger towards her. Warm mucus encloses his finger as closely as if it were a ninth skin. When he moves the finger, the surface of the enclosing liquid is stretched – sometimes to breaking point. Where the break occurs he has a sensation of coolness on that side of his finger – before the warm moist skin forms again over the break.

She holds his penis with both hands, as though it were a bottle from which she were about to pour towards herself.

She moves sideways so as to be beneath him.

Her cunt begins at her toes; her breasts are inside it, and her eyes too; it has enfolded her.

It enfolds him.

The ease.

Previously it was unimaginable, like a birth for that which is born.

It is eight o'clock on a December morning. People are already at work or going to work. It is still not fully light and the darkness is foggy. I have just left a laundry, where the violet fluorescent lighting bleaches most stains out until you unwrap the washing and look at it in your own room. Under the fluorescent lighting the girl behind the counter had the white face of a clown with green eye shadow and violet almost white lips. The people I pass in the rue d'Odessa move briskly but rigidly, or hold themselves stiff against the cold. It is hard to imagine that most of them were in bed two hours ago, languid, unrestrained. Their clothes – even those chosen with the greatest personal care or romantic passion – all look as though they are the uniforms of a public service into which everybody has been drafted. Every personal desire, preference or hope has become an inconvenience. I wait at the bus stop. The waving red indicator of the Paris bus, as it turns the corner, is like a brand taken from a fire. At this moment I begin to doubt the value of poems about sex.

Sexuality is by its nature precise: or rather, its aim is precise. Any imprecision registered by any of the five senses tends to check sexual desire. The focus of sexual desire is concentrated and sharp. The breast may be seen as a model of such focus, gathering from an indefinable, soft variable form to the demarcation of the aureola and, within that, to the precise tip of the nipple.

In an indeterminate world in flux sexual desire is reinforced by a longing for precision and certainty: beside her my life is arranged.

In a static hierarchic world sexual desire is reinforced by a longing for an alternative certainty: with her I am free.

All generalizations are opposed to sexuality.

Bird sighs for the air,
Thought for I know not where,
For the womb the seed sighs.
Now sinks the same rest
On mind, on nest,
On straining thighs.

THE LOVER'S SONG
W. B. YEATS (1865–1939)

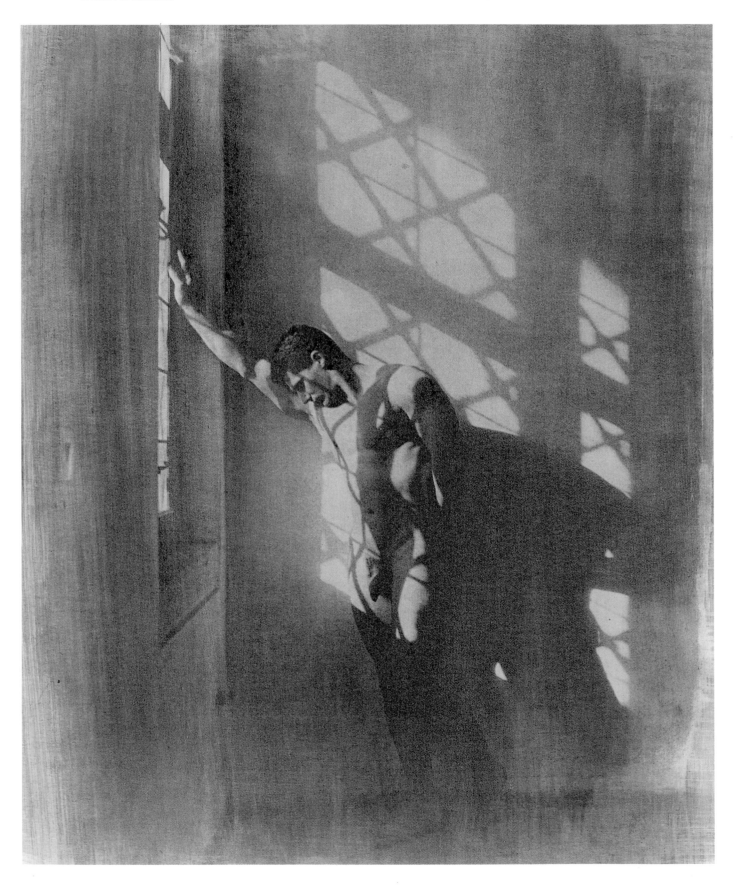

Every feature that makes her desirable asserts its contingency – here, here, here, here, here, here.

That is the only poem to be written about sex – here, here, here, here – now.

Why does writing about sexual experience reveal so strikingly what may be a general limitation of literature in relation to aspects of all experience?

In sex, a quality of 'firstness' is felt as continually re-creatable. There is an element in every occasion of sexual excitement which seizes the imagination as though for the first time.

What is this quality of 'firstness'? How, usually, do first experiences differ from later ones?

Take the example of a seasonal fruit: blackberries. The advantage of this example is that one's first experience each year of eating blackberries has in it an element of artificial firstness which may prompt one's memory of the original, first occasion. The first time, a handful of blackberries represented all blackberries. Later, a handful of blackberries is a handful of ripe/unripe/over-ripe/sweet/acid, etc., etc., blackberries. Discrimination develops with experience. But the development is not only quantitative. The qualitative change is to be found in the relation between the particular and the general. You lose the symbolically complete nature of whatever is in hand. First experience is protected by a sense of enormous power; it wields magic.

The distinction between first and repeated experience is that one represents all: but two, three, four, five, six, seven ad infinitum cannot. First experiences are discoveries of original meaning which the language of later experience lacks the power to express.

The strength of human sexual desire can be explained in terms of natural sexual impulse. But the strength of a desire can be measured by the single-mindedness it produces. Extreme singlemindedness accompanies sexual desire. The single-mindedness takes the form of the conviction that what is desired is the most desirable possible. An erection is the beginning of a process of total idealization.

At a given moment sexual desire becomes inextinguishable. The threat of death itself will be ignored. What is desired is now exclusively desired; it is not possible to desire anything else.

At its briefest, the moment of total desire lasts as long as the moment of orgasm. It lasts longer when passion increases and extends desire. Yet, even at its briefest, the experience should not be treated as only a physical/nervous reflex. The stuff of imagination (memory, language, dreams) is being deployed. Because the other who is palpable and unique between one's arms is – at least for a few instants – exclusively desired, she or he represents, without qualification or discrimination, life itself. The experience = I + life.

But how to write about this? This equation is inexpressible in

Each of these superb contemporary nudes has been coloured and finished by the photographer, Giovanni Zuin. OPPOSITE 'Nudo Maschile alla Finestra'; BELOW Another 'Donna Addormentata'.

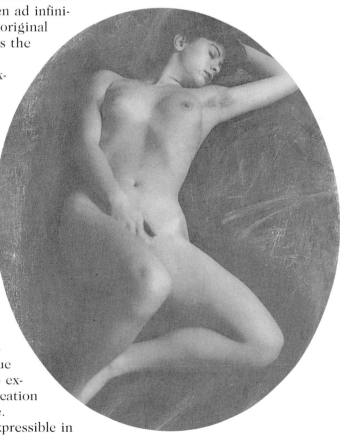

Children are dumb to say how hot the day is,
How hot the scent is of the summer rose,
How dreadful the black wastes of evening sky,
How dreadful the tall soldiers drumming by.

But we have speech, to chill the angry day,
And speech, to dull the rose's cruel scent.
We spell away the overhanging night,
We spell away the soldiers and the fright.

There's a cool web of language winds us in,
Retreat from too much joy or too much fear . . .

FROM *THE COOL WEB*
ROBERT GRAVES (1895–1985)

the third person and in narrative form. The third person and the narrative form are clauses in a contract agreed between writer and reader, on the basis that the two of them can understand the third person more fully than he can understand himself; and this destroys the very terms of the equation.

Applied to the central moment of sex, all written nouns denote their objects in such a way that they reject the meaning of the experience to which they are meant to apply. Words like cunt, quim, motte, trou, bilderbuch, vagina, prick, cock, rod, pego, spatz, penis, bique – and so on, for all the other parts and places of sexual pleasure – remain intractably foreign in all languages, when applied directly to sexual action. It is as though the words around them, and the gathering meaning of the passage in which they occur, put such nouns into italics. They are foreign, not because they are unfamiliar to reader or writer, but precisely because they are their third-person nouns.

The same words written in reported speech – either swearing or describing – acquire a different character and lose their italics, because they then refer to the speaker speaking and not directly to acts of sex. Significantly, sexual verbs (fuck, frig, suck, kiss, etc., etc.) remain less foreign than the nouns. The quality of firstness relates not to the acts performed, but to the relation between subject and object. At the centre of sexual experience, the object – because it is exclusively desired – is transformed and becomes universal. Nothing is left exterior to it, and thus it becomes nameless.

I make two rough drawings:

They perhaps distort less than the nouns. Through these drawings, what I have called the quality of firstness in sexual experience is perhaps a little easier to recall. Why? Being visual, they are closer to physical perception. But I doubt whether this is the explanation. A skilful Roman or Renaissance pornographic painting would be still closer to visual perception and yet, for our purpose, it would be more opaque.

Is it because these rough drawings are schematized and diagrammatic? Again, I doubt it. Medical diagrams are sometimes more schematic – and again more opaque. What makes these drawings a little more transparent than words and sophisticated images is that they carry a minimal cultural load. Let us prove it obversely.

Take the first one. Put the word *big* above it. Already it is changed, and the load increased. It becomes more specifically a message addressed by writer to reader. Put the word *his* in front of *big* and it is further changed.

Take the second one and put the following words above it: *Choose a woman's name and write it here.* Although the number of words has increased, the drawing remains unchanged. The words do not qualify the drawing or use it syntactically. And so the drawing is still relatively open for the spectator's exclusive appropriation. Now carry out the instructions. Write the name of, say, Beatrice. Once again the increase of its cultural load renders the drawing opaque. The name Beatrice refers the drawing to an exterior system of categories. What the drawing now represents has become part of Beatrice, Beatrice is part of an historical European culture. In the end we are left looking at a rough drawing of a sexual part. Whereas sexual experience itself affirms a totality.

Take both drawings and put the word *I* above each one.

I am writing about the lovers on the bed.

───────── ◊ ─────────

After a brief spell in the light we are now back in the dark, or the darkroom at least. In the late nineteenth and early twentieth centuries the elitist collectors of erotica – although they never disappeared – were gradually marginalized by the supply and demand of a new mass market in sexual material. New technology, especially the camera, accelerated the process and a division opened up between literary erotica and erotic art on the one hand, and photographs, magazines and mass-market fiction on the other. There are, of course, numerous important exceptions (several in this anthology), but the general trend in the creation of 'forbidden' material can be described in this way. Some dealers and publishers of 'gallant' material have always supplied both markets. Leonard Smithers (1861–1907), whom Oscar Wilde described as 'the most learned erotomaniac in Europe', published and numbered among his circle a host of literary figures including Sir Richard Burton, Algernon Swinburne and André Gide, but he also dealt in photographs. In his entertaining book *Memoirs of an Erotic Bookseller*, Armand Coppens describes a visit to a Paris bookshop in 1948.

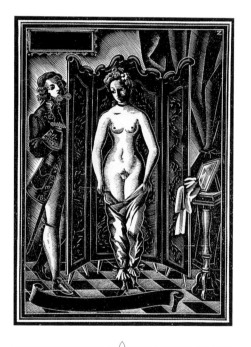

ABOVE A bookplate designed especially for a library of 'galant' literature.

───────── ◊ ─────────

'A useful book,' remarked Leclercq. 'I'll just put it aside for a moment.'

While I was looking through the rest of the books in that suitcase, I considered my financial position. Would the Carmelites expect me to pay for my stay or not?

Meanwhile, Leclercq was busily unpacking the second case from which he took an enormous number of pornographic photographs and some films.

'I'm more interested in this sort of thing,' I said, indicating the Forberg.

'It takes all kinds to make a world,' he replied. Then, tapping the second suitcase, continued:

'But this is the stuff that makes the money. God knows, if I had to depend on the few customers with your tastes, I should

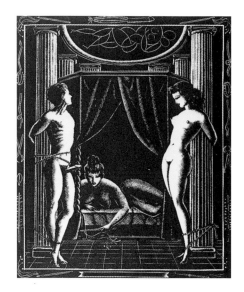

ABOVE, BELOW and OPPOSITE
Bibliophiles have always
commissioned bookplates for their
private collections; the work of
artists such as Franz von Bayros
adorns many rare items of erotica.
These fine examples – two
allegorical, the other humorous –
are woodcuts made by Italo Zetti
in the 1940s and 50s.

have starved long ago. Well, since you're a compatriot, I'll let you have it cheap. You can have it for 10,000 francs (about £7).'

I could hardly believe my ears. This was a very rare book indeed and could easily have fetched fifty pounds at any auction. Ironically, even seven pounds was a lot of money to me at that time.

While I pretended to look through the other books and make up my mind, the door suddenly opened and a tiny Vietnamese girl came into the room.

'*Bonjour, chérie*,' said Leclercq. And then, 'You're late. We only have an hour and a half now.' Turning to me he said, 'This is Mr . . .'

'Coppens,' I supplied.

'. . . Mr Coppens, a Belgian customer. At least, I hope he's going to be a customer. Would you like to look through the books again, sir?' Leclercq obviously knew my type. One looks again and again at some odd piece in a collection and increasingly realizes its beauty, rarity or value until, eventually, it is impossible not to buy.

I persuaded myself that the Carmelites simply could not demand money for their hospitality. Suddenly, I became aware of Leclercq saying:

'Just a moment, please.' He reached over and took away my Forberg.

'But I'm going to buy it,' I protested.

'Of course. At that price, who wouldn't? But I need to borrow it for a couple of minutes.'

Then turning to the boy and speaking in French, he said:

'Clear the table a bit, Henri. I'll have to use it for a while.'

The boy sighed but obediently removed some of the books. As

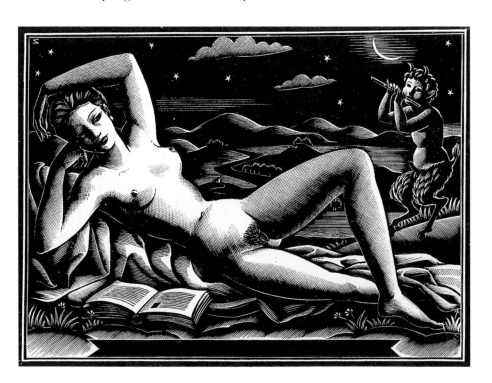

soon as he had cleared about two-thirds of the table for his employer, he returned to his own work.

Meanwhile, Leclercq was showing the Vietnamese girl – who turned out to be his model – some of Forberg's postures. He seemed particularly interested in one which showed a girl kneeling on a couch while a man made love to her from behind. In the background, a naked servant girl watches, a bottle of wine in her hand.

'We'll start with this pose,' Leclercq said to the girl and, turning to me, explained:

'I do hope you don't mind, but we are in rather a hurry. I've got to have this order ready for tonight and your book really inspires me. Please, have another look at the collection while I borrow it.'

He then produced three or four lamps which he positioned around the table. The Vietnamese girl, meanwhile, had undressed and was shivering slightly with the cold. Leclercq assured her that she would soon feel warmer under the lamps and then ordered Henri to make more room on the table.

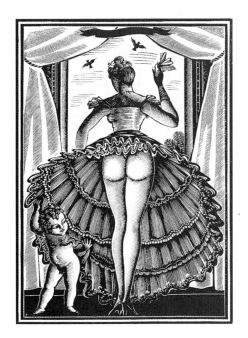

The boy uttered another of his exasperated sighs, removed more books from the table and immediately returned to his packing. Leclercq seemed content with the preparations then and began to explain to the girl exactly what he wanted.

'Up on the table now and down on all fours. That's right. Now raise your behind a bit. Wonderful! Thighs a bit further apart. That's right. You are getting a belly, dear. You'll have to lay off the absinthe.'

The girl protested vehemently at this criticism of her charms.

'Any girl would have a belly in this position. When I'm standing up, I have a perfectly nice belly. Anyway, I hate this position. It makes me feel like a cow.'

'You should worry,' retorted Leclercq. 'Where you come from, the cow is a sacred animal.'

At this moment, the preoccupied Henri made his one and only interruption.

'Do the parcels to Germany have to be registered, sir?'

'How the hell do I know?' Leclercq barked. 'Stop interrupting. Only this gentleman,' he said, pointing to me, 'seems to understand the necessity for calm, concentration.'

In silence he undressed and climbed on to the table.

'Right,' he commanded. 'As soon as I'm in her and we are moving, press the button, Henri.'

'You can forget about the moving,' the model remarked drily. 'It won't show in the pictures. Just pretend.'

This remark obviously touched the artist in Leclercq who immediately demanded:

'And what about our expressions? How are we going to look like lusting lovers if we're not actually doing anything? Who do you think we are, members of the *Comédie Française*? No, we'll do it properly or not at all.'

At the end of his tirade, he entered the girl and began moving vigorously. I found the spectacle so absorbing that I immediately forgot both the Carmelites and the precious books in the

RIGHT An engraved bookplate by
Rudolf Koch.

suitcase. Henri, however, was still occupied with his parcels.

'Hurry up, Henri,' Leclercq suddenly shouted. 'This isn't the only picture we've got to take.'

Henri did not seem in the least affected by or interested in the scene. His attitude, rather, seemed to be one of intense irritation at having his own work interrupted. As soon as the button had been pressed, Leclercq took a chair and placed it on the table. He sat down and pulled the girl on to his lap, facing him.

'This is what we call the romantic study,' he explained. 'We've got to look both sexy and serene. There must be tenderness in the way we touch each other.'

Fitting his actions to his words, Leclercq tenderly caressed the girl's breasts and laid his cheek gently against hers. The result was undeniably charming.

'O God!' he exclaimed. 'I've forgotten all about the lighting.'

'I know quite a bit about photography, sir,' I said. 'Let me take care of it.'

'Marvellous!' exclaimed Leclercq. 'The Belgians really are practical. Look at the mess the French are making of Indo-China while the Congo, which is much bigger, is a peaceful, smooth-running country.'

'Don't start talking about war, darling,' said the girl. 'I can't act tenderly while you talk about atrocities.'

Leclercq quickly reminded her that she should not find it necessary to act in her present situation. It seemed to me that the girl was getting far more enjoyment out of the session than she cared to admit.

'Everything's all right,' I reported.

'Henri!' Leclercq shouted.

At this I simply had to laugh. I was so strongly reminded of Pavlov and his dogs. I was all ready to push the button and take the photograph but practice made it inconceivable to Leclercq that the process could be satisfactorily concluded without Henri's grudging aid. Henri did respond, at length, and grumbling quietly to himself, pushed the button.

'*Salauds*', he muttered. 'You can't work properly in this bloody place. People have paid for these books and they've got to be sent off tonight. But everything has to stop because some old bastard can't get sexed up without a pile of photographs. *And* the string's disappeared, too.'

Despite Henri's protests, the session continued and, if I remember correctly, another eighteen photographs were taken. Not once did Henri lose his air of irritated indifference. As far as he was concerned the whole spectacle might have been happening on another planet. I am certain that both Leclercq and the girl must have reached orgasm more than once. But since Leclercq was constantly changing the pose and the props, carefully consulting the Romano illustrations in my book and checking the lighting, it was impossible to observe him closely. I do remember that his erection, however, never flagged and the Vietnamese girl's radiant face bore witness to the pleasure she received. After an hour and a half, as Leclercq had predicted, the session was over.

When Leclercq and the girl were dressed, I was at last able to pay for my copy of the Forberg.

'I'm sorry you had to wait so long,' said Leclercq. 'But the circumstances really were exceptional.'

◇

By the early twentieth century the pornographic photographer had become a stock figure in erotic novels, for example in *Modern Eveline* in 1904. But the contradictions of this absurd profession have never been more successfully satirized than in the following episode from *Josefine Mutzenbacher*. If Felix Salten was indeed the author he knew something about contradictions – he was also the creator of *Bambi*.

'He's getting me excited again,' cried Mrs Capuzzi.

'Albert,' shouted the photographer, 'keep your hand still or I'll be over there to help you!'

He held her breasts motionless. But now it was Melanie who wriggled about making her breasts rub against Albert's hands.

'See,' said Albert, '*you're* doing it now.'

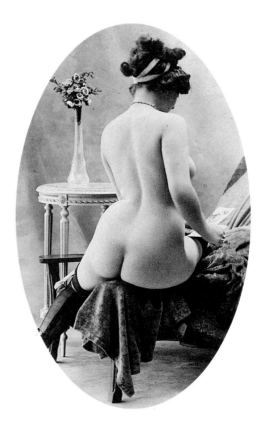

BELOW A nicely composed Parisian postcard, c. 1900.

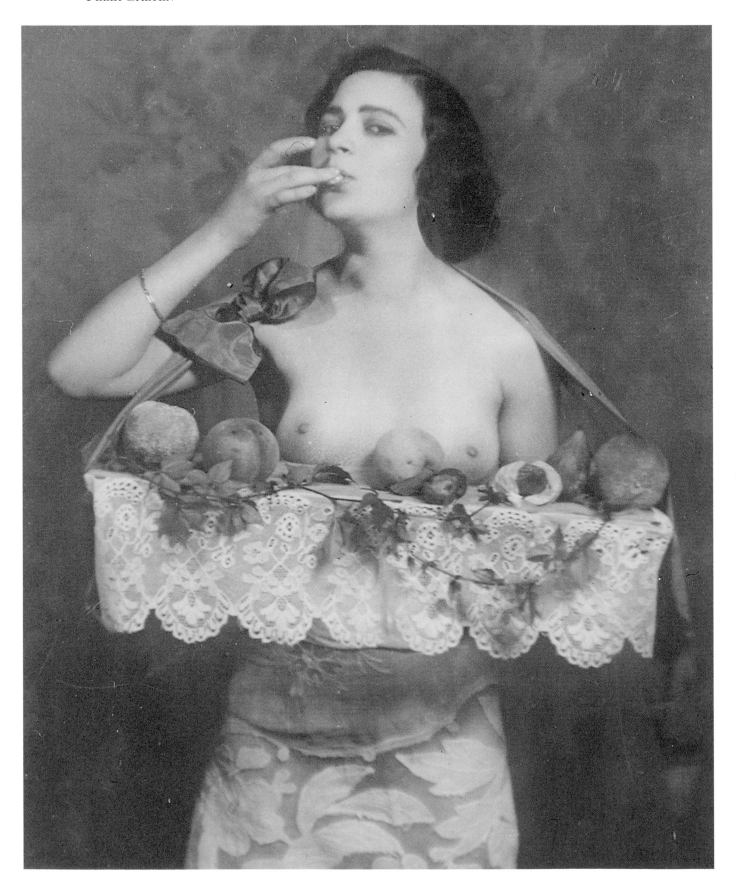

'Melanie!' Mr Capuzzi spoke in a reproachful tone.

'Well,' she said, 'when I get all excited . . .'

'Pepol,' he turned to me, 'take the cock and put it in . . . but don't take your hand away.'

I seized Albert's flagpole and put it upright. But she got there first and put the plug in the hole before I could.

'Oh,' she gasped, 'the torture's beginning again.'

'Not so deep, Melanie,' warned her husband, 'we must be able to see Pepol's hand.'

'Like this?' she asked, and lifted her popo so that only the head of Albert's cock was inside.

'Yes, that's right,' he agreed.

'But no, it slips out like that,' she cried, and dropped down on to him.

'No,' roared her husband, 'higher, dammit.'

She pulled back and said, 'If that's how you want it, but I think it would be rather good like this,' and she thrust down again.

Her husband bounded over and fetched her one on the behind so that the sound rang out.

'You're fucking him, you hussy,' he shouted, 'you can't fool me.'

'It's fucking anyway, even if he just puts it in,' she said irritably.

'No, it isn't,' he hastened to explain. 'How often must I tell you . . . it's just positions . . . it's called marking. Marking is allowed . . . but I shall never allow my wife to be fucked by another man.'

At the time this stupid distinction seemed to make sense to me and the others. Now, the thought of that extraordinary husband makes me smile.

I kept hold of Albert's throbbing bolt and gradually slid my hand up until I was touching the edges of Melanie's mussel. I could feel her squeezing him rhythmically which was naturally exciting Albert.

'Will it take much longer?' asked Melanie.

'No – look at the camera . . . smile . . . Pepi, you too . . . right . . . one, two, three, four, five – finished!'

Melanie jumped down from Albert.

'Thank God,' she cried, 'It's too much to bear.'

Albert lay motionless.

'Now the other way round – Pepi on top,' ordered the photographer. I took up Melanie's position. 'Melanie, now you put it in Pepol,' he commanded.

'Shall I touch her bosom?' asked Albert.

'Of course – what do you think – stupid!'

Albert put his hand on my bosom. We smiled at each other and he played with me. Mr Capuzzi took no notice. Then his wife steered Albert's prick into me. Albert and I smiled conspiratorially at each other and he began to thrust. I flew up and down and Melanie had to pull her hand away. But she wasn't having this and straightaway called out to Capuzzi, 'You don't say anything to them, do you? They can do what they like.'

From the Victorian period onwards, the postcard industry expanded to keep pace with the development of tourism. In addition to the standard 'views' of Europe's capitals the more adventurous could buy evocative mementoes of things not included on the Thomas Cook itinerary. OPPOSITE An Italian postcard; BELOW A Parisian beauty.

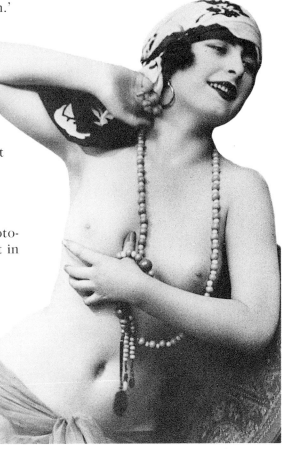

'Calm down, children,' ordered Capuzzi and counted again. 'One, two, three, four.'

We stopped moving. Melanie grasped Albert's cock again so it looked as though she was helping us.

'Finished,' said Capuzzi.

At that, we started fucking again. But this angered Melanie. 'Albert, stop that!' she cried.

'Only the tip,' said Capuzzi. 'You're only to mark – will you stop that!' he roared in my direction. And since that did no good he wrenched me down from my perch.

'I forbid it,' he said. 'You can do that later if you want.'

He began to arrange 'a new group', as he put it. Albert had to stay lying on the bench. Melanie knelt before him and took his cock in her mouth. 'Only the tip,' said Capuzzi, 'marking only.'

I positioned myself over his head and offered my cup of pleasure to his lips. Albert played a trill on my clitoris with his tongue that showed me he was an artist and made me lunge backwards and forwards in ecstasy. But then he was still and just 'marked'.

Melanie tried to compete with me. I could see from her cheeks and the twitching of Albert's noodle that she was secretly licking the little bit of gristle her husband would allow her. She wheezed

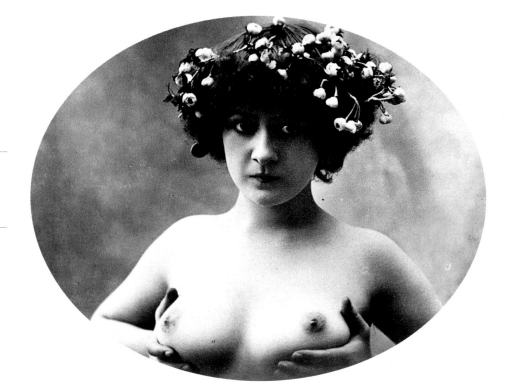

RIGHT The technical and aesthetic quality of erotic postcards was often superb.

and cast wary glances at her husband. When he dodged behind his black cloth again she took her chance and pushed the bung into the barrel as far as it would go.

A moment later came the count, 'One, two, finished!' Albert gave me a last tongue trill.

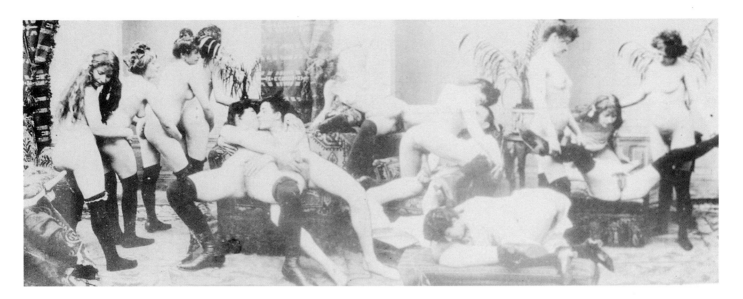

'Change over,' ordered Capuzzi. It was now my turn at Albert's cock and I swallowed him to the hilt, which he enjoyed. Melanie crouched over his mouth and I could tell from his movements that he wasn't just marking. Melanie made a great effort not to move. But I could see her thighs trembling, her eyes rolling and she pressed down more firmly onto Albert.

'Melanie', called her husband, 'you could play with your tits – look as if you wanted to kiss your nipples.' She lifted her breasts, lowered her head and used the opportunity to rock back and forth a little. This must have made her clitoris slip out of Albert's mouth, for there was a sudden smacking sound. Capuzzi heard it, bounded over and said in a rage, 'Albert, you're not really sucking?'

'Of course not,' gurgled Albert from beneath his burden. 'You'd better not,' repeated Capuzzi, bending over to see exactly what Albert was doing. 'But he's not doing anything!' snapped Melanie in a temper. Capuzzi looked into her face. 'You're all excited,' he said, threateningly. 'Of course I am,' she replied. 'I always get excited – I'm not made of wood. Hurry up and let's get it over with.'

But while Capuzzi was returning to the camera and under his black cloth she made a few quick lunges, giggling at me as she did so, and Albert thrust his tongue into her. But Capuzzi was finished before she was. There was a 'one, two . . .' from behind the camera and his 'finished' scared us apart.

'Now what?' asked Melanie, standing there with trembling breasts and breathing in gasps.

'You lie down now,' said her husband. She obeyed immediately. 'Now Pepol's to crouch over your mouth and Albert lie on top of you.' 'No,' she protested, 'I don't want to lick her.' 'You don't have to,' he answered, 'just mark!' 'Why? I don't like doing it with my mouth.' 'All right, Pepi can lie down and you can crouch over her.' But she didn't want to give up the chance of getting at Albert's cock. 'I know, Pepol could stroke my breasts, it'll look more innocent.'

He agreed. I knelt on the floor next to her and taking her breasts in both hands placed my lips on her raspberries. I did my very best and even managed to give her a little pleasure. Excited by my kisses she began to twitch, jigging her popo up and down and in so doing thrusting Albert's beam deep into her body. With one stride Capuzzi was beside her and boxed her ears. 'Will you stop this fucking, you hussy,' he shouted. 'I'm not doing anything,' she screeched. 'Oh yes – that's what you always say!'

'You brute,' she complained, 'Pepi's tickling my breasts – that's what makes me jig up and down.'

'Stop tickling her,' he ordered me, turning back to berate his wife further. 'It's just excuses – you're always seeing if you can have it away with Albert, I know.' 'Leave me alone,' she said, 'It's no wonder I have to wriggle about when a big cock like that touches me.'

'Well, you'll have to wait – I'll give it to you myself in a minute,' he replied and went back behind the cloth. 'One, two, finished.' 'Right, now I have to go into the darkroom, but I warn you, if you try anything I'll wallop you!'

One photographic darkroom is much like another, except that the darkroom in this scene from *Suburban Souls* – first published in 1901 – could symbolize the novel: claustrophobic and black.

. . . Lily [told] me to follow her into the dark-room immediately after breakfast, as she wanted to show me something there. We left Papa eagerly discussing the Dreyfus case in German, and as usual he was all in favour of the generals, as was the Teutonic guest. I had refused to join in the discussion, although Mamma, knowing my opinions, tried to get me to talk on the subject by telling the stranger that I held contrary views to his! I preferred to slip away with Lilian and we were no sooner inside the little cabin than after a long sweet kiss from her fevered lips, she plainly informed me that she wanted me to give her pleasure with my finger as she felt very 'naughty'. Nothing loth, I put my hand up her clothes, as she stood up, leaning against the sink, and my finger immediately touched the spot. I was very surprised to see her start and draw back, with a rapid movement, dislodging my hand completely. I saw at once what had happened. She knew, of course, that she was no longer a virgin, but her great preoccupation was to make me still believe in her virtue. In her excitement, she had presented herself in quite an easy position, the knees half-bent, eager to be manipulated, and I, full of lust and luncheon, had pushed my finger in too far, as I could tell by the soft warmth and moisture. I asked why she drew away from my touch.

'Oh, that is nothing. Don't be offended! Surely you can excuse an instinctive movement of shame?'

I was too clever, and at the same time too excited myself, to do anything but agree with her, and I was content to do my best to bring about the crisis, as she stood bolt upright now, her thighs

BELOW A dilemma: a study which is both dark and fetishistic – and beautiful. Paris, c. 1930.

pressed together. After the usual expressions of pleasure, she suddenly broke away from me, exclaiming that she had spent, and I said to myself that she had been remarkably quick about it. She now made a dive for my neglected organ, which she found quite ready to her hand, as it was all prepared, sticking out of the drawers, as I have explained. She caressed it a little, telling me to keep a sharp eye for fear any of the workgirls should come along, and bending down, took it in her hot mouth, rolling her agile tongue round its swollen head. She had not been sucking me for two seconds, when she got uneasy, and left off. I begged her to continue and finish me, as she stood by my side laughing and looking, and admiring my sign of virility, and she bent down again, once more popping it into the velvety seclusion of her warm mouth. But directly she felt that I was about to ejaculate, she left off suddenly, exclaimed that she heard footsteps, and fled rapidly from the tiny building, leaving me all alone with my stiff rod sticking up out of my trousers. The disappointment was so great that my erection soon passed off, and I was too much in love with the coquette to feel any anger with her.

Suburban Souls is an obsessional account – complete with facsimile telegrams, letters and even a floor plan – of an obsessional affair. It is well written and the characters come to life to the extent that we are left with the suspicion that the deceitful 'Lily' and the stockbroker, 'Jacky', did exist. Here Jacky embarks on a journey which will take him and the reader through three volumes of morbid jealousy and curiously oppressive sexual encounters.

NOVEMBER 26, 1897

Everyone knows the feverish excitement experienced by an eager lover, when awaiting his mistress at the first appointment. I felt hot and excited, and gave a great sigh of relief, when Lilian slowly lifted the *portière* and advanced towards me in the tawdrily furnished bedroom of the mysterious *pavillon* of the Rue de Leipzig. I quickly bolted the door, and drew her to me, placing her on my knees, as I sat on the inevitable *chaise-longue*. She seemed worried and frightened, and told me that she had great trouble in getting away from home. There was a tremendous struggle to get her dress unfastened, and she studiously avoided looking towards the large curtained bed that occupied the middle of the room. She hoped I would not touch it, as if I did, people of the house would guess we had been using it! I tried by my kisses to warm her blood, and I think I succeeded, for she grew more and more bold, and I was able to undo her dress, and feast my eyes on her tiny breasts, which were like those of a girl of fifteen. Nevertheless, the size of the red and excited nipples proved her real age. I sucked and nibbled them greedily, and her pretty ears and neck also came in for a share of attention from my eager lips and tongue. I begged her to let me take off all her garments, but she wanted me to be satisfied with her small, but beautifully made breast. I pretended to be deeply hurt and she excused herself. I must have patience. This was the first time. She would be more

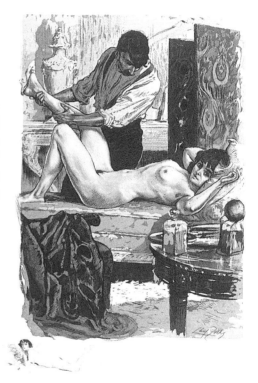

ABOVE An original illustration of 'Jacky S.' and 'Lily'.

All this the world well knows yet none knowes well,
To shun the heaven that leads men to this hell.

FROM *SONNET 128*
WILLIAM SHAKESPEARE (1564–1616)

yielding when she knew me better. I replied by boldly throwing up her skirts, and after admiring her legs, in their black stockings, and her coquettish be-ribboned drawers, I, at last, placed my hand on the mark of her sex. It was fully covered with a thick, black undergrowth and quite fleshy. The large outer lips were fatter and more developed than we generally find them among the women of France. Her legs, though slim, were well-made, and her thighs of fair proportions. I began to explore the grotto.

'You hurt me,' she murmured.

And as far as I could tell, she seemed to be intact, or at any rate had not been often approached by a man. I could feel that my caresses delighted her greatly and she gave way a little.

At last, I persuaded her to take off her petticoat and drawers. She consented, on condition that I would not look at her. I acquiesced and she dropped her skirt and took off her bodice, standing before me in her petticoat and stays. She wore a dainty cambric chemise, tied with cherry ribbons, and I enjoyed the sight of my love thus at last in my power. I gloated over her naked shoulders; the rosy nipples, stiff, and glistening with my saliva; and the luxuriant black tufts of hair beneath the armpits.

She consented now to drop her petticoat, and as I leant back on the sofa, she placed one soft, cool hand over my eyes, and with the other, undid everything, until she stood in her chemise. She would not go near the bed and struggled to get away from me. Indeed, she would not let me touch her, until I closed the window-curtains. We were in the dark. I placed her on the *chaise-longue*, and going on my knees, I tried to part her thighs and kiss her mossy cleft. With both hands, she tried to push me away.

'You hurt me!' she said again, but I licked her as well as I could, and feeling the warmth of my mouth, she opened her thighs a little, and I managed to perform my task. It was difficult, as she writhed about, uttered pretty little cries, and would not sufficiently keep her legs apart. But I was not to be dislodged. I was not comfortably installed. My neck was wellnigh broken. The room too was very hot; but I remained busily licking, sucking, perspiring, and my member, bursting with desire, already let a few drops of the masculine essence escape from its burning top. I am certain she experienced a feeling of voluptuousness, by the shuddering of her frame at one moment, and by the peculiar taste that I could not mistake. At last, she thrust my head away. And I rose to my feet, greatly pleased at leaving the prison of her soft thighs. I got my handkerchief, wiped my mouth, and returning to her, as she still laid motionless and silent on the couch, I threw myself upon her without ceremony. I inserted the end of my turgescent weapon between the hairy lips of her lower mouth, and forgetting all prudence, I pushed on. She shrieks and dislodges me. I try to regain my position, but I cannot succeed. She was a virgin; there was no doubt about it.

Lilian is half-seated on the narrow sofa, and I have no way of getting to her, unless I pull her flat down on her back. I am tired too, and very hot. I have twisted my neck and it is painful. So I relent and give up active warfare for the present.

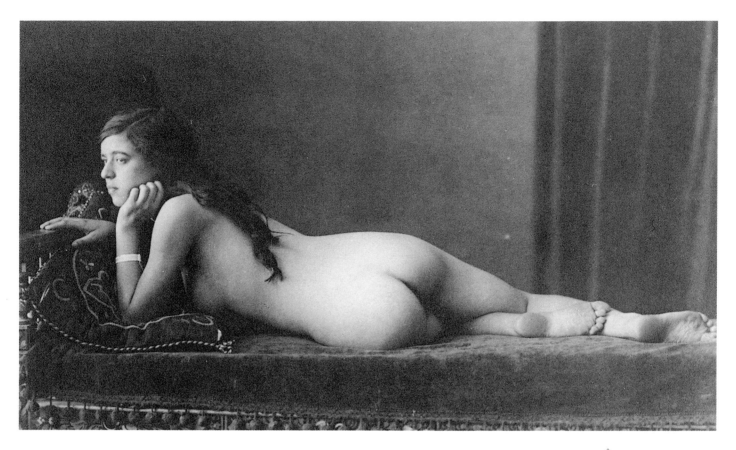

'Take it in your hand yourself,' I say, 'and do what you like with it.'

She does so, and leaning over her, I find she lets the tip go a little way in. Now all was dry and far from agreeable. I suppose I had done wrong to suck her so long. She had no more feeling of lust. So I moved up to her face, as she reclined with her head on a cushion, and straddling across her, rubbed my arrow and the appendages gently on her face and mouth. She did not move. I took her hand and placed it on my staff of life. She started and roughly drew her hand away. Strange inconsistency. She had placed it herself at the entrance of her virgin cleft; she had allowed me to caress her lips and cheeks with it, but now she recoiled at the idea of grasping it.

So I resolved to overcome any disgust she might feel, and putting the end between her lips, I told her rather roughly to suck it at once. She tried to, timidly; I could see she did not know how.

'Tell me, show me, and I will do all you wish.'

I took her hand, and sucked and licked one of her fingers by way of example.

She took to it readily, and I tried to excite her and keep her up to her work by talking to her as she sucked me awkwardly. But the soft warm caress of her capacious mouth and the clinging grasp of her luscious lips excited me to madness. I moved in and out, slowly, saying:

'Darling! Lilian! It is delicious! Not your teeth, Lily. You must

ABOVE This photograph is of the same period as the one on page 140 and the charming postcard on the facing page, but it is quite different. Fetishists need not despair: it is an image, not a woman – but it is an image of a woman, not a toy. Across time and through lenses, photographic emulsion and printer's ink she makes us aware of her personality. We are in the main thoroughfare of erotica with her, one step away from life, not in a dark alley or a prettified dead end.

not let your teeth touch it! So! Lick it nicely! Let me feel your tongue! Do not move! Do not go away. I am going to enjoy in your mouth, and you must remain as you are until I tell you.'

With angelic docility, she continues the play of her lips and tongue, and to my great surprise and delight I feel her hands gently caressing my reservoirs. And the crisis comes too soon. The pleasure I had was beyond words. I had kept back the moment of joy as long as I could, but now the charge exploded with violence, and I could feel that a very large quantity gushed into her mouth. I thought I should never cease emitting. Lilian did not stir until I slowly withdrew, having exhausted the pleasure until there was not a throb left, and my organ had begun to soften. Then she sat up and uttered inarticulate cries.

I rushed to get her a pail or basin, and in the darkness, knocked down a screen. She empties her martyred mouth. I give her a glass of water, and she rinses her throat.

'What was that?' she asked, as I half-opened one of the window-curtains.

'Little babies,' I replied. 'Did you like me sucking you?'

I lit the lamp, kissed her, and we chatted as she dressed.

'Yes!'

'And when I spurted that stuff into your mouth – did you like that too?'

'Yes.'

BELOW A lithograph from the series *The Beauty and the Little Monkey*, published in the 1920s.

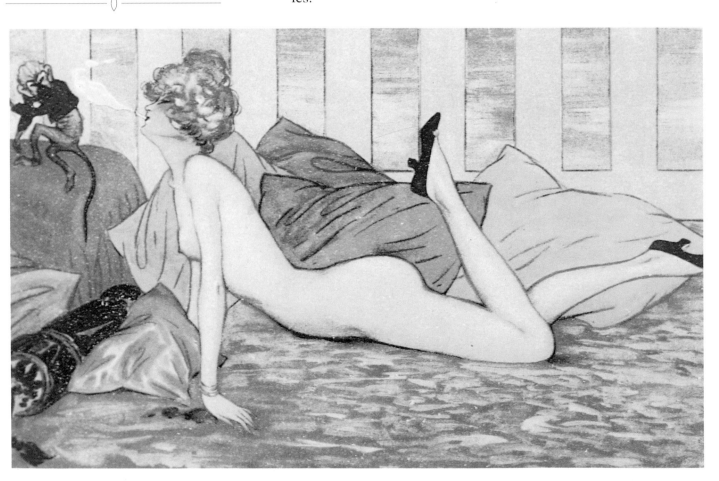

144

'I ought to have penetrated your pretty body. Why did you not let me? Has no one ever done so to you?'

'I am a virgin, I swear it!'

'Have you never given pleasure to yourself with your hand?'

'Never. It hurts. I don't like that. I love you. I shall never marry. I shall live for you. You seem to be vexed that I am a virgin? If I was not, why should I not say so?'

Suburban Souls ends abruptly with a curious note from the author.

And now, Mr Prompter, please ring down the curtain. This drama is finished.

The actors wash off their paint; the brown holland is put over the boxes. We go home, and all is dark until the next night.

So it is on the mimic stage, but in life there is no ending to the long succession of comedy and tragedy which is played out in many acts, and is never ended.

Death now and then calls at the stage-door, and one of the players: poor, painted, false 'villain, or roguish clown; tragedy queen, or meretricious dancing girl; is carried away in the black hearse, but the universal spectacle of love and hate goes on all the same.

Thus with my most vile story. I must break off here, but there is no finish to a real book, such as this is.

When the novel is a mere phantasy, it is easy to dispose of the characters. But this tale being a true one, I can only bow and go, making way for some fresh actor, who is waiting in the wings to caper in the light, when I shall have disappeared, whether I will or no; for I am, and so are you, Reader, in the hands of the Great Scene-Shifter.

JULY 1899–JANUARY 1900

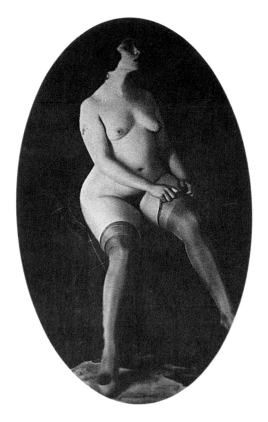

W as this postscript a hint as to the real identity of the author? Perhaps, but this anthology could do with some light comedy after the gloomy melodrama of Jacky and Lilian. This cheerful extract comes from *Passion's Apprentice*.

The irresistible mutual attraction between human beings which – mercifully for the stability of society – is a once-in-a-lifetime event for most people can, like lightning, strike some individuals with greater frequency. It has other characteristics in common with lightning such as heat, sudden and spectacular displays, and a close association with danger and disaster.

However, that gentler expression of electricity, magnetism, best describes the first exchanges between Ashton and Mrs Van Houtte in the dark intimacy of the theatre box. His foot showed a marked tendency to push against hers. Her arm pressed gently but unmistakably against his. Finally their hands, the conductivity no doubt aided by the damp condition of them, found themselves locked together between their chairs.

Lightning struck for the first time in the interval after Act One

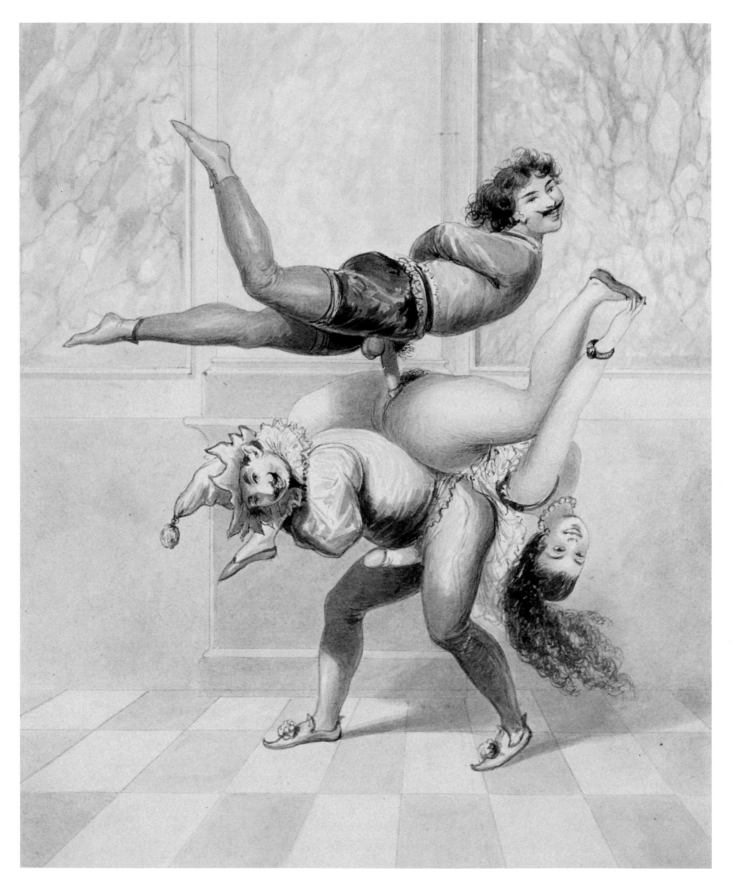

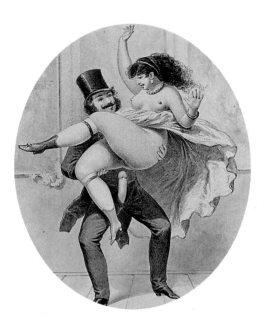

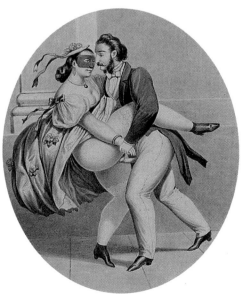

when Mrs Van Houtte's companion had been despatched to search for her glove at the entrance. Had he been successful in his chivalrous quest and returned early (which was unlikely since the missing article was in her purse) he would have been surprised to find his inamorata and the Englishman locked together, the tongue of each urgently exploring the mouth of the other.

An early return from the equally impossible task he was given during the second interval would have surprised him even more: he would have found the impetuous Mrs Van Houtte sucking noisily and vigorously at the straining red organ of her new friend which she had just released from his trousers. As it was she could not immediately thank her escort for his concern over her flushed appearance as she was still swallowing the thick seed of Mr Ashton. The Third Act was the most tense of the drama for Ashton, not so much because of any skill on the part of the dramatist but because any request for the programme would have revealed the still partially turgid member which he had not had time to put away.

He eventually managed to make this small but essential adjustment to his evening dress while the only one of their party with any interest in the play was enthusiastically applauding the end of the Third Act (on stage). Had the young Sampson wielding the jawbone of an ass climbed into their box at the beginning of the third interval (it was a four-act play) he is unlikely to have driven Mrs Van Houtte's escort from it. So on this occasion he was left behind while the others went out to 'seek refreshment'.

Finding an unoccupied box immediately adjacent to their own, and having taken the precaution of propping a chair against the door handle, they took this hurried but delicious refreshment against the plush-covered wall. Little more than a partition, this structure moved under the rhythmic pressure of Mrs Van Houtte's bottom and thighs which were crushed against it as her lover thrust into her. Nor did it in any significant way baffle the gasping cry she uttered at the consummation of her pleasure.

Returning at last to their own box they found their companion in sullen mood. 'Could they not have shared their refreshment with him?' He also confided morbidly that he fully expected to read in the morning's paper that a violent murder had taken place in the next box but was 'damned if he cared' since to intervene would have meant leaving his seat again.

Henry Miller recalls a piece of theatrical tragi-comedy in *Black Spring*, the third volume of his fictionalized autobiography, first published in Paris.

I go back over the Brooklyn Bridge and sit in the snow opposite the house where I was born. An immense, heartbreaking loneliness grips me. I don't yet see myself standing at Freddie's Bar in the Rue Pigalle. I don't see the English cunt with all her front teeth missing. Just a void of white snow and in the center of it the little house where I was born. In this house I dreamed about becoming a musician.

Sitting before the house in which I was born I feel absolutely unique. I belong to an orchestra for which no symphonies have ever been written. Everything is in the wrong key, *Parsifal* included. About *Parsifal*, now – it's just a minor incident, but it has the right ring. It's got to do with America, my love of music, my grotesque loneliness. . . .

Was standing one night in the gallery of the Metropolitan Opera House. The house was sold out and I was standing about three rows back from the rail. Could see only a tiny fragment of the stage and even to do that had to strain my neck. But I could hear the music, Wagner's *Parsifal*, with which I was already slightly familiar through the phonograph records. Parts of the opera are dull, duller than anything ever written. But there are other parts which are sublime and during the sublime parts, because I was being squeezed like a sardine, an embarrassing thing happened to me – *I got an erection*. The woman I was pressing against must also have been inspired by the sublime music of the Holy Grail. We were in heat, the two of us, and pressed together like a couple of sardines. During the intermission the woman left her place to pace up and down the corridor. I stayed where I was, wondering if she would return to the same place. When the music started up again she returned. She returned to her spot with such exactitude that if we had been married it could not have been more perfect. All through the last act we were joined in heavenly bliss. It was beautiful and sublime, nearer to Boccaccio than to Dante, but sublime and beautiful just the same.

RIGHT Inspecting the troops: French engraving, c. 1930.

Is the actress-courtesan Nana of Emile Zola's magnificent novel, his 'golden fly', a creature of the light or of the dark? Or, like a goddess, or a real person, is she composed of both? In 1878 Zola finished his *ébauche*, or outline, for *Nana*. Of the book's theme he wrote:

> The philosophical subject is as follows: A whole society hurling itself at the cunt. A pack of hounds after a bitch, who is not even on heat and makes fun of the hounds following her. *The poem of male desires*, the great lever which moves the world. There is nothing apart from the cunt and religion.

Later, Zola began to flesh out the characters for the novel. About Nana he said:

> Her character: good-natured above all else. Follows her nature, but never does harm for harm's sake, and feels sorry for people. Bird-brain, always thinking of something new, with the craziest whims. Tomorrow doesn't exist. Very merry, very gay. Superstitious, frightened of God. Loves animals and her parents. At first very slovenly, vulgar; then plays the lady and watches herself closely. – With that, ends up regarding man as a material to exploit, becoming a force of Nature, a ferment of destruction, but without meaning to, simply by means of her sex and her strong female odour, destroying everything she approaches, and turning society sour just as women having a period turn milk sour. The cunt in all its power; the cunt on an altar, with all the men offering up sacrifices to it. The book has to be the poem of the cunt, and the moral will lie in the cunt turning everything sour. As early as Chapter One I show the whole audience captivated and worshipping; study the women and the men in front of that supreme apparition of the cunt. – On top of all that, Nana eats up gold, swallows up every sort of wealth; the most extravagant tastes, the most frightful waste. She instinctively makes a rush for pleasures and possessions. Everything she devours; she eats up what people are earning around her in industry, on the stock exchange, in high positions, in everything that pays. And she leaves nothing but ashes. In short a real whore. – Don't make her witty, which would be a mistake; she is nothing but flesh, but flesh in all its beauty. And, I repeat, a good-natured girl.

Nana's theatrical triumph is not only the crucial moment in the novel's plot, it is one of the great erotic moments in literature.

> The claque applauded the scenery, which represented a grotto on Mount Etna, hollowed out of a silver mine and glittering like newly minted coins. In the background Vulcan's forge glowed like a setting sun. As early as the second scene Diana came to an understanding with the god, who was to pretend to go on a journey, so as to leave the way clear for Venus and Mars. He had scarcely left Diana alone before Venus appeared. A shiver went round the house. Nana was naked, flaunting her nakedness with a

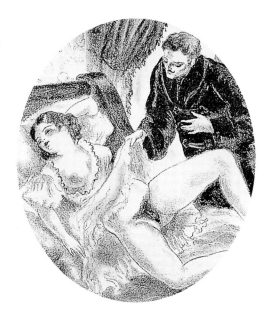

ABOVE An illustration from *Mémoires d'une Chanteuse*.

cool audacity, sure of the sovereign power of her flesh. She was wearing nothing but a veil of gauze; and her round shoulders, her Amazon breasts, the rosy points of which stood up as stiff and straight as spears, her broad hips, which swayed to and fro voluptuously, her thighs – the thighs of a buxom blonde – her whole body, in fact, could be divined, indeed clearly discerned, in all its foamlike whiteness, beneath the filmy fabric. This was Venus rising from the waves, with no veil save her tresses. And when Nana raised her arms, the golden hairs in her arm-pits could be seen in the glare of the footlights. There was no applause. Nobody laughed any more. The men's faces were tense and serious, their nostrils narrowed, their mouths prickly and parched. A wind seemed to have passed over the audience, a soft wind laden with hidden menace. All of a sudden, in the good-natured child the woman stood revealed, a disturbing woman with all the impulsive madness of her sex, opening the gates of the unknown world of desire. Nana was still smiling, but with the deadly smile of a man-eater.

'God!' was all that Fauc_ery said to la Faloise.

In the meantime Mars, in his plumed helmet, came hurrying to the trysting-place, and found himself between the two goddesses. There followed a scene which Prullière played with subtlety. Caressed by Diana, who wanted to make a final attack on his feelings before handing him over to Vulcan, and cajoled by Venus, who was excited by the presence of her rival, he gave himself up to these tender delights with the blissful expression of a fighting cock. Finally a grand trio brought the scene to a close, and it was then that an attendant appeared in Lucy Stewart's box and threw two huge bouquets of white lilac onto the stage. The audience applauded, and Nana and Rose Mignon bowed, while Prullière picked up the bouquets. A good many people in the stalls turned smilingly towards the ground-floor box, occupied by Steiner and Mignon. The banker's face was flushed, and his chin was twitching convulsively, as if he had an obstruction in his throat.

What followed gripped the audience completely. Diana had gone off in a rage, and immediately afterwards Venus, sitting on a mossy bank, called Mars to her. Never before had any theatre dared to put on such a passionate seduction scene. With her arms around Prullière's neck, Nana was drawing him towards her when Fontan, with comical gestures of rage and an exaggerated imitation of the face of the outraged husband surprising his wife in *flagrante delicto*, appeared at the back of the grotto. He was holding the famous net with the iron meshes. For a moment he swung it, like a fisherman about to make a cast: and then, by an ingenious trick, Venus and Mars were caught in the snare, the net wrapping itself round them and holding them motionless in their amorous posture.

A murmur arose, swelling like a growing sigh. There was some

BELOW The edition of *Mémoires d'une Chanteuse* from which this illustration is taken was published in Paris in 1933.
OPPOSITE A coloured engraving made to illustrate Paul Verlaine's *Oeuvres Libres* (see the poem on page 13).

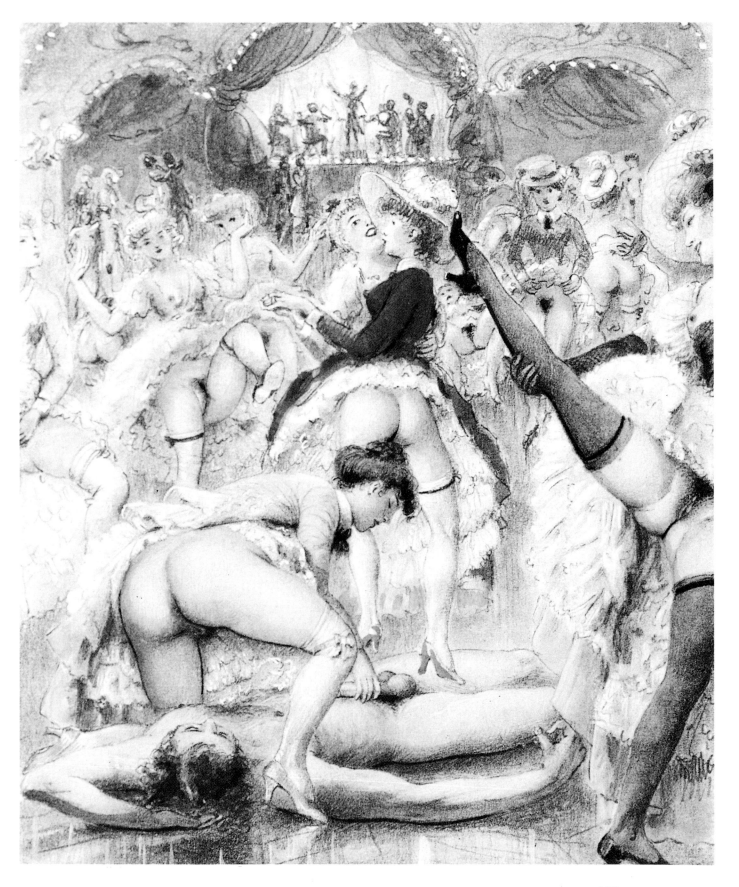

hand-clapping and every pair of opera-glasses was fixed on Venus. Little by little Nana had taken possession of the audience, and now every man was under her spell.

In *Nana* the men are the obvious victims. But is it not true that the women, Nana herself, are victims too? Perhaps it is society which is at fault, or rather unable to cope, with the potentially destructive power within our sexuality.

◊

The predatory element within male sexuality stalks the dark side of erotic literature just as the fictional Mr Hyde or the all too real Jack the Ripper prowled the dark alleyways of London. Let us follow an earlier prowler through the familiar streets of the West End. It is in many ways a journey of discovery. These are extracts from the 1763 diary of a man with a strict Calvinist background. He is James Boswell, friend of Voltaire (François-Marie Arouet) and of Jean-Jacques Rousseau, and scrupulous biographer of Dr Samuel Johnson.

BELOW Drawing of a brothel scene by an unknown artist.

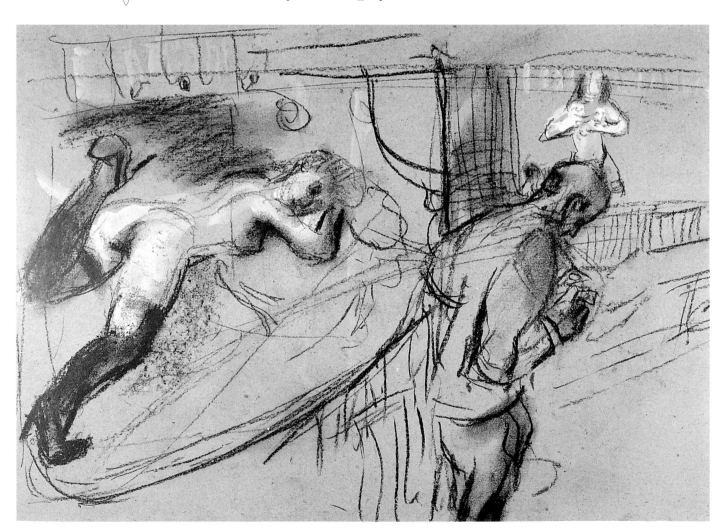

25TH MARCH

As I was coming home this night, I felt carnal inclinations raging through my frame. I determined to gratify them. I went to St James's Park and picked up a whore.

10TH MAY

At the bottom of Haymarket I picked up a strong, jolly young damsel, and taking her under the arm I conducted her to Westminster Bridge and there in armour complete did I engage her upon this noble edifice. The whim of doing so there with the Thames rolling below us amused me much. Yet after the brutish appetite was sated, I could not but despise myself for being so closely united with such a low wretch.

17TH MAY

I picked up a fresh, agreeable young girl called Alice Gibbs. We went down a lane to a snug place, and I took out my armour, but she begged that I might not put it on, as the sport was much pleasanter without it, and as she was quite safe. I was so rash as to trust her and had a very agreeable congress.

4TH JUNE

I went to the Park, picked up a low brimstone virago, went to the bottom of the Park, arm-in-arm and dipped my machine in the Canal and performed most manfully. I then went as far as St Paul's Churchyard, roaring along, and then came to Ashley's Punch-house and drank three threepenny bowls. In the Strand, I picked up a little profligate wretch and gave her sixpence. She allowed me entrance. But the miscreant refused me performance. I was much stronger than her, and pushed her up against the wall. She, however, gave a sudden spring from me; and screaming out, a parcel of more whores and soldiers came to her relief. 'Brother soldiers,' said I, 'should not a half-pay officer roger, for sixpence? And here has she used me so and so.' I got them on my side, and I abused in blackguard style, and then left them. At Whitehall I picked up another girl to whom I called myself a highwayman and told her I had no money and begged she would trust me. But she would not.

ABOVE Detail from an oleograph used to decorate a tobacco box.

Boswell's journal continues in much the same vein until:

13TH JULY

Since my being honoured with the friendship of Mr Johnson I have more seriously considered the duties of morality. I have considered that promiscuous concubinage is certainly wrong. Sure it is that if all the men and women in Britain were merely to consult an animal gratification, society would be a most shocking scene. Nay, it would cease altogether. Notwithstanding of these reflections, I have stooped to mean profligacy even yesterday. Heavens, I am resolved to guard against it.

But Boswell's good intentions cannot long control his appetite. Admittedly, here it is the prostitute who does the importuning.

ABOVE The oleograph technique which was used to produce this miniature allowed the reproduction of coloured erotic images on mass market items such as snuff boxes and cigar cases.

3RD AUGUST

. . . I should have mentioned that on Monday night, coming up the Strand, I was tapped on the shoulder by a fine fresh lass. I went home with her. She was an officer's daughter and born at Gibraltar. I could not resist indulging myself with the enjoyment of her. Surely, in such a situation, when the woman is already abandoned, the crime must be alleviated, though in strict morality, illicit love is always wrong.

Poor Boswell, he began to drink heavily after that, in the forlorn hope that the demon of alcohol might subdue the demon of sexuality, prevailing where he had failed. Poor Boswell, but what of the women he used? It is amusing for us – as it was for him – to think of copulating on Westminster Bridge, but what of the poverty that drove the girl to acquiesce? And what tale of misery could the officer's daughter from Gibraltar have told?

———— ◊ ————

In a section which is all about ambivalence – shades of light and dark – Boswell gives us a few problems to resolve in the penultimate extract of the anthology. First, there are the issues raised by that oldest of games, Love For Sale. What can we say about that? Can the winners and losers be predicted by gender: is it that simple? Not really, but as in all games of chance the odds favour the House and the manager is generally male.

The second problem which Boswell's candid diary gives us is his terminology. A highly literate man who knew the value of words, he nevertheless describes episodes of random coupling for money as 'illicit love'. The confusion of love with sex is one of the most poisonous of all the hardy perennials planted by the adversary of mankind, Satan, in the Garden of Eden. Eating the fruit of that particular tree is the surest way to taste hell while yet alive.

The final issue which the tormented Boswell raises takes us back to the very beginning of this book, to the real 'Garden of Eden' of our species in the African Rift Valley. It is an issue which has kept history's prophets and philosophers almost as busy as contemporary divorce lawyers: monogamy. How did Boswell, the archetypal male – a sexual predator addicted to casual encounters – cope with marriage? We have only to turn the pages of his blisteringly honest diary: 'from henceforth I shall be a perfect man; at least I hope so.'

Boswell put up a good fight. He was faithful for almost three years until his wife's aversion 'to hymenal rites' tried him beyond endurance. Boswell was to practise what he called 'Asiatic multiplicity' until the end of his life. In common with most of us Boswell wished to remain 'faithful' in a monogamous relationship while at the same time wanting sexual variety and adventure. It is another paradox within our sexual inheritance which each must

work out in his or her own way. Some societies seek to replicate the sexual possibilities available to our palaeolithic forbears in other forms of 'marriage' such as polygamy. But in monogamous cultures other solutions must be sought.

Nature usually provides her own compensations. Along with infinitely larger penises than our nearest simian cousins we can also boast much larger brains. We can satisfy our need for erotic variety by using our imagination and by raising 'love'-making to an art rather than a repetitive animal function. This, of course, is where erotica comes in. Kalyana Malla, medieval author of the Indian sex manual *Ananga-Ranga*, describes his purpose in writing: 'I have in this book shown how the husband, by varying enjoyment of his wife, may live with her as with thirty-two different women, ever varying enjoyment of her, and rendering satiety impossible for both.' It takes two to tango, however, and the good Mrs Boswell may have found the multiform delights of Hindu erotology as alien as the thought of copulating on Westminster Bridge.

In the last extract in this anthology we join another frequenter of the dark byways, who nevertheless had a knack for shedding light on the subject of sex. His city was Paris, and Restif de la Bretonne discovers that the perusal of erotica is not always a useful antidote for infidelity.

I have said I was faithful to Zéphire with her companions. That truth might lead you into error. I must tell all, if I am not to deceive you. Here is another of my turpitudes, all the more surprising in that it took place in a time of virtue, and that nothing seemed to foreshadow it. I was respecting my intended and abstaining from other women: I was living more virtuously than I had ever done before, and I was beginning to imagine that one could become accustomed to it. But what is going to show the danger of books such as the *Le Portier des Chartreux*, *Thérèse Philosophe*, *La Religieuse en chemise*, and others like them, is the sudden and terrible eroticism which they aroused in me after long abstinence. A great libertine, that Molet whom I have already mentioned and who was a fellow-lodger of mine at Bonne Sellier's, had come to see me one Sunday morning when I was still in bed, and had brought me the first of these books, which I had only glimpsed at La Macé's. Filled with a lively curiosity, I took it eagerly and started reading in bed; I forgot everything, even Zéphire. After a score of pages, I was on fire. Manon Lavergne, a relative of Bonne Sellier, came on behalf of my former landlady to bring me linen and Loiseau's, which Bonne continued to wash for us. I knew what Manon's morals were like. I threw myself upon her. The young girl did not put up very much resistance.

I resumed my reading after she had gone. Half an hour later there appeared Cécile Decoussy, my sister Margot's companion, who came on her behalf to ask why she no longer saw anything of me. Without any regard for this young blonde's position (she was about to be married), or for the atrocious way in which I was

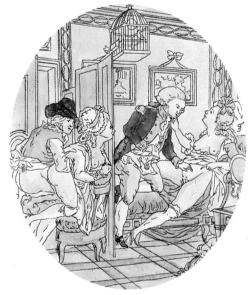

bringing shame on my sister in the person of her friend, I put so much fury into my attack that, alarmed as much as surprised, she thought that I had gone mad. I returned to my baneful reading.

About three quarters of an hour later Thérèse Courbisson arrived, laughing and bantering. 'Where is he, that lazy scamp? Still in bed!' And she came over to tickle me. I was waiting for her. I seized her almost in the air, like a feather, and with only one hand I pulled her under me. 'Oh! After what you've just done to Manon? A fine man you are!' She was caught before she could finish; and, as she was very partial to physical pleasure, she did nothing more but help me. At last she tore herself from my arms because she heard my landlord coming upstairs. She went out, leaving the door open. I finished my book.

The bed had warmed me up; the three pleasures I had enjoyed were just a spur to my senses: I got up with the intention of going to fetch Zéphire, of bringing her to my room, and of abandoning myself with her to my erotic frenzy. At that moment someone scratched at my door, which I had only pushed to. I started, thinking it was Zéphire. 'Who is it?' I cried. 'Come in.' 'Séraphine,' said a voice which I thought I recognized. I trembled, thinking it was Séraphine Destroches who had come to scold me for my behaviour with her companion Decoussy. 'Who is it?' I repeated. 'Séraphine Jolon.' The only person I had ever known by that name was the housekeeper of a painter who was our neighbour in the Rue de Poulies, and I had whispered sweet nothings to her once or twice; but then Largeville had turned up, and Jeannette Demailly, and I had left the house. Reassured, I opened the door. It was she. 'I have come,' the pretty girl said to me, 'on behalf of Mademoiselle Fagard, now Madame Jolon, my sister-in-law, who begs you to introduce me and recommend me to Mademoiselle Delaporte, who thinks highly of you and can render me a great service.' 'Immediately,' I said; 'sit down, pretty neighbour.' She was charming. As she turned round, she showed me a perfect figure. I seized her, and pushed her back on to the bed. She tried to defend herself. That was adding fuel to the fire. I did not even take time to shut the door. I finished, I began again. 'I . . . did . . . not . . . tell . . . you,' gasped Séraphine, 'that . . . my sister Jolon . . . was waiting for me.' This thought spurred me on towards a treble. I was like a madman, when the door opened. It was Agathe Fagard. 'Help! Help!' cried Séraphine. I left her uncovered; I jumped up, kicked the door to, threw the lovely brunette on to my bed, and submitted her to a sixth triumph no less vigorous than the first, carried away as I was by the force of my imagination. Agathe Fagard had not yet recovered from her surprise when, appeased by an almost simultaneous triple effort, I blushed at my frenzy and apologized to the two sisters-in-law. 'He has to be seen to be believed!' said Séraphine. I used all the arguments I could to calm them and only just succeeded. Such is the effect of erotic literature.

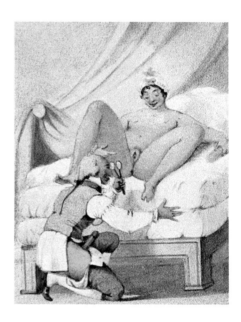

ABOVE An early nineteenth-century watercolour illustration from an erotic book.
OPPOSITE The reactions of the retainers in this French engraving are interesting. The man on the floor seems depressed at the enormity of the affair; the younger man rises in sympathy.

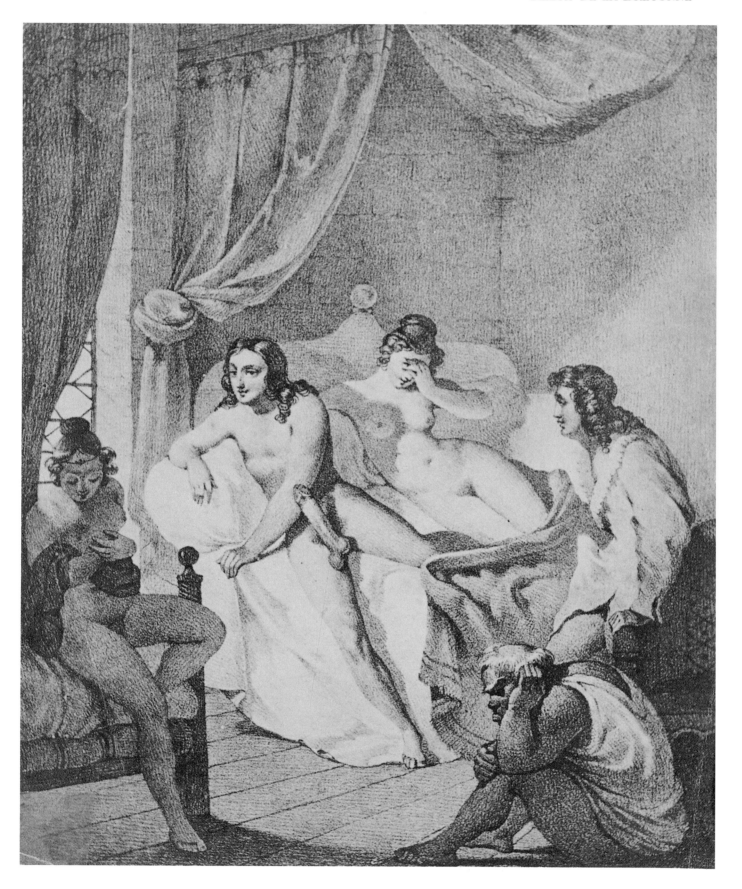

The Authors

Agathias (sixth century AD) Byzantine Greek poet and philosopher (page 119).

Pietro Aretino (1492–1557) Italian satirist, playwright and poet famous for his vicious pen and bawdy lyrics (pages 107, 113, 115).

The Marquis d'Argans (Jean-Baptiste de Boyer, 1704–71) French writer and political pamphleteer, favourite of the Prussian king Frederick II (page 115).

John Berger (1926–) British novelist and art critic (page 122).

Giovanni Boccaccio di Chellino di Buonaiuto (1313–75) Italian writer, born in Florence; he wrote the *Decameron* in 1348–53 (page 109).

James Boswell (1740–95) Scottish writer and lawyer, author of the famous biography of Dr Samuel Johnson published in 1791 (pages 153, 154).

Restif de la Bretonne (1734–1806) French novelist and diarist, called 'the Voltaire of the chambermaids' and 'the Rousseau of the gutter' (page 155).

Robert Browning (1812–89) English poet, who eloped with Elizabeth Barrett in 1846 (pages 41, 119).

Robert Burns (1759–96) Scottish poet, regarded as the national poet for his verses in the Lallans dialect (page 49).

Giovanni Giacomo Casanova, Chevalier de Seingalt (1725–98) Italian adventurer, gambler, spy, writer and librarian (pages 84, 114).

Armand Coppens (mid-twentieth-century) Belgian writer and bookseller whose *Memoirs* were published in 1969 in English, Dutch and German, 'assisted by his tired wife Clementine and her distant lover' (page 131).

Johann Wolfgang von Goethe (1749–1832) German scholar, statesman and poet, leading figure of the Enlightenment; his greatest work, *Faust*, was published in 1808 (page 28).

Robert Graves (1895–1985) English poet and novelist, author of *The White Goddess* (pages 103, 130).

Frank Harris (1856–1931) Writer and newspaper editor; born in Ireland, he lived in London and America (page 87).

Heinrich Heine (1797–1856) German Romantic poet who lived in Paris from 1831 (page 47).

Erica Jong (1942–) American novelist and poet, author of *Fear of Flying* (page 80).

Joseph Sheridan Le Fanu (1814–73) Irish writer, author of *Uncle Silas* and other stories of mystery and suspense (page 101).

Henry Miller (1891–1980) American novelist, author of *Tropic of Cancer* (1934) and *Tropic of Capricorn* (1939) (page 147).

John Milton (1608–74) English poet, supporter of Cromwell and the Puritans, who in later life became blind; he published *Paradise Lost* in 1667 (page 98).

Comte Gabriel Honoré Riqueti de Mirabeau (1749–91) French writer and political figure of the Revolution (page 10).

Adrian Mitchell (1932–) English poet (page 91).

Anaïs Nin (1903–77) French writer, brought up in New York; she began publishing her seven-volume *Diary* in 1931 (pages 33, 36, 103).

Paulos (sixth century AD) Byzantine poet and aphorist (page 122).

Samuel Pepys (1633–1703) English diarist and political figure who recorded the events of the Restoration, the Great Fire and the Great Plague (page 117).

Dante Gabriel Rossetti (1828–82) English painter and poet of Italian ancestry, a member of the Pre-Raphaelite Brotherhood (page 36).

Rufinus (c. second century AD) Greek poet and aphorist (pages 55, 60, 82).

Felix Salten (1869–1945) Austro-Hungarian writer whose best-known work is the story of *Bambi* (pages 118, 135).

William Shakespeare (1564–1616) English playwright and poet, the greatest dramatist in the English language (pages 10, 141).

Robert Louis Stevenson (1850–94) Scottish writer and traveller, author of *Treasure Island* and *Kidnapped* as well as *The Strange Case of Dr Jekyll and Mr Hyde* (page 102).

Bram Stoker (1847–1912) Irish novelist who published *Dracula* in 1897 (page 100).

Paul Verlaine (1844–96) French Symbolist poet and friend of the Impressionist and Post-Impressionist painters; his most famous work is *Les Fleurs du Mal* ('Flowers of Evil') (pages 13, 14, 25, 45).

Walther von der Vogelweide (1170?–1230) German Minnesinger or courtly poet (page 110).

Mae West (1892–1980) American film actress, famous for her suggestive one-liners (page 88).

Oscar Wilde (1854–1900) English dramatist of Irish ancestry, author of *The Importance of Being Earnest*; after imprisonment for homosexuality he was exiled to France (pages 12, 19, 28).

John Wilmot, Earl of Rochester (1647–80) English poet at the court of Charles II, famous for his bawdy poetry (page 68).

William Butler Yeats (1865–1939) Irish poet and playwright, co-founder of the Abbey Theatre in Dublin, 1904 (page 127).

Emile Zola (1840–1902) French novelist, author of the *Rougon-Macquart* series (1871–93) which includes *Nana*, *Germinal* and *La Terre* (page 149).

The Artists

Hans Baldung Grien (c. 1484–1545) German painter and engraver, one of the great figures of the northern Renaissance (page 100).

Franz von Bayros (1866–1924) German painter and illustrator (pages 15, 40, 93, 107).

William Blake (1757–1827) English mystic poet and artist who illustrated his own poetry (page 101).

Salvador Dali (1904–89) Spanish painter, a leading figure of the Surrealist movement (page 8).

Margit Gaal Early twentieth-century German artist (page 12).

Rudolf Koch German illustrator of the mid-twentieth century (page 134).

Adolfo Magrini Italian artist of the early twentieth century (pages 66, 110, 111).

Amedeo Modigliani (1884–1920) Italian painter and sculptor who settled in Paris in 1906, becoming friendly with Picasso and Brancusi (page 7).

Cesare Peverulli Mid-twentieth-century Italian artist (page 120).

Pablo Picasso (1881–1973) Spanish painter and sculptor who settled in France, one of the greatest artists of the twentieth century; he produced a considerable body of erotic paintings, drawings and etchings (frontispiece, pages 6, 7, 9).

André Provot Nineteenth-century French illustrator (page 88).

Rembrandt Harmensz. van Rijn (1606–69) Dutch painter and engraver, the most outstanding of the seventeenth century in Holland (page 114).

Leon Richet Late nineteenth-century French artist (page 65).

Auguste Rodin (1840–1917) French sculptor, whose monumental works are among the most highly regarded of his time (page 22).

Italo Zetti Mid-twentieth-century Italian illustrator (pages 33, 118, 119, 132, 133).

Giovanni Zuin Italian photographer of the late twentieth century (pages 69, 70, 104, 105, 106, 122, 124, 125, 126, 128, 129).

Sources and Acknowledgements

Bibliographical details of the excerpts in this anthology are given below, with copyright notices and permissions indicated where appropriate. Every effort has been made to acknowledge the copyright owner of the material used. If any excerpt has been inadvertently omitted, the copyright owner is invited to contact Eddison Sadd Editions, the compilers.

Pages 10, 141: William Shakespeare, excerpt from *King Lear* (1605/6); *Sonnet 128*.

Page 10: Gabriel Honoré de Mirabeau, *The Lifted Curtain*, trans. Howard Nelson, © Holloway House Publishing, 1972, reprinted W. H. Allen, 1986.

Pages 12, 28: Oscar Wilde et al., *Teleny* or *The Reverse of the Medal*. 1893. British Library. (Also published by Grove Press Inc., New York.)

Pages 13, 14, 25, 45: Paul Verlaine, extracts from 'At the Dance', 'Now, Poet, Don't be Sacrilegious', 'Even Without Presenting Arms . . .' and 'The Way the Ladies Ride' from *Femmes/Hombres*, trans. Alistair Elliot, published 1979 by Anvil Press Poetry, London, and Sheep Meadow Press, New York.

Page 28: Johann Wolfgang von Goethe, 'Gretchen at the Spinning Wheel' from *Faust* Part I, trans. © 1993 Fiona Ford.

Pages 33, 36, 103: Anaïs Nin, *Delta of Venus* (Penguin Books, 1990), © Anaïs Nin 1969, © The Anaïs Nin Trust, 1977, reprinted by permission of Penguin Books Ltd and of Harcourt, Brace & Company.

Page 36: Dante Gabriel Rossetti, *Jenny*.

Page 38: Anonymous, Greek, 'I wish I were the wind', trans. Barriss Mills, *The Greek Anthology* (Allen Lane, 1973; Penguin Classics, 1981).

Pages 38, 71, 92, 106: *Memoirs of a Venetian Courtesan*, © L.O.E.C.

Pages 41, 119: Robert Browning, *In a Gondola*; *The Ring and the Book*.

Page 43: *The Romance of Lust*, ed. William Simpson Potter, 1873–6.

Pages 45, 65, 145: *Passion's Apprentice*, © L.O.E.C.

Page 47: Heinrich Heine, fragment of a poem.

Page 49: Robert Burns, 'Wad Ye Do That?' from *The Merry Muses of Caledonia*.

Page 52: 'Walter', *My Secret Life*. British Library; reprinted by Grove Press Inc., New York.

Pages 55, 60, 82: Rufinus, 'A silvertoed virgin', 'Rhodope, Melite and Rhodoklea', 'I do not enjoy', trans. Alan Marshfield, *The Greek Anthology* (Allen Lane, 1973; Penguin Classics, 1981).

Page 62: *Souvenirs d'une Puce* ('Memoirs of a Flea').

Pages 68, 104: Pauline Réage, *Story of O*, © Editions Pauvert, 1954.

Pages 71, 74: *Gus Tolman*, early twentieth-century American.

Page 72: Anonymous Geisha song of the eighteenth century.

Pages 75, 78: *Eskimo Nell*, anonymous poem.

Page 80: Erica Jong, 'The Wingless & the Winged' from *Selected Poems*, © Erica Jong 1977.

Pages 84, 114: Giacomo Casanova, *History of My Life*, trans. Willard R. Trask, © 1966 Harcourt Brace Jovanovich, Inc., reprinted by permission of the publisher.

Page 88: Anthony Grey, *A Gallery of Nudes*, Star Books, 1987.

Page 91: Adrian Mitchell, 'Celia Celia' from *For Beauty Douglas* © 1982 Adrian Mitchell. Reprinted by permission of Peters Fraser & Dunlop Group Ltd. Note: neither this nor any other of Adrian Mitchell's poems is to be used in any examination whatsoever.

Page 92: *O My Darling Flo*, anonymous English poem.

Page 98: John Milton, *Paradise Lost*, Book I.

Page 100: Bram Stoker, *Dracula*.

Page 101: Joseph Sheridan Le Fanu, *Carmilla*.

Page 102: Robert Louis Stevenson, *The Strange Tale of Dr Jekyll and Mr Hyde*, 1886.

Pages 103, 130: Robert Graves, extracts from 'The Haunted House' and 'The Cool Web' from *Collected Poems 1975*. Reprinted by permission of A. P. Watt Ltd on behalf of the Trustees of the Robert Graves Copyright Trust.

Pages 107, 115: Pietro Aretino, extracts, trans. © Alistair Elliot.

Page 109: Boccaccio, *The Decameron*, trans. J. M. Rigg (Everyman's Library, 1979).

Page 110: Walther von der Vogelweide, 'Under the Linden Tree', trans. © 1993 Fiona Ford.

Page 113: Pietro Aretino, *Sonnet No. 4*, trans. Oscar Wilde.

Page 115: Marquis d'Argans, *Thérèse Philosophe*, 1748.

Page 117: Samuel Pepys, excerpt from his *Diaries*.

Pages 118, 135: Felix Salten, *Josefine Mutzenbacher*, 1906.

Page 122: John Berger, *G* (n.e. Hogarth Press, 1989), reprinted by permission of Random House UK.

Page 122: Paulos, 'Our kisses Rodope', trans. Alan Marshfield, *The Greek Anthology* (Allen Lane, 1973; Penguin Classics, 1981).

Page 127: W. B. Yeats, *The Lover's Song*.

Page 131: Armand Coppens, *Memoirs of an Erotic Bookseller*, © Armand Coppens, 1969.

Pages 140, 141, 145: *Suburban Souls*.

Page 147: Henry Miller, *Black Spring*, © The Estate of Henry Miller. Reprinted by permission of Curtis Brown Ltd and Grove Weidenfeld.

Page 149: Emile Zola, *Nana*, trans. © George Holden 1972 (Penguin Classics, 1972), reprinted by permission of Penguin Books Ltd.

Pages 153, 154: James Boswell, *Diaries*.

Page 155: Restif de la Bretonne, *Diary*.

The great majority of the illustrations in this volume are reproduced by kind permission of Il Collezionista, Italy. Eddison Sadd is also grateful to the following for permission to reproduce:

The National Gallery of Scotland, Edinburgh, for Edgar Degas, *Woman Drying Herself* (front cover);

Lucien Clergue for works by Pablo Picasso (*The Kiss*, frontispiece, and the etchings on pages 6, 7R, 9);

Bridgeman Art Library, London, for Amedeo Modigliani, *Nude* (page 7);

Reed International Books Ltd/The Playboy Collection for Salvador Dali: *Young Virgin Auto-Sodomized by her own Chastity* (page 8);

ADAGP/Musée Rodin, Paris (photo © Bruno Jarret) for Auguste Rodin, *The Eternal Idol* (page 23);

Collection and Copyright © Stefan Richter/All rights reserved (pages 24, 44, 53). Stefan Richter is interested in purchasing erotic daguerreotypes/photographs (nineteenth-century only) and may be contacted c/o A.R., 8 Lenhurst Way, Worthing, West Sussex BN13 1JL, England;

© Giovanni Zuin, Courtesy of Akehurst Gallery (pages 69, 70, 104, 105, 106, 122, 124, 125, 126, 128, 129).

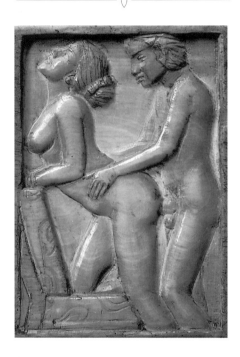

*Cras amet qui nunquam amavit
quique amavit cras amet*

*Let those love now, who never lov'd
 before:
Let those who always lov'd now love
 the more*